CREATIVE
EVIL
PHOTOGRAPHY

CREATIVE
EVIL
PHOTOGRAPHY

GETTING THE MOST FROM
YOUR MIRRORLESS CAMERA

HAJE JAN KAMPS

ILEX

First published in the UK in 2012 by

I L E X

210 High Street
Lewes
East Sussex BN7 2NS
www.ilex-press.com

Copyright © 2012 The Ilex Press Limited

Publisher: Alastair Campbell
Associate Publisher: Adam Juniper
Managing Editors: Natalia Price-Cabrera
& Zara Larcombe
Editor: Tara Gallagher
Creative Director: James Hollywell
In-house Designer: Kate Haynes
Designer: JC Lanaway
Picture Manager: Katie Greenwood
Colour Origination: Ivy Press Reprographics

British Library Cataloguing-in-Publication Data
A catalogue record for this book is available from
the British Library.

ISBN: 978-1-907579-88-2

Printed and bound in China
10 9 8 7 6 5 4 3 2 1

Contents

Introduction

Creative EVIL Photography is a photography book aimed at beginners who have (or are thinking of purchasing) an EVIL (Electronic Viewfinder, Interchangeable Lens), MILC (Mirrorless Interchangeable Lens Camera), or compact system camera—and at intermediate photographers who have bought one of these cameras, and want to learn how to make the most of them. As there are a few different terms in use for this kind of camera, throughout this book I'll be referring to them as EVIL cameras.

The book is taking the stance that EVIL cameras are high-quality, highly versatile pieces of equipment that are capable of doing just about everything you can do with an SLR camera—but since they are smaller and often cheaper, they are more likely to be bought by compact camera users with higher photographic aspirations.

Creative EVIL Photography, then, takes the reader on a journey: From the world of point-and-shoot, to serious, high-quality photos taken using some of (or all, for the ambitious photographer) the manual abilities of the camera.

The book is perfect for people who have been afraid to make the leap into the "professional" world of SLR photography, but are happy to make their first faltering steps using an EVIL camera. With this book, they have a solid base to walk on, and a hand to hold on their way.

The author believes strongly that great photography has to come from two angles: the technical (How does light work, and how can you use the camera's settings to manipulate light?); and the creative (What makes a good photo? How can you evaluate your own photographic output? How do you know if you're getting better?). Creative EVIL Photography will help the readers make beautiful photos—one baby-step at a time—using an EVIL camera.

Mind you, because EVIL cameras and SLR cameras are quite similar, this book will be a great beginner's guide to any photographer with a reasonably advanced camera (but ssh, don't tell anyone, or all the SLR owners will want to buy a copy, and all the book stores will run out!).

Welcome to the Magic of EVIL

Welcome to the world of Creative EVIL. This book is designed to make you a better photographer, no matter what "kind" of photographer you are, or how experienced you are. It won't make a difference whether you're a seasoned professional, or whether you still have your newest camera sitting in its box because you're a little bit nervous about taking it out for the first time, just in case it bites.

I remember clearly when I first started learning about photography, many years ago. Most of all, I remember the things I wish somebody had told me before I started: the stupid mistakes I kept making, and the silly misunderstandings that stood between me and taking great pictures.

Of course, this book will be especially useful to people who use an EVIL camera, but even if you don't, it is going to help in your quest to become a better photographer. Obviously, if you're using a compact camera or a full-size SLR camera instead of an EVIL camera, some of the techniques and ideas described in this book won't apply to you —but don't let that put you off. One of the beautiful things about photography is that once you start to understand it, you can find all sorts of creative work-arounds for any limitations in circumstance, the equipment you have with you, or gaps in your photography knowledge. By the end of this book, you'll have the toolbox you need to go out there and get the photos you want.

So—grab your EVIL camera, and let's get started!

EVIL cameras give you top-shelf quality, but without the bulk and weight of a typical SLR system. Perfect for travel photography!

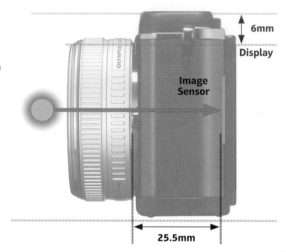

6mm

Display

Image Sensor

25.5mm

What is an EVIL camera?

There's a Scandinavian expression: "Kjært barn har mange navn," or "a child that's loved has many names." That's certainly the case with the newest generation of cameras to have made their way out of the camera manufacturer's factories.

Curiously, there isn't really a name that fits all the next-generation cameras on the market. They have been called EVIL (Electronic Viewfinder, Interchangeable lens), MILC (Mirrorless Interchangeable Lens Camera), Four-Thirds cameras—"compact system cameras," or just "mirrorless cameras."

Of all of these descriptions, only "mirrorless" is more or less accurate: Not all of the cameras that fall into this category have electronic viewfinders, not all of them have interchangeable lenses, and only a few of the manufacturers use Four-Thirds sensors.

Nonetheless the idea of EVIL covers much more than just a description of the camera: It describes a brand new approach to photography, and an important step away from the way things have been done in the universe of digital photography for a while.

Interchangeable lenses and the ability to take full manual control over your camera means that EVIL cameras have all the benefits of an SLR camera—and none of the downsides.

The small size of the EVIL cameras means that street photography becomes a lot easier—people don't realize you're taking photos with a "serious" camera, and are less skeptical as a result.

Where EVIL cameras fit in

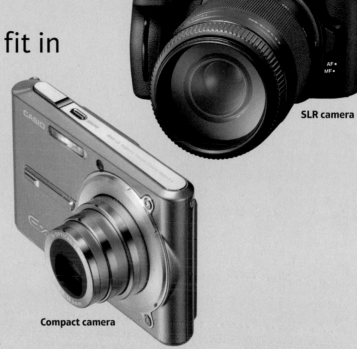

SLR camera

Ultra-compact cameras

When the camera manufacturers are thinking ultra-compact, they are really thinking about two things: size and weight. The manufacturers are willing to sacrifice ease of use, picture quality, and just about everything else, in the ever raging war to have the smallest, lightest, compact camera on the market.

These cameras are often useless to people who aspire to be creative photographers, but they're great if you want to stick a camera in your pocket or purse in the knowledge that you're always carrying a reasonable-quality camera around with you.

Compact camera

Compact cameras

The term "compact camera" is quite loose, but generally covers cameras that you can fit in a jeans pocket—more or less.

The quality of these cameras can vary wildly, starting with the cheap-and-cheerful (but photographically embarrassing) cameras you can buy at a toy store, to small cameras that punch well above their weight in terms of features and photo quality. Some compacts feature full manual control, raw files, and lenses with incredibly high quality, making it possible to shoot photos that rival that taken with an SLR camera.

WHAT IS THE BEST CAMERA TYPE?

In photography, it's meaningless to discuss which camera is "best"— it is far more useful to talk about what is most suitable for the job at hand. If you're going to try to take photos of lions in the wild, an ultra-compact camera is the wrong tool for the job. Similarly, if you're going backpacking, you may not want to drag along a huge bag with 30 kilos/66 lbs of expensive camera kit.

Myself, I used to use compacts, bridge cameras, and SLR cameras, all depending on the situation. Recently, however, it seems I find myself reaching for my EVIL cameras more and more often—especially in photography situations where I don't really know what to expect. My Olympus PEN is small enough to take with me anywhere, and the picture quality is better than that of my compact cameras, so it's a win-win situation!

Where EVIL cameras fit in

IMAGE COURTESY OF FUJIFILM

Fujifilm Finepix Z900 EXR

Using a fixed-focus 28mm lens, an awesome 3.5-inch touch screen, and weighing only 135g/4.8oz, the Fujifilm Finepix Z900 EXR is a great example of an ultra-compact camera.

IMAGE COURTESY OF CANON

Canon PowerShot S95

Packing a large sensor, the ability to record images as RAW files, and built-in image stabilization, the Canon PowerShot S95 is one of the best compact cameras currently on the market.

IMAGE COURTESY OF CANON

Canon PowerShot G12

The Canon PowerShot G12 is a flexible bridge camera with a 28–140mm lens, fully manual controls, and the ability to connect SpeedLite external flashes.

IMAGE COURTESY OF NIKON

Nikon Coolpix P100

Nikon's Coolpix P100 has an incredible zoom range of 26–678mm and built-in HDR imaging, and it can capture true high-definition video. It even has a built-in stereo microphone!

GH2

As one of the current top-of-the-line EVIL cameras, the GH2 offers stiff competition to SLR cameras—it has all the bells and whistles you expect of a professional camera, but is noticeably smaller and lighter than comparable SLR cameras.

Sony NEX-5

The Sony NEX-5 is another example of an EVIL camera—the body is the size and weight of a slightly chunky compact camera, and it gives the discerning photographer a full range of photography options—and far more flexibility than any compact camera.

Sigma SD1

The Sigma SD1 is a powerhouse among SLR cameras—it doesn't mess about with video or gadgets, and is a purist's stills camera. Fully weather-sealed, with a magnesium body and delivering top-quality, 46-megapixel image files, it's a rather special machine.

Sony A290

It's especially entry-level SLR cameras, like the Sony A290 depicted here, that will feel the pressure from EVIL cameras.

The road to EVIL

In a way, the development of the EVIL platform has been a long time coming and it has been pretty much inevitable.

From one end of technology development, digital compact cameras and bridge cameras have been getting more and more advanced. At the same time, camera manufacturers realized that SLR cameras aren't just for the photographic elite and advanced amateurs anymore. Anybody who wanted to start do some slightly more serious experimentation with photography was reaching for entry-level SLR cameras, which led some manufacturers (especially Sony) to launch more affordable and simpler digital SLR models.

In the gray area of very advanced compact cameras and very simple SLR cameras, there was an obvious gap—which was eventually filled when Olympus revived their PEN name.

The Olympus PEN brand was first used in the late 1950s, with a series of very innovative cameras. The PEN name was attached mostly to the non-interchangeable lens rangefinder. The first few models were "half frame" cameras, which, at the time, was the smallest camera to use the standard 135 film.

Leica M9

DID YOU KNOW: Leica M9

The Leica M8 has since been replaced by a new camera, predictably named the Leica M9. It isn't particularly user-friendly, and it retails at a cool $7,000 without any lenses—but it is the pinnacle of Mirrorless Interchangeable Lens Cameras—a full-frame, 18.5 megapixel picture-taking monster that accepts some of the finest lenses ever created. It still doesn't have an EVF or Live View, though…

This "rangefinder" word is important: Instead of having a mirror, so the photographer can see what they are photographing through the camera's lens, you would look through a small hole next to the lens, which would give you an approximation of the picture you were about to take—much like you would get on film-based compact cameras and disposable cameras.

The Leica M3 is in many ways the 60-year-old grandfather of the current-generation EVIL cameras.

Leica M8, the world's first digital range finder camera, is one of the few 2006 digital cameras that are still in active use by photo enthusiasts today. It is considered by many to be the first EVIL-style camera—despite the lack of electronic view finder.

The half-way house: digital rangefinder cameras

When Olympus launched the PEN EP-1, it immediately drew comparisons to the cameras from another camera manufacturer who have a long history in the world of rangefinder cameras: Leica.

Leica is one of those camera brands that most serious photographers have heard of, but that leaves amateurs scratching their heads. Hand-built in Germany, the Leica company is well-renowned for building high-precision, high-quality camera equipment that retail for obscene amounts of money.

In 2006, Leica introduced the M8, which follows in the footsteps of a long and rich history, going all the way back to the Leica M3, a rangefinder camera launched in the mid-1950s. The M8 was the first digital rangefinder from Leica, and it is still considered a very capable camera today. However, it doesn't have Live View, so there is no way of seeing what you are doing—until after you have done it. A true purist's camera, then, but considering that it was launched already in 2006, it was also an intriguing look into the future of what was to come…

Technology matures, and EVIL cameras become possible

The introduction of the EVIL cameras is the culmination of a lot of technology coming to fruition, finally. Up until 2008 or so, there had been several attempts at launching cameras with electronic viewfinders (among others, I remember the miserable experience of using a Canon Pro90 bridge camera in 2002), but the technology, on the whole, was pretty much useless.

Using the camera's sensor to display what the camera was seeing "live" on a small screen in a configuration similar to that of an SLR camera was a brilliant idea. It wasn't without problems, however: The imaging sensors were of poor quality—especially in low light—and the low-resolution displays available at the time made a pretty hopeless combination. Most people who gave EVF (Electronic Viewfinder) cameras a shot quickly returned to the safety of the SLR camera.

Meanwhile, in the compact camera world, more and more people were using the LCD display exclusively, ignoring the optical viewfinder. Camera manufacturers were noticing this, of course, and decided to concentrate on making the LCD displays better, and ditched the optical viewfinders from their cameras.

Eventually, when Live View became good enough that the viewfinder became superfluous, the technology was ready for EVIL cameras: Why should the users have to put up with the humpback design of SLR cameras when the mirror and pentaprism parts were no longer needed?

Benefits of the EVIL platform

There are many reasons why the EVIL platform is incredibly exciting to photographers. Ultimately, the only thing that means anything is the quality of images you're able to produce—and with EVIL, you're in good hands.

Opportunity

The only way to absolutely guarantee that you won't take any good photos, is if you don't take a camera with you. Without a camera, you're not going to get any photos at all. With that in mind, I've spent the past ten years or so always carrying a camera with me—either in a backpack, or in a pouch on my belt.

It's true that I always want to be able to take photos, but I don't want to sacrifice too much space in my backpack either. In the past, this meant that I would carry a compact camera most places—but of course, compact cameras have their own limitations. Until recently, you couldn't get compacts that capture raw files, for example, and you're limited with the amount of manual control you have with most compact cameras.

That all changed when I bought my Olympus E-P1—with the 17mm "pancake" lens attached. It doesn't take up a lot of space, so I was able to take it with me everywhere. The freedom of having the power of an SLR in your hands, in the package of a compact camera, is liberating and exciting—not to mention that it opens up a lot of opportunities you might have missed otherwise!

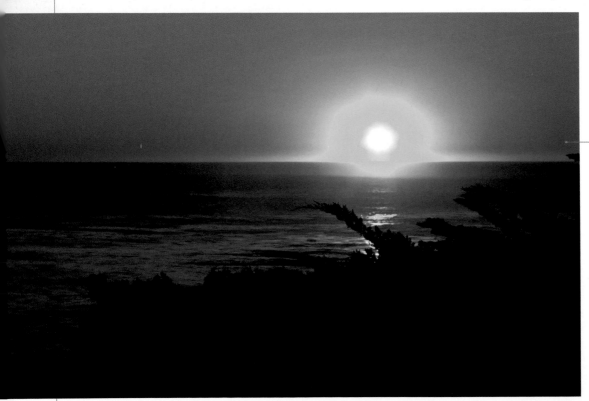

By photographing in Raw, you get the perfect opportunity to tease out every little nuance of color—and the full gamut of contrasts—when photographing tricky scenes, like a sunset.

Because I'm always carrying a high-quality EVIL camera with me, impromptu low-light shots like this are becoming a lot easier—even if I had no idea I'd be doing a photo shoot when I left the house.

Flexibility

Closely related to the "opportunity" advantage, is that upside of flexibility. Mixing and matching lenses, viewfinders, lighting equipment, and other accessories mean that you are able to ensure that your camera does exactly what you need it to do—nothing more, nothing less.

SLR cameras offer the same advantage, of course, but in a much bigger package: Take the Micro Four-Thirds system as an example; there are dozens of lenses available, ranging from 7–300mm, and a ton of different teleconverters, extension tubes, adapters, flash equipment, and so on. Everything you could wish for from an SLR camera— but in a much smaller package.

> **Cross-reference**
>
> Find out more about accessories and lenses in Chapter 5.

Looks

Okay, so perhaps looks comes pretty far down the list for most photographers—but personally, I feel like a little bit of a rock-star whenever I take my Olympus Pen EP-1 out—the retro rangefinder look, whilst subjective, is pretty awesome.

The "looks" aspect isn't just down to personal preference—it also has further implications: because the new-generation cameras are no longer dependent on having a mirror, there's a lot more flexibility for camera manufacturers to design the cameras however they want to. The Panasonic GH2, for example, looks pretty much like an SLR camera, the PEN cameras look like retrotastic rangefinders, and Sony's NEX series cameras are styled like compact cameras.

Despite the wildly different looks, all EVIL cameras have something in common: interchangeable lenses, high-quality sensors, and a fun factor that's off the charts.

Fixed vs. interchangeable lenses

One of the biggest reasons for picking an EVIL camera over a bridge camera is the ability to switch lenses—but is that really such a big deal? It depends entirely on what kind of a photographer you are.

Myself, I've spent a lot of time traveling, and I quite enjoy the challenge and limitations that using a single lens affords me. On a one-month trip to Vietnam a few years ago—before EVIL cameras became serious contenders—I only brought my Canon camera body and a 50mm fixed-focus lens. Sure, it's one of the most beautiful lenses ever created, and the photos I was able to take as a result were worth it.

The photos I took, I couldn't have taken with a compact camera: There simply aren't any compact cameras that have a sensor size and lens quality that are up to the challenge of taking the kinds of pictures I wanted to take.

If I were to make the same trip today, I would have brought an EVIL camera with a good zoom lens and a bright fixed-focus lens—and it would still have taken up less weight and space in my luggage than the SLR and fixed-focus lens.

A wide-angle lens is great for taking photos of vistas, landscapes, and when you're indoors or in confined spaces, the wide viewing angle means you get all the action in your photo!

A zoom lens is great when you want your photos to show the action up close, but you can't get close enough yourself. Lovely for safaris, concerts and sports events, for example.

If you're interested in macro photography, interchangeable lenses are a must—compact cameras simply don't have the advanced, specialized optics needed to take photos like this one.

THE EVIL ADVANTAGE

Standard SLR lenses are much, much larger than lenses made for EVIL camera systems. My Olympus 17mm f/2.0, for example, is a third of the size and a fourth of the weight of a comparable Canon 35mm lens. By choosing the EVIL system, you are choosing to travel much lighter —or giving yourself the opportunity to take a lot more lenses with you when you're going traveling.

Disadvantages of interchangeable lenses

The main disadvantage of being able to extend your camera system is the fact that lenses, especially high-quality lenses, can be very expensive. If you never intended to buy additional optics, then it might not be such a bad idea to buy a good bridge camera—but the fact that you can, means that if you're anything like me, you spend an unhealthy amount of time drooling over lovely lenses in camera shops.

The second issue is that if you've bought all these fantastic lenses, leaving them behind becomes difficult. I have a full set of lenses for my SLR, ranging from a gorgeously wide-angle 15mm to a fantastic 400mm lens. If I'm going to photograph a wedding, I know which lenses to bring. When I'm headed on safari, I have my go-to lenses. The problem comes when I'm going traveling for longer periods of time: There's only so many lenses you can bring with you when you're on a motorbike going down a dusty "road" in China. The most painful thing you'll experience as a photographer is spotting a perfect photograph, and then realizing that the lens you need is stored in a bag more than 6,000 miles away.

The last downside of interchangeable lenses is that when you change them, the inside of your camera is, however briefly, exposed to the elements. Dust and moisture can make its way inside your camera body, which isn't great: Dust on the imaging sensor shows up as blotches, and cleaning it off can be a nerve-wracking experience. This is the greatest advantage of fixed-lens cameras: They are sealed units, and dust should never be able to get inside.

Advantages of interchangeable lenses

When you are using interchangeable lenses, it is useful to stop thinking of your camera simply as a device and more as a "system" for taking photos. How you choose to upgrade is up to you, but the great thing is that you can upgrade whenever you feel you are outgrowing your equipment.

The greatest advantage, I find, of interchangeable lenses, is that you can afford to pay a lot of money for a good-quality interchangeable lens. In the past ten years, I have bought and used many camera bodies, but some of the lenses I use regularly are my oldest. The great thing is that if you spend top dollar on a high-quality lens, you know you'll get many years of pleasure from it. Best of all, when camera manufacturers release cameras with even better sensors, replace your camera body with a new one—and your fantastic lens will take even better photos than before.

The other advantage of these lenses is that you can choose exactly the right tool for the job. If you need sharpness, a good fixed-focus lens is perfect. If you are taking landscapes, a wide-angle zoom hits the spot. Going on safari? Grab your telephoto lenses. Want to shoot small things? Extension tubes can help you take better macro photos.

Of course, there are compact cameras that have either bright lenses, wide-angle lenses, telephoto lenses, or great macro capabilities—but none of them do everything equally well. Your EVIL camera with the appropriate set of lenses for the job will be able to take far better photos than even an advanced compact camera could ever dream of.

Electronic viewfinders and Live View

As we discussed in "The Road to Evil," electronic viewfinders and Live View are a relatively recent development. Before electronic viewfinders (EVF) and Live View (LV), we had to rely on optical viewfinders. These come in two different flavors.

TTL viewfinders

Through-the-lens (TTL) viewfinders are the ones you are used to from SLR cameras: Light enters the camera body through the lens, is reflected via the mirror into the pentaprism, and out of the viewfinder. When you take a photo, the mirror is flipped up, so the light, instead of going through the viewfinder, goes to the imaging sensor.

Rangefinder-style viewfinders

The other type of optical viewfinders are rangefinder-style viewfinders. These are little holes next to the lens. You don't see exactly what the camera sees, but they give you an idea of what you are photographing.

Digital viewfinders

Digital viewfinders work around a lot of the issues that optical viewfinders run into. The way they work is that the image sensor that is recording the image inside the camera is always "on." The light captured by the camera is continually converted into a digital image, and displayed to the photographer, either via an electronic viewfinder or by using Live View.

Because digital viewfinders are, well, digital, you can often choose between just previewing the image, or having a range of "enhanced" displays, such as opting to have a rule-of-thirds grid, exposure data, a histogram, or any number of other data overlays displayed along with your image preview.

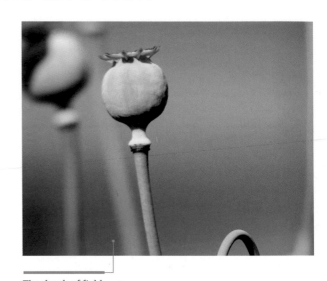

The depth of field and exposure preview features of Live View were key to capturing the photo of this poppy field.

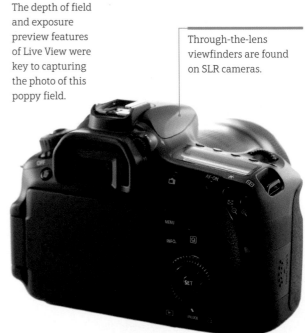

Through-the-lens viewfinders are found on SLR cameras.

PARALLAX PROBLEMS

With a rangefinder style camera, what you see is not from exactly the same vantage point as your camera's lens. As a result, what you are photographing doesn't correspond fully to what you see in the viewfinder. The effect is more pronounced the closer you get to your subject.

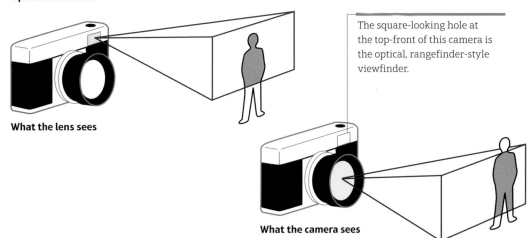

Optical viewfinder

What the lens sees

The square-looking hole at the top-front of this camera is the optical, rangefinder-style viewfinder.

What the camera sees

The difference between Live View and an electronic viewfinder

An electronic viewfinder is a hole you look into, just like on a camera with an optical viewfinder. However, instead of seeing the actual scene in front of you, the camera shows you what the imaging sensor is capturing. The great thing about electronic viewfinders is that the sun won't get in your way: You're essentially looking down a darkened opening into a small, high-resolution display.

Live View uses much of the same technology as an EVF, but instead of showing it on a display inside the camera, the image is displayed on a panel on the back.

Whether you choose a camera with Live View, an EVF, or both depends on your photography style. Users preferring SLRs tend to find EVFs more natural, while compact camera veterans usually favor Live View tech.

Neither technology is inherently better or worse—experiment with both, and use whatever you like best.

TTL VIEWFINDER

PROS
- You can see what the camera sees
- The "image preview" happens at the speed of light

CONS
- The mechanism is bulky: The pentaprism takes up space
- The lens has to be far enough away from the sensor to allow the mirror to move out of the way
- Mirror movement causes "mirror slap," which can cause vibrations on long exposures
- Mirror movement is louder than camera designs without mirrors
- The viewfinder blacks out while a photo is being taken
- Most SLRs don't have 100 percent coverage with the optical viewfinder: Your camera captures more than your viewfinder indicates

RANGEFINDER VIEWFINDER

PROS
- Because there is no mirror between the lens and the sensor, the camera design can be more compact
- No bulky pentaprism on top of the camera body
- You can preview the image at the speed of light
- Rangefinder cameras tend to be much quieter than cameras with mirrors

CONS
- Parallax problems
- The viewfinder is very conservative, and you are actually capturing a lot more than you would think
- If you use a different lens on the camera, you also need a different viewfinder

DIGITAL VIEWFINDER

PROS
- 100 percent coverage
- No parallax problems
- You see what the camera's lens captures
- Depth of field and exposure preview are possible
- Data and information overlays

CONS
- There is a very slight delay in displaying the image on the display
- Some sensor/display combinations have poor low-light performance

Equipment needed to use this book

There's been a lot of talk about EVIL cameras and equipment in the first chapter of this book. What did you expect? It's in the title of the book! However, you don't need an EVIL camera to learn a lot from this book.

It doesn't really matter if you have a compact camera, an advanced compact, an EVIL camera, or an SLR. After all, the laws of physics don't change depending on what camera you happen to be holding in your hand.

There's no law that says that compact cameras can't take lovely photos. This one was taken with a Canon PowerShot S95. It's tiny, but it does shoot in Raw, and has full PASM settings.

Mother nature can be surprising and confusing all at once. This sunset over Koh Tao in Thailand is one of the craziest lighting situations I've ever seen—if it hadn't been for shooting in a manual exposure mode and in Raw format, I don't think my photos would have been useable at all!

Embrace the PASM and Raw

Many of the creative techniques in this book do depend on you being able to directly influence what the camera is doing, however. The simplest compact cameras might not do everything you hope for, but then again, that's where most of us start—and it's as good a starting point as any!

To get the most from this book, you need a camera with PASM settings—that's photographer speak for Program mode, Aperture Priority, Shutter Priority, and full Manual mode. That means that you should be doing alright with any EVIL or SLR camera, and quite a few bridge and advanced compact cameras, too.

The other feature worth looking for on your digital camera is the ability to take photos in Raw format. We'll talk about Raw in more detail in Chapter 9.

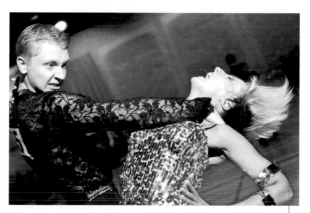

Without a tripod, this photo would have been impossible. I used a 30-second exposure to capture this café in low light.

The basics and beyond

The perfect camera equipment to get started with alongside this book would be as follows, in approximate order of importance:

• A camera body with PASM settings
• A zoom lens (equivalent to 28–80mm or thereabouts is great)
• A tripod

Beyond these things, what you choose to buy depends on the type of photos you want to take—in Chapter 7, we'll discuss the perfect equipment setup for certain types of photography. In general, when it comes to buying equipment, it is best to wait until you know what you need, and then buy the highest-quality item you can afford—especially when it comes to optical components of your camera system.

Flash photography can add a whole new dimension to your pictures—but there are a lot of additional skills to learn.

Remember

A camera body is for Christmas—a lens is for life!

Taking Better Photos NOW

One of my biggest frustrations about photography books is that you often have to do a lot of reading before you see any improvement in your photography. It's doubly frustrating because there are a series of small changes you can make to the way you take photos—right now, right this moment—and see a drastic change in your photographic output.

So, instead of going through page upon page of techno-babble about shutter speeds, lens multiplication factors, and monochromatic images, this chapter is going to leap right into the midst of things, and start improving the way you take photos, day to day. Read this chapter, then pick up your camera, and be amazed by how much better your photos can be by changing only a few little things.

In a city like Rome, sometimes it can be really hard to take a photo that doesn't feel like it has been taken a million times before. By thinking more carefully about what a place means to you, you may be able to find an angle that really shows off the city at its best. In this case: what could scream Rome more than a bright red Vespa?

Always carry a camera with you—even if it's just the camera on your cell phone. This lovely macro shot of a ladybug was taken with a Nokia N8 mobile phone!

Your pre-shoot checklist

The word "checklist" sounds rather off-putting. It screams "Wait! Wasn't photography meant to be fun? What's with the paperwork?" but trust me, a quick little mental checklist before you click the shutter can be of huge help when it comes to making beautiful images.

There are many things you can fix about your images once they're taken. A slightly crooked horizon, a slight over-exposure or a little bit of red eye won't ruin your photo—but the reason why you think about a few things before you take a photo, is that there are things that are hard to correct after the fact. If your camera is set to too high an ISO from the evening before, for example, you'll have to live with the additional noise this causes.

It looks like a pretty hefty list of things you need to do, but don't worry—you only need to do the first item before every session. I run through the whole list in under a second, every time I take a photo. It takes a bit of practice, but it really works—promise!

These photos were taken seconds apart. The foreground is the very same flower in both shots—but look at the background! It's not hard to decide which of these photos shows off the flower best…

CHECK LIST

Check your settings. Is your camera set to the mode you planned to use? Is the ISO set to a useful setting?

Fill the frame. Does your subject fill the frame? If not, get in closer, either by walking closer, or by zooming in.

Pre-focus. When you press your shutter button half way, your camera will focus and measure the light. Use that functionality every time.

Check your focus. If you're taking a photo of something with eyes, make sure you have the eyes in focus. If not, well, try to get the important bits in focus.

Compose. Keep the shutter button pressed half way, and re-compose your image so everything you want in your photo shows up the way you want it.

Check your edges. Before you press the shutter all the way down, run your eyes along the edges of the frame. Is there anything along the edges that shouldn't be there? If so, re-compose your shot and try again!

Check the background. New photographers are so focused on what's happening in the foreground, that they fail to notice the huge dog taking a poo in the background. You laugh, but I've seen it happen.

Deep breath. Hold your breath whilst you very slowly press the shutter button all the way down. This helps eliminate camera shake when you are taking the photo.

Turning your pictures black and white

Rich, vivid colors are without doubt a huge asset to photographs, but there are times where simply turning a photo into a black-and-white shot can make all the difference between a so-so shot and the president of the United States of groovy. A quick word of warning: Black and white can't save a bad photo—if your composition is poor, your focus is off, or your exposure is miles out, then there's nothing that can be gained by dialing down the hues.

Having said that, it's often rather incredible how much better a photo can look, simply by looking at it through a different pair of glasses. All photo-editing software has a way of turning your photos into black and white. Give it a whirl. You never know, you might like it!

The color original of this photo is badly under-exposed, and the colors are uninspiring. By turning it into black and white and correcting the exposure, it turned into an expressive portrait with a lot of context. That, ladies and gentlemen, is the power of shooting in Raw with an EVIL camera.

Cross-reference

In Chapter 4, we talk about color (and various approaches to removing it) in much more depth.

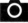

THE EVIL ADVANTAGE

Even if your photo is looking uninspiring, consider taking a look at it in closer detail. The photo on this page was taken with an Olympus E-P1. I'm sure you can agree it's impressive how much facial detail I was able to tickle out of the Raw file by giving it the full Adobe Lightroom treatment.

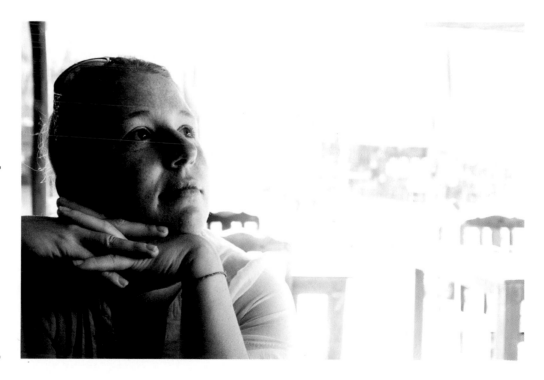

Nailing your composition

There are lots of little rules around how "composition" works, but the good news is that you don't have to remember that many of them. Implement some of these simple tips, and watch your photos sparkle.

Avoid centering your subject

When you're taking a photo, it's natural to be focusing on what is in the center of the frame: After all, that's going to be the most important part of your image. However, if you take a photo where the subject is directly in the middle of the image, you're probably doing your own photography skills a disservice.

Most images, with very rare exceptions, look much better with an off-center composition.

> **Glossary**
>
> **Subject:** The most important part of your photo. If your image has people in it, it's quite likely that they are the subjects.

THINKING ABOUT THE FRAME

The tennis-player is, without a doubt, the most important part of this photo, but by centering her, there is a huge space of nothing on both sides of her. By placing the tennis player and the racket more prominently in the image, the photo hits home much harder.

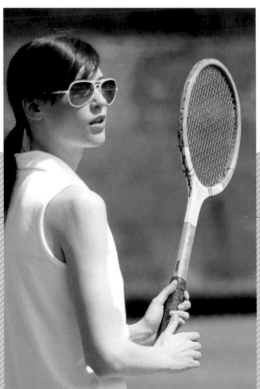

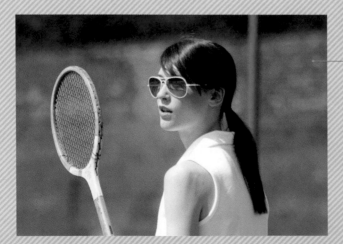

The Rule of Thirds

Once we agree that centered compositions don't look so good, the next natural question is to ask "Where should we place the main subjects?" The Rule of Thirds is the answer to that question.

To use the Rule of Thirds, place an imaginary (or actual) grid over your image. The grid should divide your photo into three, through the length and height of the photo. By placing the main elements of your image along the lines, you'll get a more visually appealing photo.

The final thing we'll take a look at is how to place people in your photograph. Whether someone is looking "out of" or "into" the photo frame makes a huge difference to how the person in your picture is perceived by your viewer.

It is difficult to explain in words (which means I'm lucky this is a book full of pictures, really), and I find it difficult to anticipate the result of placing a person facing into or out of the frame. It's worth considering, however, if you ever find yourself struggling to illustrate an emotion, try both ways, and see what works best with your particular image.

As an extra bonus exercise, look how these two photos implement the Rule of Thirds.

CROPPING FOR BETTER PHOTOS

Two different crops of exactly the same image. In the left photo, he's looking into the frame—a look of sadness, perhaps? In the other photo, he looks out of the photo, and the additional space behind him gives it a completely different feel—personally, I think he looks scared, or perhaps regretful about something he has done.

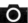

THE EVIL ADVANTAGE

Most—if not all—EVIL cameras have a built-in "photography grid." This grid divides the image into nine with two horizontal, and two vertical lines. You guessed it: These lines are there to help you compose the photo according to the Rule of Thirds. Check your manual to find out how to turn on this feature.

This image is a great example of the Rule of Thirds—the top left intersection of lines falls exactly on the skateboarder's nose.

Better photos of people

If Flickr is anything to go by, most photographers take photos of two things: Their cats, and other people. If we ignore cats for just a minute, it's clear that a lot of aspiring photographers turn to their friends, lovers and loved ones for photographic inspiration.

Get sneaky

Professional models are able to look natural in front of a camera even in a room with a thousand flash lights pointing at them. Chances are that your casual models aren't as adept at posing—but the great news is that they don't have to be.

The best thing you can do is become "that guy" or "that gal" who's always snapping photos. You'll be met with confusion and perhaps a little shyness at first, but as soon as the people around you get used to the clicking of your camera, you're free to roam as you like. Capturing your friends (and complete strangers) is an art—but it's the one sure-fire way to guarantee that your photos look natural.

You can capture the charming, the funny, and the moving—just make sure you're always taking photos. And try not to get caught!

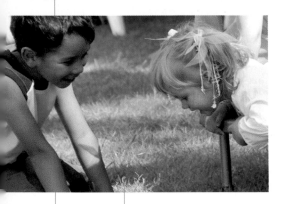

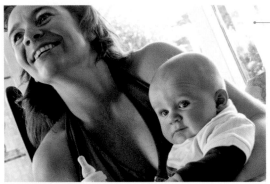

Capturing friends in animated conversation is a fantastic way to get their natural selves.

On vacation, too, sneaky shots can come in handy: This artist is restoring an ancient temple in Thailand, but I love the detail that he is clearly listening to his iPod!

Looks of delight come along all the time with children, but it always looks better if they don't know you're snapping shots!

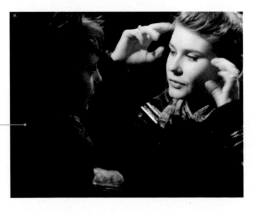

Shooting from the hip is very hit-and-miss. The successful shots are so awesome that it's worth a bit of practicing, however!

Look at what you're doing

Just a few pages ago, I recommended that you had a checklist. This is doubly true for portrait photography—it's no good having a lovely photo of your niece with a set of "antlers" in the form of coat hangers sticking out of her head.

It's also a good idea to make sure the people in your photo aren't "decapitated." This is an effect which happens if there's a line, such as the horizon, or the side of a building running through the photo at neck level.

Beyond checking if anything is sticking out of your subjects' heads, or cutting their heads off, it's always a good idea to scan the background for anything untoward. It is often much easier to take a couple of steps left or right, or to ask your subject to move away from the enormous trash truck, than to have to throw the picture away, or spend hours upon hours in Photoshop trying to change the background.

> **Cross-reference**
>
> Upset by my suggestion to ignore your feline, furry little friends? Don't worry, I've got you covered later in the book. If you can't wait, thumb to Chapter 7, where you'll find a load of advice for how to get nicer photos of tigers and lions and bears.

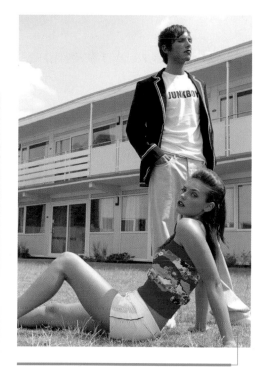

Good job the girl is there to attract the attention. If she wasn't there, you'd be telling me how the building "cuts off" the man's head.

Checking the background in your photos is a key ingredient to capturing people at their best. If this photo had a lamp post in the background, it would completely have ruined the illusion of having been taken in a bygone era.

The eyes! Get them in focus!

If there are eyes in your photograph, they must, must, must be in focus. The reason is that as humans, we're strongly inclined to look other humans in the eyes—that's true both in real life and in photographs.

If you're looking at a photo where the eyes aren't in focus (especially if something else is in focus), your brain will subconsciously think that something is off—your brain wants to focus on the eyes, but can't. It feels wrong. You don't want your viewers to feel "wrong," do you? Of course not. That brings me back to my original point. Get the eyes in focus.

In this photo, the model is squinting against the sun, so her eyes are barely visible. Nonetheless, that's the area of the photo that is in focus—because, despite her gorgeous, radiant smile, that's where your viewers will be looking.

Becoming just ever-so-slightly psychic

Photographers who have been around for a while start noticing that they are not only getting better at handling their own camera, but that they also seem to be pressing the shutter button more instinctively, and producing a greater number of good photos as a result.

Training your clairvoyance when it comes to photography really is down to being more observant about how things work in general rather than an actual sixth sense.

Know your domain

Some things are easy to anticipate—if you have background information that informs the activity you are looking at. A soccer player who has just snatched the ball from an opposing player is likely to run towards the opponent's goal, and a tennis player about to receive a serve is likely to go stand at the appropriate side of the court. These are examples of "domain knowledge." By knowing how football and tennis are played, you're more likely to anticipate what's going to happen next.

The same thing is true for animals. When I recently started underwater photography, for example, I had no idea how fish would react to me, as a scuba diver. Now, I can take an educated guess about how a fish is going to move in reaction to me and other divers.

It's all about observation

Before you take photos of a new subject matter the first time, it's worth sitting back, observing what is going on. A great example of this is when you do a wedding shoot. By meeting with the bride and groom ahead of time, you can get a feel for how they move, their facial expressions, and what their "good side" is.

Whether you are photographing children, adults, or animals, it can't be overstated how valuable it can be to just observe without taking photos for a while.

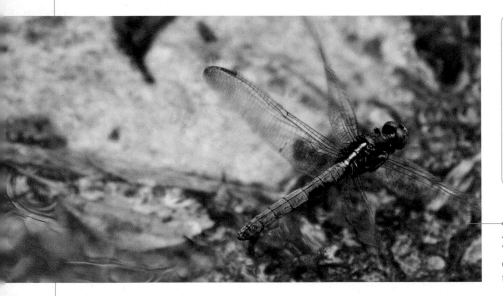

> **EXERCISE**
>
> Ask someone to throw a ball against a brick wall a few times, and catch it again. Try to take their picture as they throw the ball, and just as they are about to catch it. It will be tricky at first, but as you learn the "rules" of how your ball-thrower moves, your photography becomes much easier, and the photos rapidly improve.

A little extreme perhaps, but once you get this "anticipating photographic opportunities" thing down pat, you can start considering photos like this: A dragonfly photographed in flight!

Three things to edit on each photo

I'm a strong believer of getting perfect photos the first time, but the reality is that even if you take a near-perfect photograph, chances are that it can be improved further in post-production.

Personally, I adjust three things on every single one of my photos. Why? Because I don't think I've taken a single photo in the history of my thousands and thousands of exposures that didn't benefit from a bit of a tickle in Photoshop when I got to the comfort of my editing suite with a cup of coffee and some good tunes on my stereo.

Cropping

1 Earlier in this chapter, I mentioned the importance of "filling the frame." Truth is, that even if you got as close as you could, chances are that your photo could be even better by getting even closer in.

Of course, you consider the composition of your photographs when you take them, but once you get your photos on a bigger screen, it's possible to tweak the crop of your photo, which has a significant impact on the composition as well.

Things to consider when you crop your image:

EXERCISE

This exercise is a bit of a thought experiment. Open this book to a few random pages, and have a look at the photos. Keeping in mind that all the crops in this book will have been a conscious decision—can you figure out why I decided to crop the photo the way I have? Would you have done anything differently?

Cross-reference

We discuss aspect ratios in much more detail in the following chapter.

When it comes to a challenging shot like this, with a bird moving at great speed, there isn't much time to worry about composition. Concentrate on getting the exposure and focus right.

In post-production, it's possible to make the photo much more visually appealing. By cropping the photo like this, I'm telling a story of freedom—the seagull has a whole frame to fly into!

Don't be afraid about cropping into people. Don't just cut a tiny sliver off their heads so it looks like an accident—it's all or nothing. In this case, I decided to play the emotional card and get in really close.

Color

2 Once I'm happy with the crop of the image, I will usually adjust the colors in my image. Whether I'll decide to make the colors more vivid, more natural, more subtle, or more extravagant depends on the photo—but it's a rare photo that doesn't receive any adjustments at all.

Color is a rather huge topic (which is why there's a whole chapter dedicated to color later on in this book), but for the purposes of this chapter, I would like you to keep color in mind when you are editing your photos.

When it comes to color adjustment, there aren't really any rules—some people like to have strongly vivid colors in their photos, others prefer a more natural approach, while others again prefer muted colors—or even monochrome images, which are obviously devoid of any colors at all.

There is no right and wrong treatment of the color in images; I find myself going from periods of doing a lot of black-and-white treatments, and then falling in love with vivid, vibrant colors. This book will contain a lot of examples of both extremes and everything in between.

> **Cross-reference**
>
> We'll discuss color and white-balance adjustments in great depth in Chapter 4!

2 After white-balancing the image, the Lion fish gets some of its color back. Much better!

3 If I wanted to enhance the colors further, I could increase the saturation of the image.

1 The white balance on underwater photos tends to be miles off—this photo is much too "cold."

4 Alternatively, if I decide that perhaps a photo might look better in black and white, I'll remove all the colors instead.

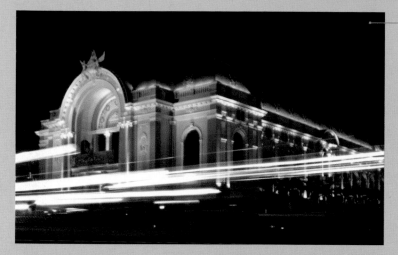

In this photo of the opera house in Saigon, the colors and the contrast of the moving cars and motorbikes make the image—without colors, it simply wouldn't work.

Low contrast

Very high contrast

Contrast

3 Contrast is the difference between the darkest and the lightest color in an image. If the difference is not very high, it is said that a picture has low contrast. If the difference is huge, it is a high-contrast image.

When the time comes to edit your photos, I recommend you take the same approach as when it comes to color: When you're getting used to photo editing, try increasing and decreasing the contrast a fair bit, to see what the effects are.

Personally, I have a strong passion for contrasty images, but as with everything else in photography, there's no point in cranking the contrast to eleven just for the sake of it. As soon as you start playing with the contrast slider, you'll start grasping what works and what doesn't.

When it comes to people, in general the higher the contrast in the photo, the more drama in the image.

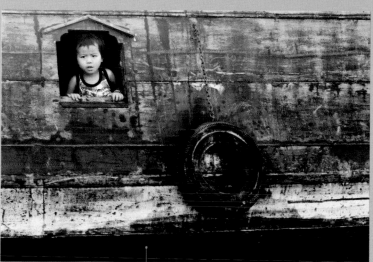

Some photos create a lot more impact when they are in black and white. For this image, color would have distracted from the contrast of the young boy against the dirty surroundings of the ship he lives on.

Scan the whole frame

My top tip to new photographers is to look at the whole picture before they take a photo. The easiest way to get used to this is to take a few landscape or still-life photos—go for a walk in the park or the nearest forest to get a bit of practice.

Getting used to pre-visualizing the photo

The first few times this process is going to feel completely alien to you—why would you sit and stare at your viewfinder for no good reason? The key here is "pre-visualization." When you are looking at the scene and your camera, you are getting used to what your camera sees, compared to what you see. You also get used to seeing a photograph as a whole.

THE EVIL ADVANTAGE

Use the features of your camera to your advantage to make your job of scanning the frame easier. By using Live View, you can see a good preview of your whole image. Trust me, it's much easier than having to look around the edges of a viewfinder.

I knew this was the photo I wanted to take long before I took the lens cap off my camera lens—that's the power of pre-viz!

Moving targets

The smiles on the men's faces tell the whole story of this street-toboggan ride on Madeira, but if I had planned and pre-visualized the shot better, I'd have taken the photo from a different place, where there wouldn't be a car in the background.

You can't do much about the motorcycle in the background, but with a little bit of planning, the cones in the foreground could easily have been avoided in this shot.

Bringing it all together

As you've been working your way through this chapter, there has been a lot to think about. The best way to deal with these small improvements is to implement them one by one.

You probably have an idea where your photography could improve the most—so it would be natural to start there—and add on the other tips as you start feeling more comfortable with your photography style and skills.

The point of this chapter has been to get you to think more—both about photos you've taken before, about what is happening when you have a camera in your hands, and about what happens when you're back at home, looking at your photos on your computer screen.

Evaluate, evaluate, evaluate

The most important thing is to keep thinking, evaluating your own photography as you go along. For every photo you take, think "how could I have made this photo better?" Or "what could I have done to make this picture better than any photo I've ever taken before?"

Rule of Thirds, choice of colors, use of contrast, the lighting, pre-visualizing, and exact focus: By methodically working through my own checklist, this photo turned out pretty good!

EVIL Concepts

There are many ways you can look at photography. Some photographers see it as a way to document the world around them, others choose to use photography as an artistic endeavor. Others again are interested in the science that hides behind every photo you've ever looked at.

You may be surprised to learn that the camera you're used to holding in your hands is actually an astonishingly sophisticated piece of scientific equipment—and the "science" bit is very broad-ranging. Engineering is pretty obvious, but beyond that, every lens you use on your camera is the result of some rather impressive physics—and that's without dwelling on the advanced mathematics that happen inside your camera body.

If your heart beats a little bit faster when you start thinking about mathematical formulae, I'm afraid you have picked up the wrong book, but in order to become a good photographer, you need to have at least some basic knowledge of how light works, and how your camera takes light and turns it into the tasty image files you're striving for.

In this chapter, I'll take you, baby-step by baby-step, through the basic concepts of photography, along with how you can knit a closer friendship with your camera, and take much better photos in the process.

From a technical point of view, photography is a carefully choreographed ballet, involving a series of stars moving in perfect harmony. You'll be introduced to our lead performers ISO, shutter speed, aperture, focus, focal lengths and depth of field, all in due course.

Focus and depth of field

If you've taken any photos before, you've probably stumbled across the concept of a photo being grossly out of focus. Don't worry, it happens to all of us from time to time.

There's actually quite a lot that can be said about how you can determine whether a photo is in focus or not, but ultimately, it's quite subjective. Some photographers are not bothered by a photo being slightly fuzzy, whilst others only want the sharpest of sharp photos.

Another example of pin-prick sharp focus: The gentleman's nose is sharp, but his ear, which obviously was only a couple of inches closer to me as I took the photo, is blurry.

This photo was taken at ƒ/1.4, and you can see how only part of the text is in focus. The "T" is pretty sharp, but you can see the "I" and "N" are already quite fuzzy. As you can see, the background (a busy record store in East London), is completely out of focus.

By shooting at ƒ/32—a very small aperture indeed—I was able to ensure that all the buildings in this shot were in perfect focus.

What is "in focus"?

On a theoretical level, there is always one distance away from you that is perfectly "in focus." If you focus your lens at the tip of your nose of your subject, then that part of their body—and everything else that is the same distance away from your camera—will be in perfect focus.

Beyond the distance from your camera where things are "in focus," there is a gradual drop off closer to, and further away from, your focusing distance. How fast this drop-off is, is described as "depth of field." If the sharpness drops off rapidly, it means you are taking photos with a "shallow" depth of field: If the sharpness is more gradual, you have a "deeper" depth of field.

What affects depth of field?

The focal length of the lens (i.e. whether you are taking a photo with a wide-angle or tele lens) affects depth of field: Tele lenses tend to have shallower depths of field, whilst wider lenses have deeper depths of field.

The distance to your subject affects depth of field: If you are focusing close to the camera, depth of field tends to be shallower—if you are focusing near infinity (i.e. if you are taking a photo in the far distance), you tend to get deeper depth of field.

Finally, the depth of field is affected by the aperture you choose, as discussed before. A larger aperture has shallower depth of field.

FOCUS EXPLAINED

Plane of focus

There is only a very thin sliver of the photo that is in perfect focus.

Area in focus f/2.8

Large Aperture
Your depth of field will be limited.

Area in focus f/5.6

Medium Aperture
Your depth of field is slightly larger.

Area in focus f/11

Small Aperture
You enjoy a deeper depth of field.

DEPTH OF FIELD EXPLAINED

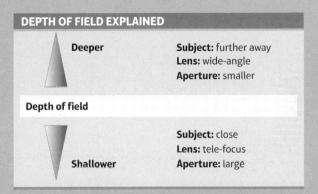

Deeper
Subject: further away
Lens: wide-angle
Aperture: smaller

Depth of field

Shallower
Subject: close
Lens: tele-focus
Aperture: large

HOW TO HELP YOUR AUTOFOCUS ALONG

Something being "in focus" depends on two things: what you actually focus on, and the depth of field you choose. The tricky bit is getting the focus right in the first place.

When focusing, it's often easiest to aim your camera at an area of contrast. Personally, I like to set up my camera so it always focuses on the center of my frame. I can then use the following approach to "help" my autofocus get the focus spot on:

1. Aim your camera at an area of high contrast in your photo: a detail of a building, a person's eye, or similar.

2. Half press your shutter button. This will cause your camera to focus.

3. Keep the shutter-button half pressed, and compose your image the way you want it.

4. When you are happy, press the shutter button all the way to take your photo.

By using the above technique, you'll ensure that your autofocus works fast and efficiently.

This building doesn't have a lot of definition, which might cause your autofocus to get confused. To help it along, I focused using the top edge of the window in the bottom at the left of the frame.

Focusing and focus modes

We've talked about what affects depth of field, and how you can adjust your focus as well as possible, but that's only half the battle. Since focusing is such an important part of photography, the camera manufacturers have built in a lot of fancy features to help you along.

Focusing modes

One-shot automatic focus is what most people think of when they think "autofocus." In this mode, when you press the shutter button half way, the camera attempts to focus on the subject your camera is pointed at. When it finds focus, it "locks" the focus until you either take the photo, or until you release the shutter button and half press it again. This mode is great for most subjects that don't move a lot.

Continuous autofocus (also known as "continuous Servo" or just "Servo" focusing) is a mode you find on many advanced cameras. It works similar to the one-shot autofocus, but instead of "locking" the focus, it continuously tries to keep your subject in focus. This mode is best when you are taking photos of quick-moving subjects that come closer and move away from you a lot.

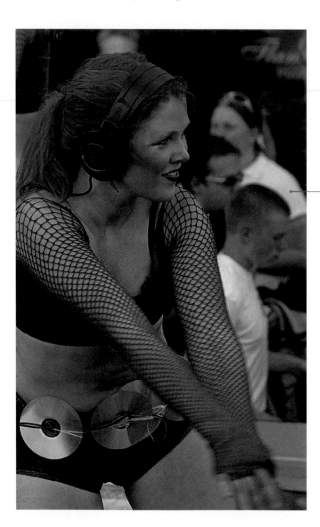

Dancers move a lot when they do their thing, but since this dancer didn't move toward or away from me, I used one-shot automatic focus for this photo.

In the fast-moving world of sports photography, continuous autofocus is invaluable.

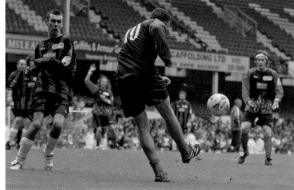

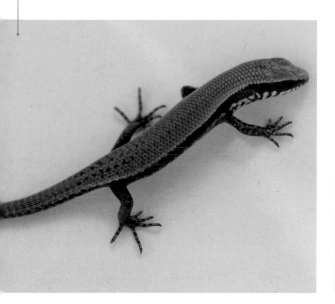

When you are working with subjects very close to
your camera, it is sometimes easiest to use manual
focus. Turn your lens to focus as close to the
camera as possible, and then move your camera
closer or further away from your subject to focus.
Live View is a great tool to ensure your subject
really is in focus.

AI Focus (or "Intelligent Focus" on some cameras)
is the half-way house between the two previous modes.
For subjects that don't move, the camera uses one-shot
autofocus. Generally, the AI Focus modes I've seen on
cameras aren't quite good enough to rely on. So if you know
what you want, it's best to select one-shot or continuous
autofocus yourself.

Manual focus is what it says on the tin: The camera
leaves the focusing to you. On most cameras, when you are
focusing manually, it will tell you when it thinks your subject
is in focus, either by making a beeping noise, by showing you
a green dot or light, or by flashing the focusing point that
the camera believes to be in focus.

Manual focus with automatic correction is a new focusing
mode that exists on some cameras—it enables you to focus
manually, but if the camera thinks you're doing a bad job, it
fine-adjusts the manual focus for you. I don't really see the
point, myself.

Use Live View for better manual focus

If you are using manual focus, particularly for stationary
subjects, it's often a good idea to use Live View, and if your
camera supports it, use the "manual focus assist" feature.
This means that instead of showing you the full frame
you're about to photograph, it shows a crop of your image
(in effect, your camera shows an enlarged view of the center
of your scene).

Using Live View and the manual focus assist makes it
a lot easier to focus precisely. It is incredible how big a
difference small adjustments to the focus ring on your
camera's lens can make. In particular, when you are taking
macro photos, the Live View technique can be very useful.

Exposure: What is an exposure?

Photographers love talking about "exposure," but it turns out that not everybody understands what it is or how it works. Not to worry, that's why you're reading this book, right?

A camera is, at its very basic level, a light-proof box with a light-measuring device inside. If you were using a Polaroid camera, the "light-recording device" would be instant film. If you are holding a film-based camera, the light is recorded on film. In the digital era, the camera contains an imaging chip, which does the light-measuring for us.

Regardless of what the "light measuring device" inside your camera is, it has a certain sensitivity to light. If the sensor gets too little light, the photo will come out very dark; if it gets too much light, the photo will come out too bright.

Getting a "correct exposure" is your camera getting the right amount of light hitting the sensor, so your photos come out looking as good as possible.

IMAGING CHIPS

In the infancy of digital photography, there were a lot of discussions about different types of imaging chips, and what was best. The battle was (and is) largely between Charge-Coupled Devices (CCD) and Complementary-Metal–Oxide–Semiconductor (CMOS). Both technologies are still in use, and from a practical point of view, they are both about as good as each other.

Three versions of the same scene—the darkest of these photos is underexposed, the brightest shot is overexposed, and the one in-between is "correctly" exposed.

What is a good exposure?

Throughout this chapter—and the rest of this book, for that matter—I'll often mention words like "overexposed," "underexposed," and "right exposure." These things mean, respectively, that a photo is too bright, too dark, or somewhere in between.

It's definitely worth keeping in mind, however, that the "right" exposure is a subjective judgment call. The right exposure will be the exposure that achieves the photo you planned.

This photo is overexposed in a bad way: It's so white that I lost definition in the grasshopper's eye. Compare that with the second shot, and it's easy to see which photo looks best.

THE EVIL ADVANTAGE

SLR users have to look through the viewfinder of their camera—great for composition, but it doesn't give them a preview of exposure. On your EVIL camera, because you are using an electronic viewfinder or Live View, your camera will show you a preview of your photo's exposure before you take the picture.

This image is extremely contrasty, both overexposed (the entire background has "blown out" into being pure white) and underexposed (the razor-wire has "clipped blacks" —pure black without any detail). Despite breaking both the "rules" of exposure at once, it's still an appealing photo.

What affects an exposure?

Getting a good exposure is a balance between three different variables: shutter speed, aperture, and ISO. Adjusting either of these three changes the exposure of a photo, but just to complicate things further, changing one of the settings has effects other than just making a photo brighter or darker. The true magic in photography comes from applying these three simple settings in different ways for creative effect.

Shutter speed—Inside your camera, there is a shutter. This is a mechanical device which opens and closes a set of curtains that live in front of the imaging sensor. The duration that the shutters are open is known as the shutter speed. A long shutter speed lets in a lot of light, whilst a shorter shutter speed lets in less light. Easy to remember: If you turn on your kitchen tap for ten seconds, less water comes out than if you turn it on for thirty seconds.

Because the details in the model's face have vanished into pure whiteness, most people would consider this photo to be "overexposed." It doesn't mean it's not a good photo, though.

In this photo, the exposure is better: The background is still blown out, but you can see how the model's skin is still visible in all detail.

It can be useful to think of the three variables in an exposure as a slider. If you increase one and decrease another, you end up with the same result.

	Exposure 1				Exposure 2				Exposure 3		
Lighter											
Darker				=				=			
	ISO 400	1/400	f/8.0		ISO 200	1/200	f/8.0		ISO 200	1/800	f/4.0

WHY LEARN ABOUT THE EXPOSURE?

It's true that your camera will look after exposure for you if you ask it to. However, when you start getting more creative with photography, a lot of the creative effects you have at your disposal are related to the three exposure controls, so it's best to get a grasp of how it all works early on.

Aperture—"Aperture" comes from a Latin word meaning "hole." Your camera lens will have a variable aperture inside it. A variable aperture means that through using a series of aperture blades, your lens can make the hole smaller or bigger. It's all pretty obvious, really: A big hole lets in more light, and a small hole lets in less light. Going back to my "shutter speed" analogy opposite: If you turn on your kitchen tap all the way for ten seconds, you get more water than if you turn it on to a trickle for ten seconds.

Do be aware, though, that aperture numbers are backwards: f/2.0 is a bigger aperture than f/3.5.

ISO—The final variable in our exposure puzzle is ISO. In the days of film, ISO was a number describing how sensitive the film was to light—an ISO 400 film was twice as sensitive as an ISO 200 film. This isn't quite how it works in the digital world, but for all practical purposes, it's best to think of ISO as light sensitivity: Higher ISO is more sensitive, lower ISO is less sensitive.

Aperture numbers

The numbers used to measure aperture are f/stops, and are written something like "f/11" or similar. Check out "Understanding Aperture" later on in this chapter for an explanation for what this is and how it works.

Equivalent exposures

As we have mentioned, changing, for example, the aperture on your camera changes things beyond the amount of light that gets into your camera. As such, you might decide that you want a smaller aperture, in order to get a greater depth of field. A smaller aperture means that less light comes in to the camera. How do we solve this?

Your camera has three different adjustments for exposure. If you adjust one so the exposure would be brighter, you can adjust another one to compensate for the additional light captured.

For example: Let's start with an exposure taken at 1/100 second, f/4.0 and ISO 200. Now, you can change your camera settings to 1/200 second. That would let half the amount of light into your camera compared to 1/100 second, because the shutter is only open for half the duration. Your photo will now be darker. If you change your ISO to 400, the sensitivity of the sensor is doubled, and the photo will come out looking more or less the same, from a brightness point of view, as your original exposure.

You can change any of the settings to compensate for any of the other settings: A smaller aperture can make up for a higher ISO, a faster shutter speed can make up for a larger aperture, and a lower ISO can make up for a slower shutter speed.

What affects an exposure?

Aperture tends to be the variable that trips new photographers up. Shutter speed is intuitive enough: If you increase your shutter speed from 1/200 second to 1/400 second, you obviously get half the amount of light going into your camera. ISO is similarly easy to grasp: Go from ISO 400 to ISO 800, and it doubles the sensitivity of the sensor, and your picture goes twice as bright.

Aperture is more confusing—how come bigger numbers are smaller apertures? And how are you meant to remember all of this?

Taken with my 50mm F.1.4 lens at f/4.0, 1/200 second shutter speed and ISO 800, this image is so ludicrously sharp that you can almost count every hair on Holly's head.

What do f/stops mean?

Apertures are measured in f/stops. I'll be honest with you: until someone explained it to me, I didn't think the f/stop scale made any sense. For one thing, f/2.8 is a pretty weird number, but how can f/2.8 be a larger aperture opening than f/4.0?

The aperture opening f/stops are, in fact, a fraction. Specifically, an aperture opening is a fraction of the focal length of your lens. So, if you have a 100mm lens set to f/4, what you are really saying is that the aperture opening in the lens is 1/4th of 100mm. Let's do the math: 1/4th of 100mm is 25mm—or about an inch. This fraction is obviously the reason why f/4 is a larger aperture than f/8—if you get a 1/4 (25%) of a cake, you're getting more cake than if you're getting 1/8 (12.5%) of a cake.

The best aperture to use

In a lot of these examples, I'm either using a very large aperture, or a very small aperture. Truth is, your lens is sharpest somewhere in between these two. Similar to exposure, the "right" aperture to use is the aperture that achieves what you are looking for with your photo.

THE f/STOP SCALE

The scale of f/stops is a geometric sequence of numbers: the sequence of the powers of the square root of 2. Granted, that sounds a little mystical, but have a look at the table elsewhere on this page; you'll no doubt recognize the aperture f/stops as ones that your camera comes up with when you're taking photos.

So why did they choose this scale? Well, f/stops increase and decrease (inverse) geometrically in powers of the square root of two, because when the aperture diameter increases by the square root of two, the size of the area of the aperture (in other words: the amount of light that hits the sensor) is doubled. The reason for choosing to use the square-root-of-two scale, then, is that it keeps the intervals equivalent to the doubling and halving of exposures.

Fractions	Exact number	f/stop
$\sqrt{2}^{0}$	1	f/1.0
$\sqrt{2}^{1}$	1.414213	f/1.4
$\sqrt{2}^{2}$	2	f/2.0
$\sqrt{2}^{3}$	2.828427	f/2.8
$\sqrt{2}^{4}$	4	f/4.0
$\sqrt{2}^{5}$	5.656854	f/5.6
$\sqrt{2}^{6}$	8	f/8.0
$\sqrt{2}^{7}$	11.31370	f/11

f/stops are easier to understand once you know what's behind them; a series of square root fractions.

How does aperture affect a photo?

Your camera adjusts the aperture by increasing or decreasing the size of a hole inside your lens. Making changes to the size of the aperture affects two aspects of a photo: the exposure, and depth of field.

A larger aperture (i.e. a smaller *f*/number) lets more light into your camera. A smaller aperture (a larger *f*/number) lets less light into your camera. Because of this, aperture is one of the basic adjustments you use to ensure that your images are "correctly" exposed.

A larger *f*/number (smaller aperture opening) is great if you want greater depth of field.

Depth of field and aperture

Aperture is the control on your camera that adjusts the depth of field you have available to you. This is a crucial setting you can use for a lot of different creative effects. If you are taking portraits in a messy environment, for example, using a large aperture will give you a shallow depth of field, enabling you to "isolate" your subject from the background.

The opposite is also true—small apertures give you a huge depth of field, which you can use for good effect when you want a lot of your image in focus.

By using a large aperture, this street photography focuses on my main subject; the smoking girl with the bunny ears. If the photo had been taken with a small aperture, the mass of people in the background would have been very distracting.

The limits of aperture

When you are taking photos, remember that you need to think about your exposure. If you're taking photos with a very small aperture, you get beautiful depth of field, but you reduce the light coming into your camera quite a lot, which means that you need to compensate for this somehow.

You can adjust for a small aperture by using a slower shutter speed, or a higher ISO setting. This comes with its own problems, however. Slow shutter speeds means that you have to start to think about using a tripod, and very high ISO settings can cause digital noise.

Conversely, very large apertures have their own challenges. Most high-end cameras have 1/4000 or 1/8000 second as their fastest shutter speeds, and if you are taking photos in broad daylight, it is possible that you start hitting

By using *f*/22, everything in this photo is in focus, but I did need to use a 30-second exposure.

the limits of your photographic equipment. Even at the slowest ISO and the highest shutter speed, your photos could come out overexposed when you are shooting at the largest aperture you have available to you. If that happens, all you can do is to darken your scene (by blocking out some light, or using a Neutral Density filter on the front of your lens), or select a slightly smaller aperture.

How does shutter speed affect a photo?

Whereas aperture gets to affect the depth of field, shutter speed has a couple of tricks up its sleeve all of its own. The most obvious effect changing the shutter speed has is that it controls brightness of your exposure—just like aperture does.

The creative side of shutter speeds has everything to do with motion, but to explain how it works, we're going to have to take a look at how an exposure works in regards to duration of the exposure.

Stopping motion

Your camera is basically just a light-recorder, which "records" light for the whole duration of an exposure. So, if your shutter speed is a thousandth of a second, your camera records the light for 1/1000 of a second. If your shutter speed is a second, it records light for a second.

This "duration" becomes relevant when you are photographing something that moves. A car moving at 40 mph, for example, moves about 0.7 inches in a thousandth of a second. In most circumstances, this movement will be so little, that it appears that the car stands completely still. If you photograph it at a 1/4000 second shutter speed instead, it moves only 0.17 inches—which results in an even crisper car. In other words, you can use fast shutter speeds to freeze the motion of moving objects.

Capturing a droplet as it hits a surface takes a lot of patience—and a very fast shutter speed.

Illustrating motion

You can also do the opposite, of course. If we go back to the car driving at 40 mph and photograph it with a 1/60 second shutter speed, it moves nearly a foot during our exposure.

A foot is a significant distance in most photographs, which means that your car will probably look blurry. In some photos, this can be a problem, but in others, this is a cool effect, all depending on what you are trying to show.

Thinking about motion

It's a good idea to keep movement in mind when you're taking photos, as there are lots of different types of movement that affect your images. You can have movement in the photo, of course, and you can "freeze" the motion by using a fast shutter speed, or make it look "flowing" by using a slower shutter speed. It's not just your subjects, though: Keep in mind that your camera can also move as you're taking a photo.

If you're in a moving car, you have to use a shutter speed that's fast enough to compensate for the movement of the camera—but as shutter speeds get longer, you're going to have to start considering a tripod or other support to keep your camera steady

Because the motorcyclist in the foreground didn't move much, he appears to be standing still. The 2.5 second exposure was enough to turn the cars moving in the background into streaks of light, however.

Camera movement can give some pretty cool effects, even if nothing in the scene itself is moving.

Creative use of shutter speed

By applying what you know about shutter speeds, you can probably start coming up with a few ways of using shutter speeds to your advantage to create awesome photographs. Since we're talking about shutter speeds, there's basically two things you can do: Freeze or show motion, in various ways.

If the water moves faster, you don't need to slow down the shutter speed as much. In this shot, taken at 1/13 of a second, the water fall has an obvious "speed" to it, while the people in the foreground remain still.

Waterfalls

It's a completely cliché shot, but waterfall photos can be beautiful, both when frozen in time (so you can see every little droplet in the waterfall) or when photographed with a long shutter speed.

To find out how long an exposure you need, you can either use some very complicated mathematics…or good old trial and error. Start with 1/20 second exposure, and adjust from there. Alternatively, set your camera to "Aperture Priority" and choose a small aperture—like f/11 or similar—and see what results you get.

A five-second shutter speed turns this burbling brook into a beautiful, smooth streak of white.

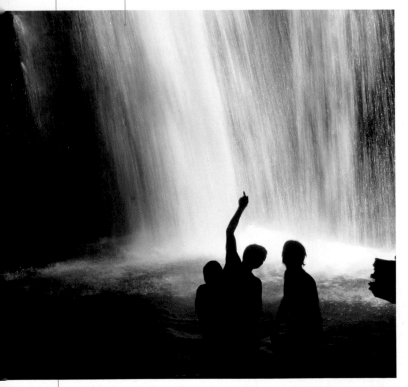

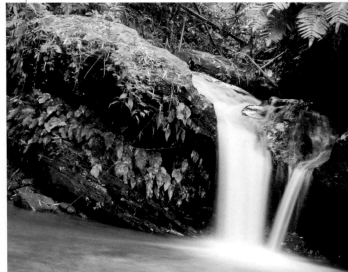

Panning shots

We've already seen how a moving object in the frame can come out blurry. But what if you want the moving object sharp? It takes a little bit of practice, but you can use a technique called "panning" to get some rather eye-catching shots. Cars, cycles, and runners look particularly good in panning photos.

By moving my camera to keep the subject in the same place of the frame for 1/25 seconds, the motorbike looks like it stands still, whilst the rest of the world whizzes by.

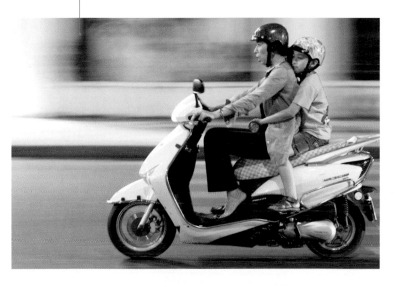

To get a panning photo right, it's easiest if your subject is moving perpendicular to your photo. Stand with your toes facing where you want to take the photo, and turn your upper body from the hips toward where your subject is coming from. As it is driving by, keep it neatly in the same spot of the frame, and slowly press the shutter button. Keep turning with it all the way.

Again, finding the right shutter speed is a game of trial and error, but for cars and motorcycles, start at about 1/30 second, and adjust your shutter speed depending on the effect you're going for.

Zooming shots

Anything that's moving can be turned into a long-shutter speed shot, but of course it's possible to introduce movement yourself, by moving the camera. Another way of getting movement is to zoom your lens in or out whilst taking a photo. This technique is dependent on having a camera that can change its zoom while you're taking a shot; most EVIL and SLR cameras let you do this easily enough.

To get a zooming shot, you'll need a tripod or a sturdy surface to place your camera on. First, take a meter reading and focus the camera by half pressing the shutter button, and then start zooming in (or out) very slowly. Press the shutter button all the way, and keep zooming as smoothly as you can. You get the best result with zooming shots when there are plenty of light sources in the frame, as they will create a cool "streaky" effect.

By putting your camera on a tripod and zooming in whilst taking a photo, you can get a *Star Wars*-style feeling of speed.

This photo was taken hand-held at 1/3 second while zooming and using a flash to "freeze" the model's face. It looks pretty crazy, but it's a cool effect to experiment with.

How does ISO affect an exposure?

ISO is the only exposure control that doesn't have a huge effect on your photos optically—but you guessed it: Adjusting the ISO isn't completely without side effects.

Until quite recently, the higher ISO values (beyond ISO 800 or so) were useless on most cameras, because it introduced a lot of digital noise into the final photos. These days, things are better. As a general rule of thumb, if you have enough light, it's a good idea to take photos at as low an ISO as possible—under ISO 800, certainly. This reduces the amount of noise in your image, and the color rendition is as true as possible.

Don't be scared of high ISO

Having said that, current-generation cameras are incredible at dealing with high ISO. On top of that, software like Adobe Lightroom is getting increasingly sophisticated when it comes to filtering out digital noise, too.

All in all, high ISO is one of the areas where new camera bodies are improving rapidly, and I've noticed that every generation of SLR and EVIL camera just keeps getting better. At the very least, it's a good idea to test your camera at various ISO settings. If you don't like the way your photos look at ISOs beyond, say, 1000, the solution is simple: Don't use faster ISO settings than that! It's better to find the limits of your personal taste before you embark on an important photo shoot.

Taken at ISO 1600 with an EVIL camera, this photo shows that you don't have to worry too much about digital noise: If the subject is pretty enough, a bit of noise doesn't matter.

Even with a relatively long shutter speed (1/30 second) and a very large aperture (f/1.4), I had to use ISO 6400 to get the exposure right in this photo, taken in my local pub. It's not a masterpiece of composition by any stretch of the imagination, and I had to turn it into black-and-white to deal with the colors, but it does show that you can take some pretty decent photos in the light of a single candle.

Creative use of ISO

There's not much creativity in low ISO (apart from gorgeous, knife-sharp pictures with a minimum of noise), but you can use high ISO to great effect by introducing a lot of digital noise on purpose.

Especially when combined with black-and-white conversions, "noisy" pictures can look incredibly gritty and attractive. When you start taking pictures at higher ISO, it can be beneficial to try to keep your shutter speeds fast—long shutter speeds at high ISO tend to generate a lot of digital noise.

Shot at an incredible ISO 12,800, there's a lot of noise in this photo—and yet, it also has a lot of character, and looks a lot like a Kodak T-Max photo from my days of developing my own film in my basement.

By using off-camera lighting and a high ISO (in this case, ISO 6400), it's possible to create some awesome and very creative effects, with a minimum number of external flashes. Of course, there is a lot of noise present in the photo, but the general grittiness of the scene means that I don't think the noise detracts much from the overall "feel" of the photo.

Shooting modes and preset scene modes

A shooting mode generally refers to the method your camera will use to select its exposure. Most advanced cameras have four manual modes (known colloquially as the "PASM" modes) a fully automatic mode (marked with a green box, or "auto"), and a series of scene modes.

Preset scene modes

Most EVIL cameras have "preset" modes that are semi-automatic modes designed to help you with your photography. In effect, what you are doing is telling the camera what kind of photos you are about to take (say, sports photos, portraits, or photos at night), and the camera helps you by using its pre-programmed modes, customized for the type of photos you are taking.

I think scene modes are a lazy option—they don't do anything you can't do with a little bit of understanding of photography and the PASM modes. Later on in this book, in the chapter "Perfect Pictures of Perfect Scenes," we'll go through all the different types of photos you might want to take, the settings at which you need to take them, and the things you need to think about.

A photo taken in Amsterdam, with a compact camera set to fully Automatic mode.

In sports mode your camera picks a fast shutter speed to freeze motion—but if you know what you are trying to achieve (i.e. freezing motion), you may as well use Shutter Priority, and pick a fast shutter speed yourself.

Program mode is great for fast holiday snaps. No need to think; just point and shoot, but you do get the benefit of controlling things a little bit.

Auto mode

In Auto mode, the photographer has a very limited amount of influence over what the camera is doing. The camera selects the aperture, shutter speed, ISO, focusing mode, and just about everything else, too. Much like simple compact cameras, this mode turns your camera into a "point and shoot" camera—point at what you want to take a photo of, press the button, and the camera does the rest.

There's nothing inherently wrong with using the Auto mode, but what people photographing in Auto are missing out on, however, is the ability to make any adjustments to what they are doing.

PASM modes

P—Program mode is one step up from Auto mode—and I am happy to confess that I use it on a regular basis. The photographer selects everything except the aperture and shutter time, which the camera calculates for you. If the camera comes up with a combination of the two you don't like, you can usually use a wheel on your camera to change the settings for equivalent exposure: Turn one way and you'll see the aperture get smaller and the shutter speeds get faster—and vice-versa for turning it the other way, obviously. You can also use EV compensation to over- or underexpose your images a little.

S or **Tv**—Shutter-speed-priority mode is a mode where you dial in a shutter speed (say, 1/200 second), and the camera will attempt to get the "correct" exposure by using the aperture to compensate for varying lighting situations. One situation where it might be handy is if you're shooting sports, or where you want to use shutter speeds for creative effect.

A or **Av**—Aperture-priority mode is the opposite of Tv mode, above: You select the aperture, and the camera calculates the right shutter time. Personally, I tend to shoot either in Av or in fully manual, because for most of my photography, the depth of field is more important to me than whether the motion is frozen or not. When shooting in Av mode, still keep an eye on your shutter times—if they are very fast without you needing them to be, you may be able to use a slower ISO (switching from ISO 400 to ISO 200), which gives images with less noise. If they're very slow, your photos might be coming out blurry, and you may want to ramp up the ISO or use a slightly larger aperture.

M—Manual mode is for the true control-freaks among us. In Manual mode, you're selecting all the settings yourself, including ISO, aperture, and shutter speed. Your camera will still help you along by showing its light meter—it'll tell you whether it thinks you are choosing too low, too high, or a "correct" exposure. However, you're free to ignore the camera's recommendations and take your photos with whatever settings you want.

For the Love of Light and Color

Light, in all its guises, is the be-all and end-all of photography—at the most basic level. Even the word "photography" is derived from a couple of ancient words meaning "light" and "drawing."

To make photos, you don't need a lot. You don't need a lens. In fact, you don't even need a camera in its conventional sense—if you look on the internet, there are plenty of tutorials about how you can build your own pinhole camera out of anything from a cigar box to a box van. The one thing you do absolutely need in order to do any sort of photography, is light.

Photography, then, is the art of drawing with light. The beauty of light, is that it is a bit like a toy store: It comes in every shape, color, and brightness you can imagine, and each different quality and quantity of light affects your photography differently.

In many ways, knowing photography is knowing—and understanding—light. Where it comes from, how it travels, what it reflects off, and how you "bend" and manipulate the light as it passes through your lenses into your camera.

You don't need a lot of light to get a photo. This image, for example, was taken in a seemingly pitch-dark night. The whole photo is lit only by the stars, but a 63-second exposure captured what little light there was.

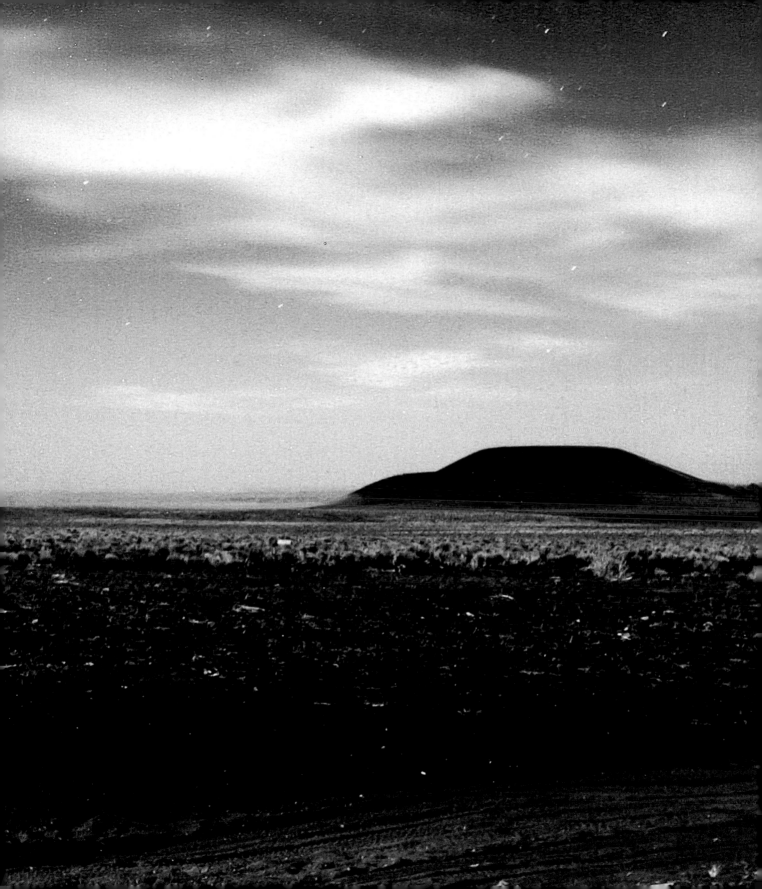

What is light and how does it affect my photography?

As we said, if there's no light, there can be no photography—but what is light, exactly? Without going knee-deep into physics, light can be thought of as tiny little particles that move very, very fast. In fact, if you could drive a car between New York and Los Angeles at the speed of light, for example, you could drive back-and-forth 75 times in a single second.

In order for something to be visible, it either has to emit light itself (like a light bulb, for example), or it has to reflect light from another source. "White" light contains the same amount of light as each wavelength. When something is "red" it means that the item is absorbing all wavelengths except red—the light you see is the light that has been reflected from the item.

Seeing the light

I'm just going to make the bold assumption that we all agree that light is rather important in photography. The next step is to start "seeing" the light.

We'll be discussing the characteristics of light and what they mean to your photos later in this chapter—but there is something you can start doing right now to gain a deeper appreciation of light. Look around you, and look for shadows. Say you find a shadow cast by a tree. The next thing to look for is the object that cast the shadow—in this case, a tree. Finally, consider the light source that is being blocked by the object. If you spotted a tree, it's likely to be the sun. It feels like a pretty weird exercise, but "tracing" the light like this is very valuable to you as a photographer.

When you start getting better at recognizing where the light is coming from in the world around you, you can apply the same skills to photographs.

By taking photos on an overcast day, this photo takes on a "soft" look—no harsh shadows, just lots of beautiful light and subtle colors.

You can easily use the shadows to determine the direction of the light in this photo. It's coming in from the right, because the left hand of the model is darker.

"Soft" and "hard" light

There are many different ways to describe light, but one of the most important considerations is the "hardness" of light. How "hard" light is depends mostly on the size of the light source.

A small light source (like a bare light bulb, a flash, or the sun in the sky) gives hard light and harsh shadows. A large light source (like light reflected off a large surface like the ceiling, or the sun diffused by a layer of clouds) does the opposite—the light will be "soft" and the shadows will be much softer as well.

The hardness or softness of light is important in many genres of photography, but people, in particular, tend to look better in softer light. In effect, that means that if someone is standing in direct sunlight, your photos rarely come out well. There are a few ways around this conundrum. You can add more light (by using "fill flash" or reflect some light back into the darker areas of your subject's face), you can move your subjects out of the sun into the shade, or you can try to soften the light somehow.

Taken just before a heavy rainfall, I took this photo at around noon, under a thick layer of clouds. The light is so soft and diffused that you can't really see any shadow cast by the bike at all.

In direct sunlight, you get hard light and hard shadows. Half the face and body of this skateboarder "disappears" in dark shadows, and if you look at the shadow of the skateboard, you can see that it is very dark, and clearly defined.

In some situations, like outdoor live events, you'll just have to grin and bear hard lighting. You are not allowed to use a flash, and due to limited access, you can't diffuse the light either.

Using reflectors and diffusers

Okay, let's start by teaching you a little bit about reflectors and diffusers with a couple of examples.

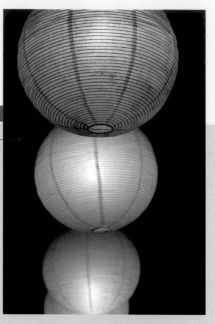

DIFFUSING A LIGHT BULB

Since light becomes softer the "bigger" the light source is, it stands to reason that you can make light softer by making your light source bigger.

Let's try just that: Go to a room with a lampshade. Turn off all other light sources than the light you're experimenting with, take the shade off the light bulb, and have a look around the room. Pay close attention to the shadows the light is causing. In addition, make sure you take a look at items both far away from and closer to the light bulb. Replace the lampshade, and see how big the difference is. Pretty amazing, huh?

Even cheap and simple lamp shades like these make a huge difference to the softness of light.

The big white thing on the front of this studio strobe is a soft box, which is basically a diffuser. It makes the light from the flash nice and soft.

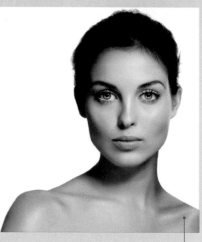

By using a soft box placed just out of frame, this model's face is gorgeously, softly lit.

EXPLORING DIFFUSERS

For this little experiment, you need an item to take a photo of, a sheet of white printer paper, and a light source—a desk lamp is perfect.

Turn on the light source, place your item in the light beam, find your camera, and take a photo of your item. You'll see that the item casts some pretty sharp shadows.

Now, place a sheet of paper between the light source and your subject. You want it as close to your subject as you can, without catching the paper in your photo. Take the photo, and compare the two images. You'll notice that in the second shot, the light is less bright, so you may have to use a different exposure (either a longer shutter speed, a larger aperture, or a faster ISO) to make up for the loss of light. On the other hand, the light is a lot softer, the shadows should be faded, and the light-fall off should be more gradient.

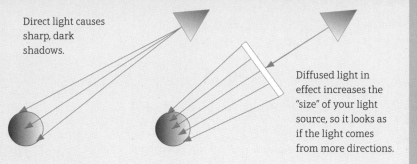

Direct light causes sharp, dark shadows.

Diffused light in effect increases the "size" of your light source, so it looks as if the light comes from more directions.

DIY reflector

It's easy to make a reflector yourself: Crunch up a length of aluminum foil, then flatten it again. Tape it to a piece of cardboard, and you have a perfectly useable reflector for next to no money!

By reflecting the light back at your subject, you "lift" the shadows a little.

EXPLORING DIFFUSERS FURTHER

While you still have the items you were using for "exploring diffusers" kicking about, let's put them to good use. Use the same setup as in the diffusers experiment, but instead of placing the white sheet between the light bulb and your subject, try moving the sheet while looking at the darker areas of your subject. You'll see that while the effect is quite subtle, but it definitely works.

Next, angle the piece of paper in such a way that it reflects as much light as possible, and take the photos as before. This time, your exposure will probably stay the same, and the main difference is that the darkest areas of your photo will come out a little bit lighter.

This model is lit with a light to the left of the camera. In one shot, we used a silver reflector to "bounce" light back onto the model from the right. As you can see, the difference can be quite dramatic!

The directions of light

Light can come from all directions—it can come from above, from below, from the sides. And each different direction of light has a unique effect on your photos. Obviously, this is important when you are taking photos in a studio setting, but it's equally wise to keep in mind when you are outside, or in a situation where you are less likely to be able to adjust the light source.

Remember that even if you can't do anything about the light itself, nothing is stopping you from altering the angle you are taking photos from.

Front lighting

To the vivid surprise of absolutely nobody, front lighting is light that hits the subject from the front—in other words, when you have a light source coming from roughly the same angle as your camera.

Front lighting can look quite good for certain subjects, especially if you want to show off the details of something. Most product photography uses front lighting, and if you're taking photos of buildings, they tend to look best if the light hits front-on, too. The downside of front lighting is that it does have a tendency to make things look a bit flat and two-dimensional.

Taking product photos like this can be deceptively challenging—this shot took me several hours—but it's one of the shots where I used front lighting, to tease out every bit of detail in the watch.

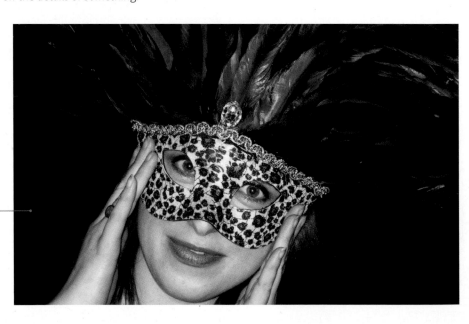

Taken with a flash and a diffuser, this photo is an excellent example of front lighting. The photo looks quite two-dimensional.

Side lighting

No prizes for guessing where the light comes from when a subject is side-lit. This is one of the most common lighting setups for portraiture—and just about every other genre of photography, as well. With the light coming slightly from the side, you add a sense of depth and drama to an image.

There are lots of different ways to achieve side lighting, and to be honest, there are lots of "directions" of light that could be said to come from the side.

In addition to direction, remember to consider the color (covered later in this chapter) and softness (covered earlier) of the light as well. Hard side lighting can give you some very dramatic effects, whereas softer light is better for beauty shots, where you're trying to make the model look as staggeringly gorgeous as possible.

Back lighting

If anyone has ever told you anything about photography, it was probably to tell you to "always shoot with the sun at your back." In a way, they told you two things: Use front lighting, and avoid back lighting. It's true—for most photos, it's very challenging to capture a good shot when the light is coming from behind.

There is one particular technique, however, where back lighting comes in particularly handy, and that's if you want to create a silhouette. There are many ways you could do a silhouette, but the key trick is to set your exposure so the bright background comes out beautifully, while the dark foreground is allowed to be underexposed.

Mixing and matching light

The examples in this section are all a little bit extreme—in reality, you are probably going to get a mix of light. Even in a scene where the sun is coming in from the side, realistically some of the light is going to be reflected off the ground, buildings, and other things in your surroundings. In a studio, for example, you might use several light directions at once in order to make the picture "come together" perfectly, making your model look as smoldering as possible.

The challenge when dealing with different light sources stems from the fact that all the light sources are likely to be of different intensities (reflected sunlight is obviously less bright than light directly from the sun). Plus there are varying degrees of softness, and different color temperatures of the various light sources.

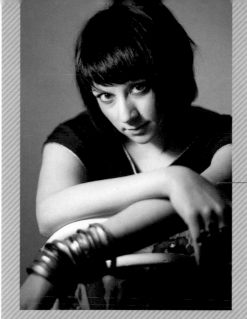

Cross-reference

We'll deal with color temperature and white balancing later on in this chapter!

A lot more subtle, but the most important light in this image is from above and to the left of the model.

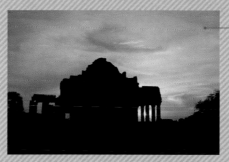

When photographing sunsets, you could use something in the foreground to keep things interesting. In effect, you're back-lighting the subject, creating a silhouette.

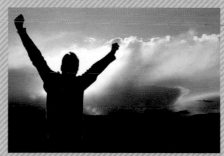

Back lighting can be used in portraiture as well, but if your subject is only lit from the rear, it can be hard to see who they are.

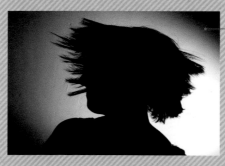

This portrait of the model quickly shaking her head created a cool-looking silhouette, too. I used a flash on the wall behind the model—but the front of her is completely dark!

CASE STUDY Multi-flash

Multi-flash setup

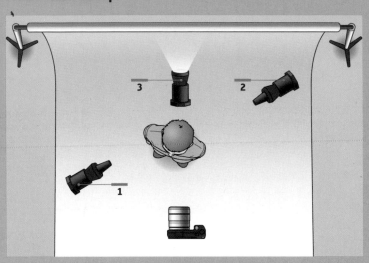

The holy grail of lighting, for many, is using lights in "proper" studios. You may have seen it in the movies or on TV: The photographer directing a beautiful model around, with lots of impressive-looking lights hanging in all sorts of places in the studio. With perfect final results, of course. Studio lighting might seem like pure magic, but it's not actually all that difficult to do yourself. Personally, I like to use small portable flashes when I work in the studio, but the theory of working with strobes is true no matter whether you have powerful studio flashes or smaller, more portable off-camera flashes.

BREAKING IT DOWN LIGHT BY LIGHT

The best way to start "building" a lighting situation is to consider your lighting situation light by light. It makes sense to start with the main light. In this case, I'm going to use direct flashes (i.e. without any diffusers or softboxes).

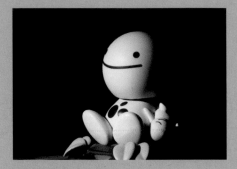

1 Using a single flash, our friend HappyHead comes across as very "moody" indeed, which is perfect, if that is the feel you are going for. We want a more well-balanced lighting situation in general, though.

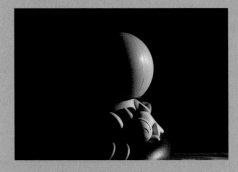

2 The second light we add to the mix is largely designed to "lift" the shadow caused by the first light.

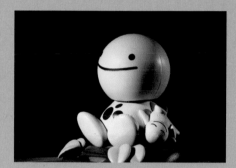

3 If we take a look at both these lights firing at once, we see that they balance each other out nicely—a pretty good start to our portrait!

4 However, the background is still too dark, so I added a strobe which blasts the background into a pure white. This flash on its own creates a good silhouette photo.

5 Now that I'm happy with my flash setup, I can get them all to fire at the same time—the flashes help each other out in creating the lighting situation I'm looking for.

6 When you've perfected this lighting setup with a figurine, it's time to replace the doll with a real, live person. Take a close look at this photo—the lighting setup is exactly the same as that we used for HappyHead.

It's all about the quality of light

Despite what many aspiring photographers assume, it's not the case that more light is the same thing as better light. As camera technology progresses, we are able to use higher and higher ISO values with acceptable amounts of digital noise. The result is that it's possible to do exciting things with portable studio equipment—and in low-light in general.

Far more important than how much light you have available, is the quality of light. By "quality" we mean mostly the direction, softness, and color of the light: If you have these things, it doesn't necessarily matter that the light isn't very bright.

Glossary

Speedlite—a portable, battery-powered flash that can be used on or off camera.

Strobe—any flash that can be used for photography.

Off-camera flash—a flash that can be triggered without the need to be connected to the camera.

In portraiture, too, quality of light is paramount. In this photo, I was taking photos with a flash, but due to the diffusers I was using, I didn't have a lot of light to work with. As with the picture of the cat, I had to use ISO 6400.

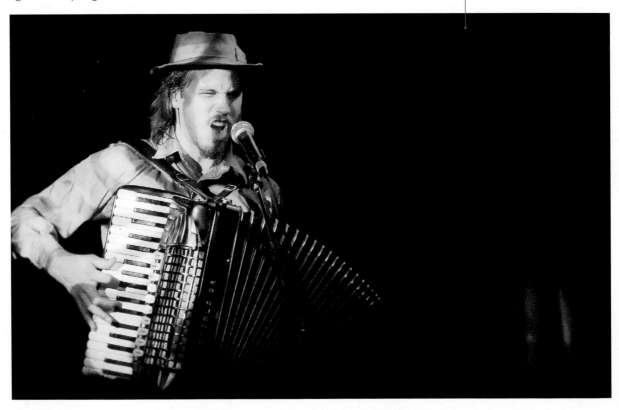

Your camera vs. your eyes

When it comes to "quality" of light, it's worth bearing in mind that your eyes sometimes interpret scenes very differently than your camera does. This goes two ways: Sometimes, you may find yourself in lighting situations that look fantastic to you, but that are extremely elusive when the time comes to capture them. Other times, you see something interesting, point your camera at it, and realize later that the photo came out a lot more interesting than you remembered the scene being.

The disparity comes from the differences between the way your eyes "reads" a scene. Being able to "see" the way your camera sees comes with experience. It's experience you can only get by learning as much as you can about photography and, of course, taking as many photos as you can.

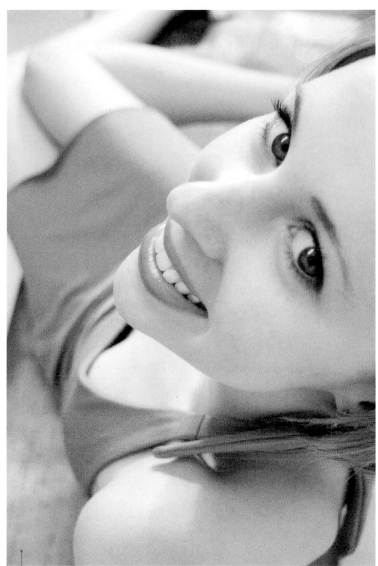

This photo was taken in the very weak light at the break of dawn. By using a huge aperture (f/1.4) and a high ISO (ISO 6400), I was still able to capture the scene successfully. There wasn't a lot of light—but the little light available was beautiful.

This photo is lit with a 500W halogen shop light, aimed at the ceiling. It didn't give a lot of light, but the effect of the white ceiling and walls in the room gives absolutely divine light.

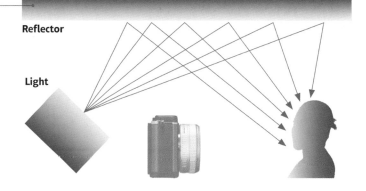

Reflector

Light

The golden hour

You know why, in cowboy films, they always have their duels at dawn? It has nothing to do their love for getting up early to shoot holes in each other: It's all about the light that shows up the first few minutes after the sun peeks over the horizon. And not for the benefit of the gunslingers either: It's the cinematographers who love their sunrises and sunsets. And so should you.

For a period of time just before and just after sunset, there is magic in the air: The way the sunlight is reflected off the atmosphere makes the sunlight look golden—and a good photographer is ready for that moment when it comes.

The duration of the "golden hour" depends on where in the world you are—near the equator, sunrises and sunsets are very brief indeed. At higher latitudes you may find that you get the magic light for much longer.

If you're out traveling, it's always worth checking the times of sunset and sunrise. Most good nature photographers make sure to hit both the setting and rising of the sun, to make the most of their photography time, as this is when you get the majority of truly stunning nature photos.

Looking out and looking in

There are two ways to look at a sunset: One is to look at the sunset itself. No problem there, as there are a lot of beautiful things to take photos of when you're looking that way. Bear in mind, however, that when people are talking about "golden light" they are looking the exact opposite way. It is by using the last sunrays as lighting for your photos that you get the full effect of the beautiful light.

Pets, people, mountains, monuments and just about anything else you can aim a camera at benefit; it's hard to say exactly why, but you can't argue with the results.

Portraiture is another fantastic candidate for photos as the light turns magic.

The light at sunrise is certainly worth getting up early for.

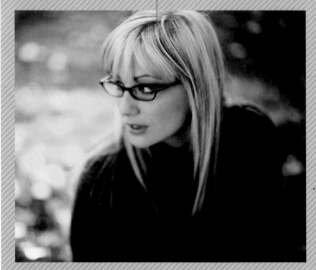

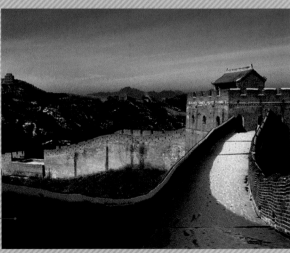

The great wall of China—impressive in any light, positively gorgeous during the golden hour.

What is color?

Color has three characteristics: It has a hue, saturation, and luminance. The hue describes which color we are talking about, such as red, purple, orange, or green. Saturation expresses how vivid the color is—or how much there is of the color. The luminance describes how bright the color is —a color with a high luminance is very light (baby pink is an example of a color with high luminance), whereas a color with low luminance is a darker color—burgundy, for example, could be described as a "red color with medium saturation and low luminance." Or, as you would really say it when you're talking like a normal human being, "dark red."

For the purposes of photography, color becomes important for two things: the color of things, and the color of light. Everything you take a photo of will have some degree of color. In portraiture, the people you photograph have a color, the things they wear have a different color, and so on. Because we're used to walking around looking at things all day, we're quite used to the way this aspect of color works. Remember that pure white light contains all the colors of the rainbow. If you are looking at a ball that you perceive as red, it means that the ball has absorbed all colors except red— and that it reflects the red back into your eye.

Where it can become confusing is when we introduce colored light. In the previous example, if we take all reds out of the light (by placing a blue filter on our light source), then the ball will look black.

Remember that you can adjust the color of light at two stages: at the source of the light, or with a filter in front of your camera. Once you've taken your photo, you can further adjust the colors in your photos on your computer.

By using a blue or red gel on the flash illuminating the background, you can change the look of the photo completely. Because the background is white, it reflects all light hitting it. As a result, blue light makes the background look blue.

This original photo in color has a lot of reds and blues in it.

By placing a red filter on the lens, the blues of the sky don't register in the camera, and turns into a dark shade. As far as the camera is considered, there is no light in that part of the photo.

If we place a blue filter on the lens, the blues are back, but the camera doesn't "see" the reds, which means that the red brickwork gets a lot darker, whereas the sky goes bright.

White balance

White balance is one of those topics that gets discussed to death on internet forums and websites. If you want to, you can get incredibly geeky about the topic of white balance. It often scares people off, however, learning how much can be said about white balance. You'll be pleased to know, then, that you don't have to know all that much about white balance to make it work for you.

What is white balance?

The reason that white balance exists at all is that brains and cameras work slightly differently. Our brains are truly astonishing at interpreting different situations, and determining what "white" is.

Per definition, "pure gray" is a color where all the colors of the rainbow are represented in equal brightness. Out in the real world, this happens rarely. The color of the sun changes throughout the day: It's "warmer"—or more red—in the morning and evening, and "cooler"—more blue—in the middle of the day. Artificial light also comes in a variety of different color tones.

The good news is that your camera can compensate for the different colors of light, by mixing the colors. In automatic white balance, if your camera discovers the picture is too "cool" it can mix the colors differently, adding in more reds and removing some blues, which results in a well-balanced image.

Color temperature and color cast

When it comes to "white balance," there are two possible problems with your images, generally referred to as color temperature and color cast.

Color temperature is what tints the photo toward blue ("colder" temperatures) or red ("warmer" temperatures). Color casts come in different guises, but casts affecting your photos will usually be cyan (a pinkish cast) or green. White balancing your photo fixes both temperature and cast issues at the same time.

This would never happen to your eyes, but your camera can be fooled. In this case, I had my camera set to a manual white balance for indoor photography, which is why this image of Norman Jay came out looking very blue.

The image in the center is correctly color balanced, more or less. The surrounding images show possible white balance and color-cast issues. Top left has a cyan color cast. Top right is suffering from a "cold" color balance. Bottom right has a green color cast. Bottom left is color-balanced too "warm."

JPEG and Raw

Your camera stores your images as digital files. On most cameras, this is either JPEG (the same file format that is used on the Internet a lot), or Raw.

There are many reasons why it's better to shoot in Raw than in JPEG, and white balance is one of them, but in short, by shooting in Raw, you are in effect taking the burden of making the decision away from your camera, and putting it where it belongs: In your own hands. When you're a photographer, being a control freak is perfectly acceptable!

Cross-reference

Confused by the Digital Darkroom
White balance and its adjustments are intrinsically linked with digital editing—check out Chapter 9 for a general introduction to the digital darkroom; that should help make sense of the rest of this chapter, too.

JPEG vs. Raw
We discuss the JPEG-versus-Raw question in greater detail in Chapter 9.

WHY GRAY, NOT WHITE?

You can color-balance using a white object, but this can cause challenges with exposure. Pick up a gray card from a photography store if you want complete accuracy—or buy a sheet of cardboard from a craft store that is approximately neutral gray if you just want a good starting point for fine adjustments.

Using a gray card helps color-balance your photographs

White balance

White balance in post-production

Since we're taking photos in Raw, we can adjust our white balance on the computer. Here's how:

Using different software?

For this book, I'm assuming you're using Adobe Lightroom—but most software that can edit Raw files have similar functionality built in, and the steps will be similar.

USING THE WHITE BALANCE SELECTOR

1. Load your photo into Adobe Lightroom, and enter Develop mode so we can make changes to the image.

2. Press the White Balance Selector eyedropper (or just press "w" to quick-select it).

3. Find an area of your photo which you believe should be a neutral gray; click on it with the White Balance selector.

CAN'T BE BOTHERED WITH WHITE BALANCE?

Unless I'm doing particularly important shoots (like a cover shoot for a book), I generally can't be bothered with white-balancing my photos. When that's the case, I use automatic white balance on my camera, and make minor adjustments on my computer if required.

Using trial and error

Sometimes, if you can't find a neutral gray in an image, the White Balance Selector isn't going to be of any help. Use the drop-down menu, and select Auto. If they are available, you can choose a preset such as "sunny" or "tungsten." If your photo looks better that way, you can fine-adjust from there.

✓ As Shot
Auto
Daylight
Cloudy
Shade
Tungsten
Fluorescent
Flash
Custom

If that didn't work, you have to roll out the big guns and adjust manually: Slide the Temp(erature) and Tint sliders back and forth to see what gets you closest to your intended outcome. It's not a very scientific approach, but it usually does the trick.

What if you can't white-balance the image?

There are a few lighting situations where it's impossible to white-balance the image. This could happen, for example, if you are taking photos in artificial light where there is only (for example) red light, such as at a concert. If that happens, you may have to live with the image not being white-balanced.

Of course, if you're ready to give up, you can always throw in the towel and turn the photo into a black-and-white image instead. After all: No colors, no color balancing.

Mixed light sources

In many lighting situations, you'll find that you have a series of different light sources. You may be sitting in a restaurant, lit by candle light, with a light-bulb above the table, and some Halogen light spots in the background, and fading sunlight outside. These are all different-colored light sources. Unless you're going to do some extremely high-tech photo retouching, you'll never get them all to look the same.

The best you can do with mixed light sources is to color-balance for one of them, so at least part of your photo looks "natural"—and consider the rest of the photo a mood-lit background.

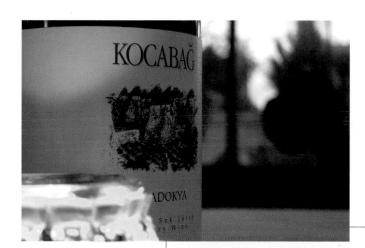

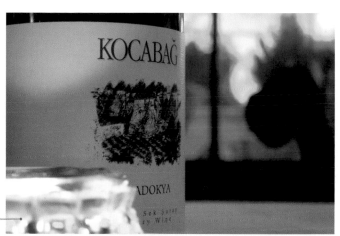

White-balancing on the outside world makes the wine bottle look way too "warm"—but if you white-balance on the bottle, everything else looks far too "cold." In situations like this, you can't win—part of the photo is going to look off.

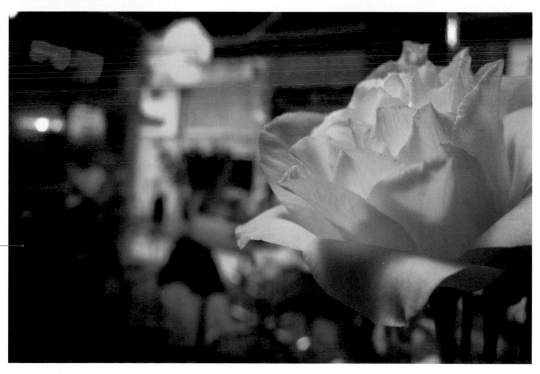

You can use different light sources for creative effect: White-balancing for the white rose inside a restaurant gave a beautiful, dramatic blue background, even though in reality, it was just a normal, sunny day.

Creative use of color balance

For all the ranting I'm likely to do about getting color balance "right," there are a lot of exceptions to the color-balancing rules as well, and many fun effects that can be achieved by mis-balancing the color in your photo on purpose.

Getting creative with color balance isn't hard. Sometimes you'll find that a happy accident here and there goes a long way toward discovering an unusual-looking technique. Whether your "accidents" happen in-camera or during digital editing, it's worth paying attention to how you achieve your final result—keep a little notebook handy to write down how you made your magic happen.

EXERCISE

Make a habit of experimenting with your photos as you're editing them. In particular, in Lightroom, with its non-destructive photo editing, you can't do any harm: Your original photos are a simple click of the "reset" button away.

This photo was taken with my underwater camera just after I re-surfaced from a dive, so the white balance was way out of whack, but I quite enjoyed the way this turned out.

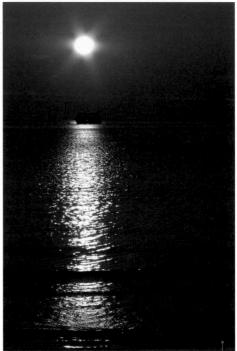

Another sunset, this time balanced to an extreme cool color. A blue sunset? It'll be obvious to everybody who sees the photo that you're guilty of digital trickery, but nobody can deny that it looks unusual.

Clarity, vibrance and saturation make up the "presence" controls for color in Adobe Lightroom.

I find that increasing the vibrance but decreasing the overall saturation for images works very well for my street photography. This particular combination of settings gives a slight tinge of otherworldliness to the photos, which I rather like.

Muted, neutral, and vivid colors

When you've got your white balance set properly, the next choice you have to make is how colorful you want your photographs to be. In Lightroom, this concept is known as the "presence" of colors.

Saturation is quite intuitive to understand. Increase an image's saturation to make the colors in your photo brighter, or reduce it to make your photos less colorful. All the colors in your photo are affected equally, so colors that are already saturated could become over-saturated. Over-saturation is not necessarily a problem, if that's the effect you're going for, but it can look very unnatural, especially if there are people in your photos.

Sliding the saturation slider all the way to zero results in a black-and-white image.

The vibrance slider is like the saturation slider, but it only has an effect on the colors that aren't very saturated to begin with. Using the vibrance slider means that you can add a bit more color to your photos without worrying about over-saturating the rest of your photo. You can also add a negative vibrance to a photo: This has the effect of desaturating the least intense colors even more, which can give some pretty cool effects in some photos. Experiment with combinations of high saturation and low vibrance and vice-versa for creative effect.

The last slider has to do with clarity. This is an expression of the mid-tone contrast in an image—increasing it gives photos a higher contrast between the individual colors. Reducing this slider gives an effect not unlike using a soft-focus lens (you may have heard the expression "vaseline on the lens," a technique used in the early years of Hollywood to make the starlets look less flawed).

MUTED

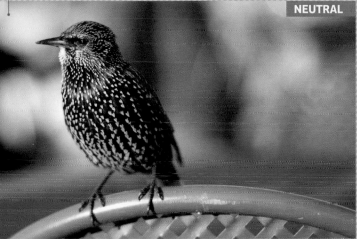

NEUTRAL

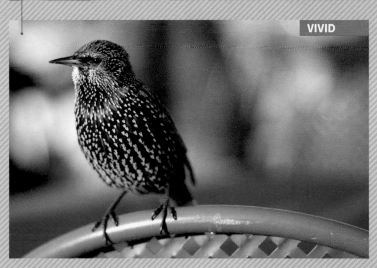

VIVID

Different ways to turn photos into black and white

Earlier in this chapter, we've already seen how easy it is to make a photo black and white—you simply slide the Saturation slider all the way to zero, and your photo comes out all lovely looking. Brilliant, right?

As a photographer, I'm a huge fan of having full control over everything that happens, which means that I only rarely use the "desaturation" trick above. In Photoshop, I'll use the Channel mixer—and Lightroom has a similar set of controls to give you an astonishing amount of control over how your black-and-white photos are converted from colorful masterpieces to monochromatic artworks.

In Adobe Photoshop

1 Open your image

2 From the Image Menu, choose Adjustments, then Channel Mixer

3 In the Channel Mixer dialog box, choose "Monochrome"

4 You can now choose how many reds, greens, and blues you want to use to "mix" your perfect black-and-white photo

Image	Layer	Select	Filter	View	Window	Help
Mode	▶					
Adjustments	▶		Brightness/Contrast			
			Levels...	⌘L		
Auto Tone	⇧⌘L		Curves...	⌘M		
Auto Contrast	⌥⇧⌘L		Exposure...			
Auto Color	⇧⌘B					
			Vibrance...			
Image Size	⌥⌘I		Hue/Saturation...	⌘U		
Canvas Size	⌥⌘C		Color Balance...	⌘B		
Image Rotation	▶		Black & White...	⌥⇧⌘B		
Crop			Photo Filter...			
Trim...			Channel Mixer...			
Reveal All						

As you can see from these three images—showing black-and-white photos made from the blue, green, and red colors in the image—black-and-white photos can look dramatically different depending on the colors in the original photo.

When you are mixing up your black-and-white images, a bit of color theory is a good idea: If you use the blue channel, there are no reds, so anything red in the photo will appear dark. If you bias your image toward blue on people with freckles, for example, their freckles will look darker and a lot more obvious.

The opposite is true as well: use the red channel, and freckles (and most skin imperfections) simply vanish.

Use the examples on this page—compare them to the color photo—to get a feel for what the impact of each of your colors are on your black-and-white conversions.

Of course, nothing is stopping you from combining several channels, mixing and matching the colors together, in order to create the look you're going for.

Blue

Original color image

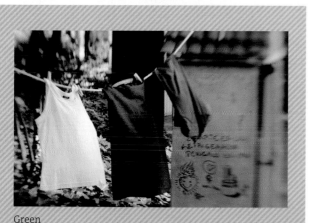

Green

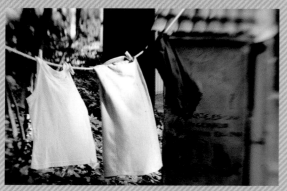

Red

Using mostly the red channel for this photo means that her skin looks almost like porcelain—but her lips nearly vanish as well.

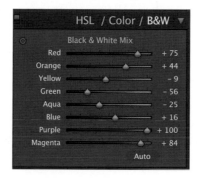

HSL / Color / B&W ▼

Black & White Mix

Red	+ 75
Orange	+ 44
Yellow	– 9
Green	– 56
Aqua	– 25
Blue	+ 16
Purple	+ 100
Magenta	+ 84

Auto

By using mostly the blues, the model's lips show up a lot better, and her cardigan (which is purple in real life) looks nearly black.

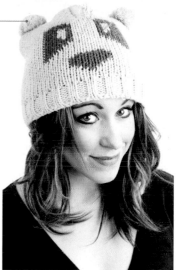

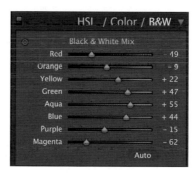

HSL / Color / B&W ▼

Black & White Mix

Red	49
Orange	– 9
Yellow	+ 22
Green	+ 47
Aqua	+ 55
Blue	+ 44
Purple	– 15
Magenta	– 62

Auto

In Adobe Lightroom

In lightroom, you can choose "black and white treatment" under the basic controls to turn your photo into black and white. Whereas Photoshop will give you three sliders, Lightroom bombards you with many more options in the form of extra sliders. Nonetheless, the results are generally very similar, even though there's more to consider.

Capturing the sunset of your dreams

There's something inexplicably romantic about sunsets in all their guises. Watching the sun sink slowly into the ocean or past the horizon fills the world with a beautiful calm. Why wouldn't you want to take a photo of such a gorgeous moment?

1 Be prepared. You can find out on the Internet what time the sun goes down where you are. Find a good spot ahead of time, and try to visualize where the sun will go down. Sometimes, moving a few hundred yards north or south along the beach can make the difference between an OK shot and a great one.

2 Make sure your camera is stable. Use a tripod or balance your camera on a fence, some rocks, or similar. During a sunset, the lighting will change rapidly, and the last thing you want is to miss the perfect shot because it's suddenly too dark to get the photo you want without a tripod.

3 Keep an eye on the clouds. When it comes to sunsets, most of the beauty comes from the interplay between clouds and the sun. It's sad but true: The more pollution there is where you are, the better the sunsets, because the particles in the air reflect the sunlight in beautiful ways.

4 Think about your foreground. Sunsets are pretty, but you can add a lot of drama to the shot by including something in the foreground, too. A person, a plant, or a building—anything to capture the audience's attention.

5 When it comes to sunsets, it is all about color. Underexpose your photos ever so slightly to make sure you capture all the color at its most beautiful.

It's all about the clouds—seriously! (See Step 3).

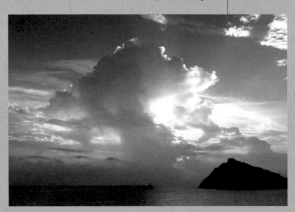

If you're creating a silhouette shot, make sure your foreground is in focus—but ensure your exposure is correct for the background. If in doubt, underexpose slightly. (See Step 4).

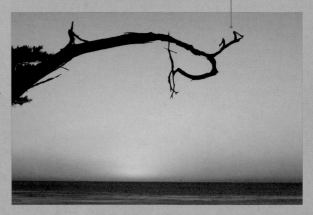

6 Keep your aperture small. There's a lot of light coming from the sun (it is pretty bright, after all), which is a bonus: As you remember from earlier in this book, a small aperture means a large depth of field—great to ensure everything is in perfect focus. For maximum sharpness, aim for the middle of your aperture range—on most EVIL cameras, $f/8.0$ or so is perfect.

7 Keep your ISO low. When you have large areas of similar colors, digital noise becomes very noticeable. The lower your ISO the better, as this cuts down the noise in your images. Besides, because you followed tip #2, you have a tripod, and slightly longer shutter speeds shouldn't be a problem.

8 Think about your composition. Is the sky or the ground the most important element in your photo? If you have a beautiful sky, make sure that it covers most of your frame.

9 Keep your horizon straight. When taking photos of the sunset, you usually have the horizon in the frame—if it is, make sure the horizon is straight. Nothing is more off-putting than a slightly crooked horizon. If you want a diagonal horizon, that's OK too. Just make sure it's very diagonal—so people don't think you did it by accident!

10 Stick around. Don't put your camera away as soon as the sun vanishes, because sometimes you'll find that the colors just keep getting better, as the sun continues to reflect off the clouds along the horizon.

THE EVIL ADVANTAGE
Most EVIL cameras have the option to turn on a Rule-of-Thirds grid in your photos—make sure you turn it on. It makes it a lot easier to help you get the horizon straight.

Here's why you stick around even after the sun goes down: the colors keep changing even after the sun has dipped under the horizon. Don't miss it! (See Step 10).

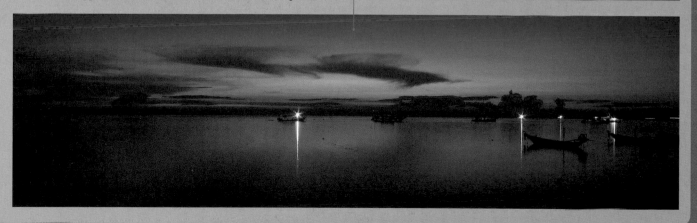

EVIL Equipment

It's quite curious to me, how discussions about photography always seem to degenerate into "Mine is bigger than yours"-style discussions. It's doubly confusing, because in my experience, among amateurs, the people with the most extravagant equipment have the least clue about how to use it.

On the other hand, you do need equipment—there's one guaranteed way you're not going to capture a single good photo: by not having a camera with you.

I've used all sorts of high-end cameras. Today, I take most of my photos with relatively simple equipment—my favorite camera at the moment is the Olympus PEN E-P1, and when I'm not taking photos with my PEN, I use a Canon compact camera (the Canon PowerShot S95) or a Canon EOS Rebel T2i.

This means that if you want to be a better photographer, I really wouldn't worry too much about your equipment. Worry about the person holding the camera: Work on becoming a better photographer, and your photos will improve. All the camera gadgets in the world are going to be a distraction if you're struggling with the basics.

My humble Canon PowerShot S95 compact camera can take some delightful photos.

What to look for in a camera body

When considering a camera body, there are an astonishing number of things you need to be looking for. Before you descend into a panic, however, let me tell you something that makes the buying experience much less stressful. As of right now, there aren't any truly terrible camera bodies out there. In fact, in the hands of a capable photographer, you can create gorgeous photos with every single camera body that is currently on sale.

So, if you can't go wrong, what should you be looking for?

Viewfinder

It's useful to be able to see what you are doing before you do it, and the way you look at your photos differs from camera to camera.

Optical viewfinder—Some cameras come with an optical viewfinder. This can work in two different ways: Either, you're looking through the lens itself (this is how it works on an SLR camera), or you're looking through a little viewfinder hole. The viewfinder can be built into the camera, or some cameras have add-on optical viewfinders.

A simple slide-on viewfinder fits into the hot shoe on this Olympus E-P1 to help you compose images taken with the 17mm pancake lens. Of course, you can still use Live View instead, if you want.

LCD screen with Live View—Most recently launched cameras support Live View on the LCD screen. This is similar to how people have become used to using their compact cameras: You point it at something, and the screen on the back shows what you're aiming at.

Electronic viewfinder—An electronic viewfinder is a combination of the two above technologies: You're looking into a little hole at the back of the camera, like with an optical viewfinder, but instead of looking straight through the camera lens via a mirror, you are looking at a little display mounted inside the viewfinder. The EVF has a benefit over LCD screens in that it's easier to use in bright sunlight.

Which type of viewfinder you want will impact the choice of your camera—but before you make the choice, ensure that you go to a shop and try before you buy. The three viewfinder options are quite dramatically different from each other, and some people find that they can't get used to an EVF, for example.

There is also a huge difference between cameras that use the same technology. LCD screens especially can vary wildly—from the nearly-useless, low-resolution units found on some older compact cameras, to the iPhone-quality screens you find on newer, more high-end cameras. The only way you'll know if the viewfinder is good enough for your needs is to give it a try yourself.

Lens mount

An important thing to check before you decide to splash out on a new camera, is what the lens mount is—and which lenses are available for the lens mount you have on your camera. Bear in mind that lenses with different mounts aren't easily transferable from one mount to another, so if you're going to start investing serious cash into your lenses, the lens mount will be one of the most important choices you'll make in your photographic career.

Writing a little script of the things you do with your camera is a good idea—it helps you test cameras in the shop more efficiently, and it'll give you a good impression of how easy the camera is in everyday use.

Controls

Camera controls come in all sorts of shapes and forms, from the super-intuitive cameras that are so easy to use that you'll never even dream of opening the manual, to cameras that are so infuriatingly complicated and counter-intuitive that you'll want to throw them against a wall.

Personally, I find that I know whether I'll get along with a camera or not after playing around with it for about twenty minutes or so. If you can, walk into a camera shop and do just that—try to change the settings, take some pictures, change the settings again, and take some more photos. It's not hard to make a little "test script" of things that you do when you take photos on an everyday basis.

Flash

Simple: Does the camera have a built-in flash? Can you use external flashes? What flashes are available—and are they easy to use? You don't have to run off and buy an internal flash right away, of course, but it's good to know that you can, if you want, at a later date.

Shutter speed

Unlike aperture, which is controlled by the lens you attach to your camera body, the shutter speed is controlled by your camera body, so it's worth checking it has all the features you need. The three things to look for are the maximum shutter speed, minimum shutter speed, and bulb mode.

Maximum and minimum are self-explanatory—most cameras have a shutter-speed range from a few seconds (usually 30 or 15 seconds) to a fraction of a second (usually 1/2000 or a bit faster, for EVIL cameras). You're unlikely to run into problems with your maximum shutter speed being too slow—but it's entirely possible that you'll have issues with the slowest shutter speed on some cameras.

Bulb mode is the final shutter speed you should check—"bulb" (or just B) means that the shutter stays open for as long as you keep the shutter button pressed. That means that you can use as long a shutter speed as you want—great for stuff like taking photos of firework, rivers in motion, or photos of the night sky.

ISO

The ISO range of the camera is important because at high ISOs, you're able to take photos in low light with decent shutter speeds. However, don't just go for the number—there's a huge difference in ISO 2000 on a camera that went on sale ten years ago, and on a brand new camera. Technology is developing rapidly, and not all the manufacturers are as cutting edge as they'd like to think.

Testing low-light capability is tricky, as you don't really start appreciating how good (or bad) your camera is until you've been using it for a while. The best approach here is probably to go to a reputable online review site, such as Digital Photo review (http://www.dpreview.com) and see how they rate the camera for low-light photography.

Raw or JPEG?

These days, it's rare to find a camera aimed at serious photographers that doesn't store its photos in a Raw file format—but it's worth checking. If the camera you are considering doesn't have Raw, I'd suggest you walk away; there are plenty of other cameras to choose from.

Video mode

If you're planning to use your new camera to make videos in addition to taking photos, you will have to consider the video mode on the camera as well. Important things to look for are what the resolution of the video is, and whether the camera has support for external microphones.

Megapixels

The resolution of your final photos—seriously, don't worry about it too much. Resolution (i.e. the number of pixels in a single photo) means a lot less in the grand scheme of things, than how easy your camera is to use, the quality of the lenses you are using, and how good you are at finding beautiful light.

Micro Four Thirds system

The Micro Four Thirds standard was co-developed by Olympus and Panasonic to extend the usability and enjoyment of the existing Four Third System lenses—and to develop the platform further, of course.

Micro 4/3 cameras have interchangeable lenses and a lot of SLR-like manual controls but because they use different sensors, they deliver pictures with a 4:3 aspect ratio as opposed to the 3:2 aspect ratio of most SLRs; 4:3 aspect ratio—hence Four Thirds cameras.

The Micro 4/3 system has enabled the development of far more compact and lightweight interchangeable-lens cameras. The main idea behind the Micro 4/3 system is the elimination of the mirror, pentaprism and optical viewfinder, creating a radically reduced-size camera. The differences in the platform mean that the lenses that can be used are much smaller as well, without negatively affecting image quality.

Due to the design of the Micro Four Thirds system, it's great for tilt-shift photography—in this case, facilitated by the Lensbaby Tilt Transformer, which enables you to mount Nikon lenses for tilt-shift photography.

Fun and easy to use, great quality pictures, and eminently portable. What's not to like?

An optical revolution

By removing the mirror box, the Micro Four Thirds system makes it possible to design much thinner camera bodies, which in turn brings the lens much closer to the digital sensor. This creates several optical advantages for wide-angle lenses, as they can be used without requiring extreme retro-focus or inverted telephoto designs.

Eliminating the mirror box also reduces the mount-to-sensor distance up to 50 percent and brings it to 20mm, which allows the rear element of wide-angle lenses to project a significant distance into the camera. To some extent this is the same way some wide-angle lenses project inside the body of Leica rangefinder cameras even though the 4/3 sensor is only 1/4 the size of 35mm film.

From the mundane to the exotic, there seems to be an impressive array of choices available for the Micro Four Thirds lens mount.

Worth a look?

One of the main reasons consumers are starting to shy away from SLR cameras is that they are simply too big. This was one of the main reasons why the Micro 4/3 systems were introduced—by using a smaller sensor, lenses and bodies could be made much thinner and thicker than those for SLRs, creating more attractive cameras overall.

It all makes sense if you consider that a smaller sensor size allows for lower lens manufacture cost, and smaller and lighter telephoto lenses. Also, almost any lens can be used on Micro 4/3 camera bodies by using the proper adapter. For example, 4/3 lenses can be used with autofocus using the adapters created by Olympus and Panasonic. The popularity of the Micro 4/3 system has grown considerably since 2003 when Olympus launched the Olympus E-1. Today, while Panasonic have the widest selection of cameras, Olympus dominates the 4/3 camera market in terms of cameras sold.

Lens selection

Of all the EVIL cameras, Micro 4/3 seems to have the edge in terms of the number of lenses that are available, which is absolutely crucial in whether or not you decide to buy into the system.

There are anything from standard zooms, like the Olympus 14–42mm f/3.5–5.6 that gets bundled with a lot of the PEN cameras, via some attractive telefocus zooms, such as the Panasonic 100-300mm f/4–5.6 with optical image stabilization, to an impressive range of specialized glass.

You can go wide (Panasonic Lumix 7–14mm f/4), super bright (Noktor Hyperprime 50mm f/0.95), macro (Panasonic Leica DG Macro-Elmarit 45mm f/2.8), and Fisheye (Panasonic Lumix G Fisheye 8mm f/3.5).

In addition, alternative lens manufacturers like Lensbaby have embraced the lens mount as well, boding well for future development.

WHERE TO SPEND YOUR MONEY

If you have a limited amount of money available to invest in your photography hobby, there are ways that you can spend your money more cleverly so your equipment will stay ahead of you for a long time.

The most important part of your camera isn't actually your camera body—it's your lenses. I still use lenses today that I bought many years ago—but my camera body gets a refresh every few years. The great thing about buying good lenses is that they will actually get better as you upgrade your camera body later: Better imaging chips can take advantage of good lenses, and your photos will come out sharper than ever before.

This photo is taken with a 50mm lens. It is one of the first lenses I ever bought, in fact. Ten years later, it's still going strong.

NEX system

Along with the offerings from the competitors, Sony launched their own series of mirrorless system cameras—known as the NEX range.

Unique for the NEX range, the cameras use APS-C sensors, which means that they use the same-size sensors as many digital SLR cameras. The bigger sensor means that it's easier to use depth of field creatively, and should in theory mean lower-noise, high-ISO photos.

Huge sensors, it turns out, need not mean large camera bodies, and the NEX cameras are some of the smallest mirrorless cameras available.

Unlike Sony's larger stablemates, the NEX cameras have no in-body image stabilization units, but feature lens-based optical "SteadyShot" stabilization instead.

A huge imaging sensor, and several different camera bodies to choose from is the platform Sony is building on.

Sony's NEX system has more than a few tricks up its sleeve.

It may not have the size of some of the other EVIL cameras, but the amount of tech packed into the Sony range is astonishing.

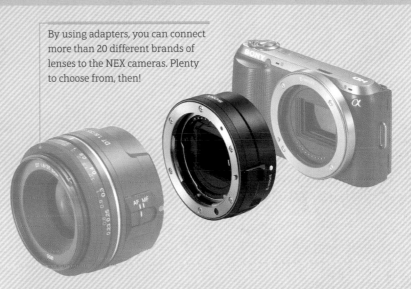

By using adapters, you can connect more than 20 different brands of lenses to the NEX cameras. Plenty to choose from, then!

All the gadgets

Sony have long been better known as a technology brand than a photography brand, and the company has a tendency to throw a lot of features and functionality into their cameras. The NEX series is no exception. As an example, they've included an improved version of the Sweep Panorama feature from its recent Cybershot compact camera models, which allows users to easily create 220° panoramic shots. Sweep Panorama mode also has 3D capability, which helps users create 3D panoramas that can be played back on 3D Sony Bravia TVs.

The NEX cameras include Sony's Auto HDR feature that takes multiple shots of the same scene at different exposures merging into a single image with greater shadow and highlight detail.

Lens availability

Whereas the Micro Four Thirds standard has a wide selection of lenses available to them, Sony's offering in the E-mount series is slightly more limited.

They have the standard pancake lenses and multi-use zooms, but so far, there hasn't been the full breadth of lenses that keen photography amateurs and professionals would be looking for—the absence of a long tele lens or any very bright prime lenses are painful oversights.

Then again, the lens offering that is there is pretty solid, and the quality of the glass offered by Sony is very high indeed.

Despite the low number of lenses available for the E-mount cameras natively, the camera does benefit from being able to mount a serious number of other lenses by using adapters. There are currently more than twenty adapters available, letting you use Canon, Nikon, Leica, Hasselblad, Contax, and dozens of other lenses on your NEX camera: Perfect for picking up cheap lenses on eBay, or for getting the most extortionately expensive and exclusive glass you can find.

NX system

Samsung was a late comer to the market, and entered the mirrorless cameras sector back in June 2009 with its new hybrid system, in the shape of the NX series. The concept is similar to the Micro Four Thirds system, but uses a larger APS-C sensor (like that on the NEX cameras), which combines the high potential quality of an SLR with the simplicity and portability of a point-and-shoot camera.

Like typical DSLRs, the NX Series utilizes an APS-C image sensor that provides a much larger surface area to capture light and deliver high-quality images. A true EVIL camera, the NX cameras have no mirror boxes. Instead users can take advantage of their camera's Live View functionality to compose the shots.

The amazing thing is that a larger sensor doesn't necessarily mean larger cameras; the NX10, for example, is smaller than the Panasonic G1. The bigger sensors do mean that the lenses have to be slightly bigger, however.

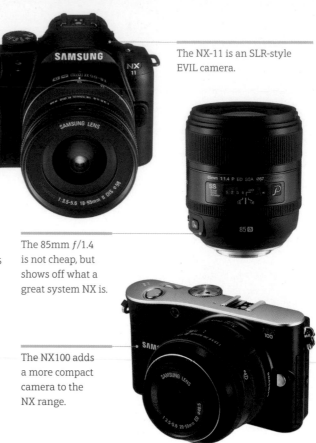

The NX-11 is an SLR-style EVIL camera.

The 85mm *f*/1.4 is not cheap, but shows off what a great system NX is.

The NX100 adds a more compact camera to the NX range.

Innovative improvements

Lenses have long been passing information back and forth to their camera bodies, but in the NX series of cameras, Samsung have taken it a step further.

A much-talked-about innovation from Samsung is their i-Function, which allows users to easily control the camera settings (Shutter Speed, Aperture, Exposure Value, White Balance and ISO) through the lens. By placing the i-Function button on the lens, the focus ring takes on a new role and becomes the "dial" that is used to change the aperture and shutter speed.

In addition to the i-Function, Samsung have built in a lens-based priority mode called i-Scene. This function allows the camera to automatically recognize what type of lens has been attached and select scene options that are best suited for the lens currently being used. Users simply need to choose the scene they like, and the camera is optimized to take the perfect shot.

Lens availability

Samsung's NX series of lenses is relatively well developed, with everything from 30mm *f*/2.0 prime lenses, a series of image-stabilized zoom lenses, a macro lens, and a tasty 85mm *f*/1.4 prime lens. Samsung has also announced it is rapidly expanding the lens line-up.

As with all the EVIL cameras, the NX system accepts adapters so you can use lenses from other manufacturers (at last count, there were around ten different lens adapters available). The downside with using an adapter on the NX cameras is that you lose the i-Function controls that are built into the purpose-built lenses, which can be a frustration if you've become used to the additional flexibility offered by the i-Function control ring.

In the marketplace

Samsung's NX range is most similar to the Micro Four Thirds range, with a reasonably wide array of lenses and adapters available, but using a much larger sensor gives the NX cameras a bit of an edge—at least on paper.

Leica M-series system

The name Leica sends photographers' hearts a-flutter all over the world as soon as it is mentioned. Building on a rich and impressive history, Leica have two EVIL-like cameras currently on the market.

I say "EVIL-like" because unlike true EVIL cameras, the M-series don't have Live View or electronic view finders. They do have interchangeable lenses, they don't have mirrors, and they are sexy as hell, so for the sake of completeness, I'll include them here in this chapter.

Lens range

Introduced in 1953, the Leitz M lenses were subject to changes that brought an improvement in the optical performance, as well as cheaper lens mounting and amazing barrel finishing. By adding the Leitz screw mount to the Leica M bayonet mount adapter, consumers can still use the old Leica lens.

The range of Leica lenses available—mostly prime lenses—is absolutely astonishing, and Leica's lenses are widely accepted as some of the finest, sharpest, and best-built lenses in the history of photography.

With a range spanning from the wide-and-bright 21mm ƒ/1.4, the world-record-breaking 50mm ƒ/0.95, and the legendary 135mm ƒ/2.8, you're likely to run out of money before you've had a chance to try all of Leica's exclusive glass.

A slightly saner option would be to use the M lens adapter, which makes it possible to use the RF lenses made by other manufacturers, such as Contax, Nikon, or Canon. If you do, however, you're likely to be lynched by Leica purists.

The Leica M8 was introduced in 2006, but is still a desirable piece of photographic kit today.

The 18-megapixel Leica M9 is one of the finest cameras you can buy. However, it's a lot more expensive than most other EVIL cameras.

What to look for in a lens

Lenses can be a little confusing at first, so in this section, I'm going to take a closer look at what each of the features on a lens means—and how to choose one.

Focal length

Focal length is the distance the light travels from the imaging sensor to the front lens element. This distance is generally measured in millimeters (mm).

A long focal length (e.g. 200mm), called a "tele" lens, works much like a pair of binoculars: It makes items that are far away look closer to you. Tele lenses are great for portraiture, concerts, sports, and wildlife photography.

A short focal length (e.g. 24mm) is called a "wide" lens, and does the opposite to a tele lens. By photographing a wider field of view, you can get more in the photo. Wide-angle lenses are fabulous for landscapes, indoor photography, and architectural photos and so on.

Focal length tends to be marked on the lens. If the lens has a single focal length marked on it, it's a prime lens. If it has two focal lengths with a dash in between (such as 17–35mm), you're looking at a zoom lens.

Using a wide-angle lens is great when shooting in a cramped space, but it can do weird things with perspective—look how big the model's hand looks in this shot! In this case, I used a 17mm lens on a APS-C camera with a crop factor of 1.6—so the equivalent of a 27mm focal length, approximately.

I was pleased to be shooting with a tele lens in this shot— I'm not that keen on becoming a lion's dinner! This was taken with a 200mm lens on a camera with a crop factor of 1.6x; the equivalent of a 320mm focal length.

CROP FACTOR

Traditionally, film cameras had film frames sized 36x24mm, and photographers would talk about focal length as it related to that film frame size. When digital photography came along, the sensors were smaller than that of film, but photographers would still use the same lenses. This means that when you're taking a photo with a 200mm lens on a smaller sensor, you would, in effect, get a higher magnification than you would get with a full-frame sensor.

On a camera with a Four Thirds sensor (which is 17.3x13mm in size) the crop factor is about 2x. That means that if you were to attach a 200mm lens to a Four Thirds camera, it would be the equivalent of a 400mm lens.

The crop factor of a lens won't be marked on the lens, as this depends on the camera body the lens is attached to.

Full frame (1.0x) APS-C (1.6x) Four-thirds (2x)

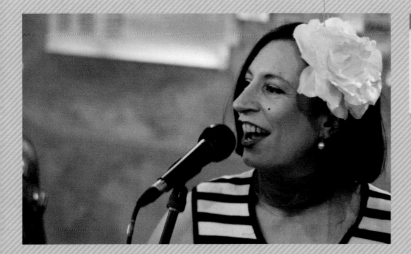

Maximum aperture

The next thing you'll want to look for on your lens is its maximum aperture. This is the biggest aperture you can use while taking photos.

On prime lenses, this is usually written as "50mm f/1.8"; in this case, f/1.8 is the maximum aperture of the lens at 50mm.

On zoom lenses, maximum aperture can be written in two ways. If your lens reads "70–200mm f/2.8," you have a constant maximum aperture lens. Here it means that your lens can zoom from 70mm to 200mm, but regardless of how far you zoom in, your maximum aperture will always be f/2.8. Constant maximum aperture lenses tend to be of higher quality than other zoom lenses, but they are also a lot more expensive.

The other option on zoom lenses is a variable aperture lens. This would be written as "17–35mm f/2.8–3.5." On these lenses, the maximum aperture goes down as you zoom in further—so at 17mm, you have a maximum aperture of f/2.8, but when you zoom in to 35mm, your maximum aperture is f/3.5.

When it comes to maximum aperture, in general brighter is better, because it gives you more flexibility to use limited depth of field. In addition, fast lenses tend to be of higher quality than slower lenses.

Being able to shoot at f/2.8 with my 200mm lens means that I was able to get up-close-and-personal with the musicians in this photo shoot.

Manual focus

Most lenses have a way of being focused manually. If you care about this, it's a good idea to take a closer look at how the lens works, and whether you like the way manual focus is implemented.

On some lenses, you have direct control of the focusing. This means that you can turn an adjustment wheel (called a "focus ring") on the lens, and it'll physically move the lenses. This form of control is fast and precise, and intuitive to use. Some lenses require you to select manual focus on the lens or camera before you can take control, while others can override automatic focus for fine-adjustments after you've already focused.

On other lenses, you're given an adjustment wheel which adjusts the focus fly-by-wire. On these lenses, you don't actually adjust the lens elements themselves, but you use a focusing ring which tells the camera that you want to change your focus. The camera then adjusts the focus for you using its internal focusing motors.

Personally, I'm not a huge fan of fly-by-wire focusing, but it's better than not having any manual focusing controls.

THE EVIL ADVANTAGE

If your lens is a variable aperture lens, and you are taking photos in limited light, try taking more of your photos fully zoomed out—it means you get a little bit of extra brightness in your shots.

Optical stabilization

The final feature you'll find on some lenses is optical image stabilization. This is some pretty nifty technology that moves a lens element inside the lens to counteract vibration or camera shake. If you shoot hand-held a lot (as opposed to having the camera on a tripod) in poor lighting, it may be worth considering a lens with an optical stabilizer.

Do pay attention, though—it may be that your camera body already has stabilization built in, and you don't want the two image stabilizers to get into a civil war.

For some photos, you really want manual focus in order to get the best results. This photo, for example, wouldn't have been possible without pre-focusing the lens at where you knew the droplet was going to hit.

Prime lenses and zoom lenses

When picking a lens, there are two main categories of lenses. You're probably familiar with zoom lenses: Most cameras come with a zoom lens, whether it's a compact with a lens built in, or a kit lens that comes with your interchangeable-lens camera system.

Prime lenses are lenses with a single focal length—or "non-zoom lenses," if you will. Most new photographers see primes as relics from a time gone by, but bear with me—there are some excellent reasons to add a prime lens or two to your camera bag.

In low-light situations, you can't beat a fast prime. This photo was taken with a $f/1.4$ aperture and ISO 800. If I only had my zoom lens, I doubt I'd have been able to take this photo.

The pros and cons of zoom lenses

There's nothing wrong with zoom lenses in themselves they're very convenient indeed, and you can save yourself a lot of walking around by using a zoom lens.

There are a few downsides to using zoom lenses, though. Most importantly, most cheap zoom lenses have variable maximum apertures, which means that as soon as you zoom in, you lose a lot of brightness.

The other downside with zoom lenses is that they per definition are a compromise: in order to work well at all the different focal lengths, it means that the quality is slightly reduced compared to a good prime lens.

Of course, there are zoom lenses that rival, and in some cases exceed, the quality of prime lenses, but they are so eye-wateringly expensive that it makes your bank manager twitch. Unless you have a serious stack of dollar bills hidden behind your sofa, or you are taking photos for a living, the top-end zoom lenses remain a distant dream for most of us.

The biggest advantage of zoom lenses, as alluded to earlier, is pretty obvious. The flexibility of being able to zoom in on something that's further away, or to zoom out to get the wider picture, is hard to argue with.

The case for prime lenses

Prime lenses can seem rather inconvenient the first time you hear about them. Only a single, fixed focal length? Really? On the other hand, primes have a couple of fantastic tricks up their sleeves, too. Because the lens manufacturers know exactly what the focal length is going to be for the lens, they don't have to make compromises, and can create a lens that does only one thing—but does it really well.

Prime lenses tend to have much larger maximum apertures, and are generally sharper, delivering crisper photos than their zoom-lens counterparts. It is not unusual to find prime lenses with apertures as wide as $f/1.2$ or even $f/1.0$.

Even if you don't want to go to the extremes when it comes to brightness of your lenses, primes tend to be cheaper, lighter, and sharper than comparable zoom lenses.

So, what should you buy?

Personally, I think I shoot approximately 50/50 with prime and zoom lenses. I love both, but for different reasons. At the same time, I'm aware that my photography style might be quite different to yours.

The best thing I can recommend is that you have a go at using both zoom and prime lenses, and see what works best for you. If you can afford it, I recommend that you buy a good zoom and a good prime for your camera body. If it turns out you never use one or the other, you can always sell it on.

Creative lenses

The great thing about interchangeable-lens camera bodies is that you can attach just about anything to the front of them. Whether the "anything" you attach actually is successful in making photos is a different matter altogether, but there's a lot of fun to be had with experimenting.

Tilt-shift

Tilt-shift lenses were originally developed to enable photographers to correct perspective challenges when taking photos of buildings (for example), but in recent years, a side-effect of tilt-shift lenses is what has made them famous.

By moving the lens up or down ("tilting") or from side-to-side ("shifting"), you can throw part of your image out of focus, keep focus in the middle, and keep the rest in focus as well. The effect is that it looks as if the scene is in miniature.

There are a series of tilt-shift adapters available on the market—a quick internet search of your camera and "tilt shift" will prod you into the right direction.

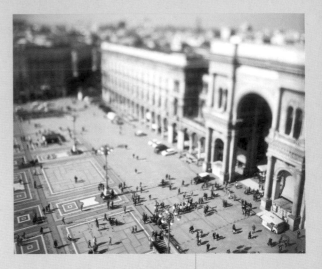

Tilt-shift lenses can create the illusion that the real world is miniature.

Pinhole

As far as photography goes, Pinhole photography is as basic as it gets. Technically, a pinhole isn't a lens—it's just a tiny little hole in a lens cap. You can make your own (see http://bit.ly/diy-pinhole for a guide), or you can purchase a ready-made pinhole body cap online.

Because the pinhole is in effect a miniscule aperture, you get a near-infinite depth of field. That means that everything in the frame is in focus! Of course, the quality of pinhole photos is limited (there is a reason why proper lenses cost money, after all), but a lot of photographers quite enjoy the dreamy look and the strong vignetting achieved by taking photos with a pinhole body cap.

There's something alien and low-tech-looking about pinhole photos. The heavy black border (called "vignetting") comes with the territory.

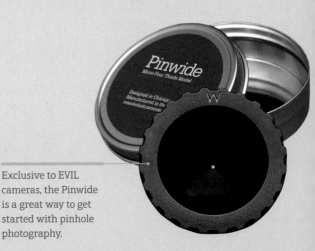

Exclusive to EVIL cameras, the Pinwide is a great way to get started with pinhole photography.

A photo of a half-burned matchstick, taken with a set of macro extension tubes.

Impressionism and Lensbaby lenses go hand in hand.

Macro extension tubes

If you're interested in having a go at a spot of macro photography, the cheapest way to get in close is to use extension tubes. These are metal extension tubes that go between your camera body and your lens.

By adding extra distance between your lens and the camera body, you change the way the lens focuses, which, in turn, means that you can get very close to your subject. All those beetles, sugar crystals and soap bubbles you've been itching to photograph will be within your reach!

Extension tubes are usually sold in sets of three, with three different thicknesses—if you want to get in closer, you can simply stack several extension tubes on top of each other.

Lensbaby lenses

The Lensbaby company (lensbaby.com) have a series of "alternative" lenses for people who don't take photography all that seriously. Opening the door to some serious creativity, the Lensbaby lenses are a great introduction to "bending" light to your own wishes.

Closely related to tilt-shift lenses, Lensbaby have many choices available to EVIL photographers—and they keep surprising with new products as well.

To me, my Lensbaby lens is the antidote to lack of inspiration. If I don't know what to shoot, I break out my lensbaby and find myself wading in new ideas within minutes. Your mileage may vary, of course, but if you have a bit of spare cash laying around, and an urge to be more experimental with your photography, you could do a lot worse than giving the Lensbaby website a closer look.

THE EVIL ADVANTAGE

EVIL cameras—due to their smaller imaging sensors—are very well suited to tilt-shift photography.

Going wide—The Pinwide, made by Wanderlust Cameras, is an EVIL camera exclusive. Because EVIL cameras don't have mirrors, Wanderlust were able to place the pinhole much closer to the sensor than usual—which creates a wide-angle pinhole. Awesome!

Lens adapters

One of the unexpected side effects of mirrorless cameras with small sensors, is that they are very adaptable to use lenses from other camera manufacturers—and even lenses that were never intended for photography. There are all sorts of adapters available, enabling you to use Canon, Nikon, Leica, Panasonic, Olympus and all manner of other exotic lenses on your EVIL camera.

From one lens mount to another

The awesome thing about the adaptability of the EVIL camera system is that if you have a collection of old lenses sitting in a cupboard somewhere (Perhaps your grandma or dad has a bag full of old photo equipment?), you can start using them again with your new digital equipment. All it takes is an adapter ring which enables you to connect the old lenses to your EVIL camera.

Sure, a lot of the lenses you can use won't have automatic focusing or even aperture controls, but that shouldn't stop you; there is a lot of creativity in old camera equipment, still—especially if you like the slightly low-fi look that some of the older lenses give to your photos.

C-mount

One of the highlights of adapters, in my opinion, is the availability of a C-mount adapter. This adapter means that you can use C-mount lenses on just about any EVIL camera.

This particular lens mount was used for a lot of different things, including 16mm movie cameras, microscopes, and security camera lenses. The great thing is that most of these cameras (and their lenses) have fallen into disuse. As such, you can often find great-quality C-mount lenses secondhand.

My favorite eBay purchase in the C-mount category was a 25mm f/1.4 lens (that's a super-bright prime!) including the C-mount adapter for my Olympus E-P1—all for under $40!

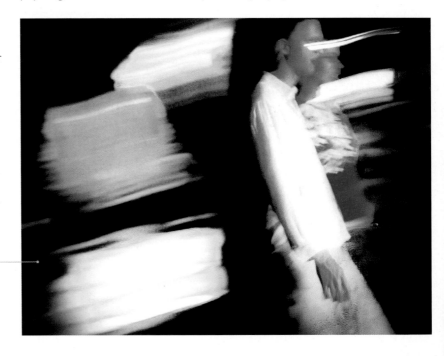

Hardly the height of quality, but the grungy, lo-fi photos I got with an 1960s Olympus lens on my EVIL camera are appealing in all their impressionistic glory.

Tripods

It used to be that few things were as important in photography as a good tripod. Since I travel a lot, I don't usually bother bringing one with me, but I do always throw my Joby Gorillapod in my bag just in case.

As the camera manufacturers keep building cameras that are better and better in low light situations, and with high ISO being more useful for every generation of new cameras that is released, the purchase of a Tripod is slowly becoming less important.

Nonetheless, as you start developing and experimenting with new techniques, there are times where you'll find you can't really make do without a tripod.

Choosing a tripod

There is a lot to choose from in the world of tripods, but the common denominator in the world of tripods is "stability." If your tripod can't hold your camera still, then you may as well not bother.

A lot of old-school photographers live by the notion that a heavy tripod is the only way to go. There is something to that, in that a good steel tripod is going to last the rest of your photographic life, and they aren't going to get blown over by the wind anytime soon. However, if your tripod is so heavy that you don't feel like carrying it with you, it's useless as well: Your tripod isn't going to help you take better photos if it's in the attic or in the boot of your car.

Some photo scenarios are nearly impossible without a good tripod. Taking long-exposure shots at night is one of these situations.

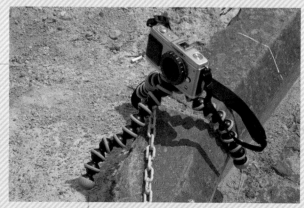

For traveling, a Gorillapod is a great alternative to a "proper" tripod. In this case, I was taking Pinwide photos with long shutter speeds, so I had to stabilize the camera properly.

Flashes

One of the next logical purchases is a flash for your camera system. What kind of flash you choose depends on what type of photographer you are—a small off-camera flash to help you light up the darkness is a very different beast from a full-on studio lighting kit. Again, this is why using a camera system is such a cool idea: You get full freedom to assemble the parts you need to take photos your own way.

Accessory flash

An on-camera flash is far more powerful than the flash built into your camera. That's great news if you need a little bit of extra light on your subjects, and there are lots of different types to choose from. Most camera manufacturers make their own range of flashes, but there are also many third-party manufacturers that make very capable flashes.

Describing each and every accessory flash available on the market is beyond the scope of this book. Of course, you'll need to buy a flash that is compatible with the camera system you're using, but if you're looking to buy an accessory flash, there are a few other things to look out for as well.

TTL metering—If the flash you are buying supports Through The Lens (TTL) metering, your camera and the flash will work together to ensure that the aperture, shutter speed and flash brightness all work together. It makes flash photography much easier to grasp, and less frustrating as well.

Remote trigger—Some more advanced flashes have the ability to act as "master" flash which can trigger other flashes. Others act as a "slave," but that's useful too, as you can use them with master flashes, and create elaborate lighting setups. Note that some cameras have flash remote control capabilities built in—check your camera manual to find out.

Guide number—The maximum light output of a flash unit is expressed as a guide number—the higher the guide number, the brighter the flash. It's always a good idea to buy more powerful flashes than you need, as flashes tend to cycle faster (i.e. shorter period between each flash) when they are operating on less than full capacity.

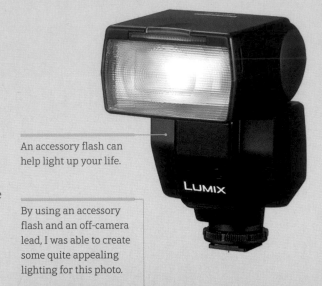

An accessory flash can help light up your life.

By using an accessory flash and an off-camera lead, I was able to create some quite appealing lighting for this photo.

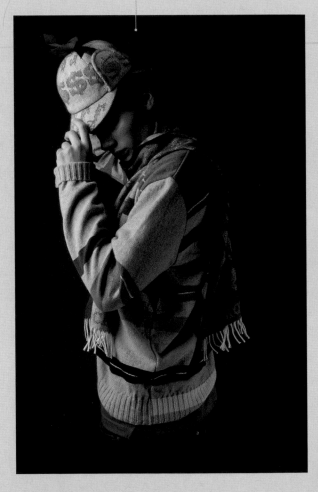

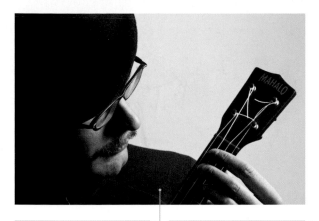

Using off-camera flash gives you the freedom to create the lighting setups you want.

Once you take the leap into full-on studio equipment, the sky is the limit, lighting-wise.

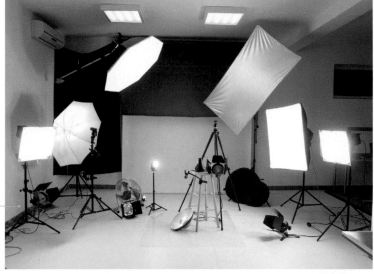

Off-camera solutions

As discussed in an earlier chapter, front lighting isn't very flattering. When you have a flash mounted on your camera, front lighting is the most obvious lighting pattern—but it doesn't have to be the only one. The trick to beautiful flash lighting is to move the flash away from your camera to create more elegant, dramatic, or natural lighting.

CROP FACTOR

There are several ways of triggering flashes that aren't connected to your camera. The most common ways are:

Wired—A lead runs from your camera to your flash. These leads typically come in 2–3m lengths at most.

Optical—Most remote-control flash systems use optical triggers. In an optical remote system, a coded infrared or visible light flash sends a signal to the other flashes, which then fire. It's an elegant and relatively cheap solution, but obviously you need line-of-sight to the flashes you are triggering, and the range is limited.

Radio—The last way to trigger external flashes is via a radio trigger. This is a little device that intercepts the optical signal from your flashes, and translates it into a radio signal to a receiver, which then triggers your flashes. These systems are sophisticated, can be quite expensive, but have the benefit of not requiring line of sight: If your radio signal can reach the other flashes, then the flashes will trigger.

Studio flashes

There are many great books out there covering studio equipment and techniques, but the important thing to know for now is that most studio equipment is compatible with most camera systems. I have done quite a few studio shoots with my EVIL camera system with great success. The smaller form factor and light-sensitive sensors means that most EVIL cameras are great studio companions.

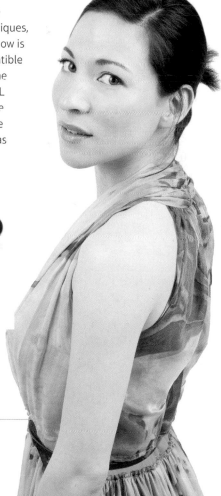

By using an off-camera cord, you can move your flash away from the camera.

Taken with an EVIL camera in the studio.

CASE STUDY Lo-fi Lomo

The lo-fi photography movement has been a long time coming. In a world where quality is going up all the time, a small (but growing) group of photographers are saying "I've had it with quality, let's go back to basics." A new generation of photographers are shunning digital photography, and turning to so-called "toy cameras": Equipment often of deeply inferior quality, but that create quirky, one-of-a-kind photographs.

If you're not quite ready to abandon your EVIL camera, then you'll be glad to know that the effects can be recreated with a combination of funky lenses and a bit of clever editing.

1 Get a Lensbaby or other tilt-shift lens. They make it easy to get one of the popular looks of lo-fi photography.

2 Take the photo in lo-fi style; don't worry about straight horizons or focusing perfectly. The key is to shoot from the hip and add a bit of spontaneity to your shots.

3 Open up your image in Lightroom.

This protester in Madrid was a perfect candidate for a spot of faux Lomo. (See Step 2).

4 Adjust the colors. Don't worry about getting the white balance right: As long as it looks funky, it's all good!

5 Add vignetting and additional grain to get an extra lo-fi look. Both these controls are under Effects in your Lightroom tool box.

6 (optional): Put on some sunglasses, and revel in being the coolest kid on the block.

By making the colors colder and upping the contrast a little, we have a good start to a Lomo-esque shot. (See Step 4).

A bit of digital Lomo magic, and you end up with a great shot! (See Step 5).

Better Pictures Through Better Composition

What makes a good photo? Few things confuse me more than someone asking me what camera I use. I understand the question, but I can't help but wonder why the answer would tell them anything about me as a photographer. After all—a painter is rarely asked about what brand of brushes she uses, nor do people care much about which word processor a famous thriller-writer uses.

A great photograph needs two things: It needs a creative vision, backed up by a solid set of technical skills. A photo that has one of these two things nailed can be good—but it won't be great.

Technically, there's nothing wrong with this photo. Creatively? Well, let's just say that if it wasn't to make a point, I wouldn't have used it in this book.

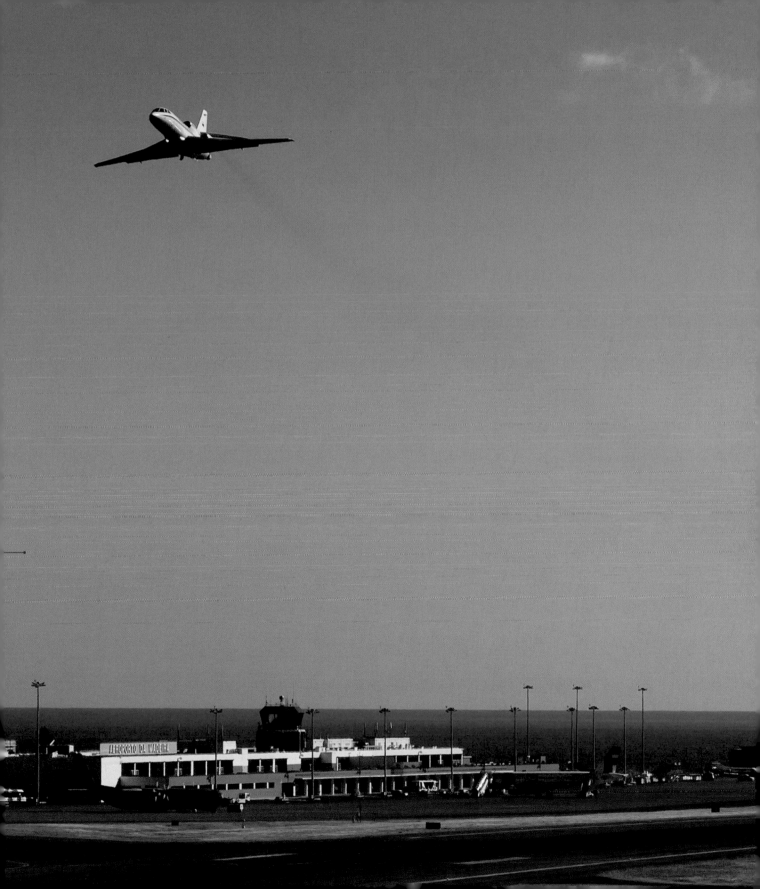

Becoming a better technical photographer

The technical side of photography has a myriad elements to it, and a good photographer has to juggle all of them to create the perfect photograph. Getting a photograph is an equation of lighting, shutter speed, aperture, ISO, focal length, depth of field, focus, blurring (or the absence thereof), and a whole boatload of other variables. As a photographer, you are akin to a scientist using a sophisticated optical instrument, measuring the world around you, one fraction of a second at a time.

Photographers who are just starting out tend to have the biggest problems with the technical side of photography: Over- or underexposure are the arch-enemies of many a fledgling snapper. The challenges of avoiding focus blur, camera blur, and subject motion blur—we've all been there.

Over time people learn their tools and what can be done with them. They'll pick up rules, tips and tricks that help them compose well-exposed, correctly white-balanced images that are tack-sharp, well lit, and generally attractive, realistic, and accurate depictions of the world.

While being able to take technically perfect photos is a surprisingly rare skill, a technically proficient photographer is still merely a technician. Granted, there are places where photographic technicians have a place (archeology and crime scene work, to pick a couple of examples), but in most cases, merely getting a photo in focus and correctly exposed is not enough.

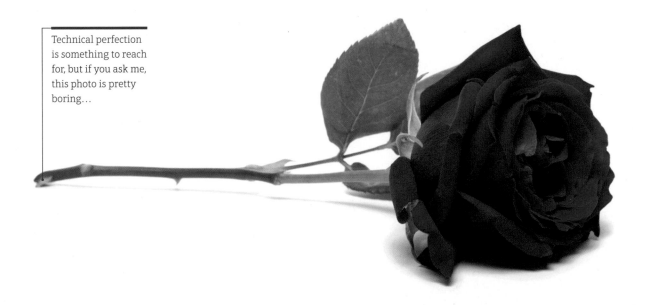

Technical perfection is something to reach for, but if you ask me, this photo is pretty boring…

Improving technically

At first, it can be quite hard to become a better photographer technically—where do you start? Well, the trick is to improve your photography one little bit at the time, by identifying which part of your photographic output needs the most help, from a technical point of view.

Good places to start:

Focusing—Autofocus is extremely good most of the time, but there is a bit of technique needed to be able to use the autofocus to its best potential. If you notice your shots are slightly (or completely) out of focus, paying extra attention to focus for a few days of shooting can help hugely. Zoom in all the way on every photo you take, and see whether your main subjects are in focus. If they aren't, try again. You could even consider using a slightly smaller aperture to increase your depth of field—that way you increase the odds of your focusing being spot on.

Exposure—If your photos are coming out under- or over-exposed, you can either start paying more attention to your metering, or try autoexposure bracketing. Bracketing means that your camera takes three photos in quick succession—one slightly over, one slightly under, and one right where the camera thinks it should place its exposure. When you're looking at your photos on your computer later, you should be able to spot a pattern, whether most of your photos are slightly under- or over-exposed. Perhaps all you need to fix it is to change the EV compensation setting on your camera? Check your camera manual to find out how to use Auto Exposure Bracketing and EV compensation.

Blur—I'm discussing the various types of blur later on in this chapter, but before you get there, have a quick think—do your images suffer from any kind of blur?

Perfect lighting, gorgeous model, nice smile… But I didn't notice until I started processing the image that it was out of focus. Infuriating, but it happens to us all from time to time.

Becoming a better creative photographer

You've probably been at a party where someone is telling a story and it seems as if everybody is clinging onto the storyteller's every word. The onlookers are practically cheering the narrator on to continue with the incredible tale. I'm willing to bet that this particular raconteur could make any mundane, trivial topic come to life. That's what a good photographer can do, too.

If the technical side of photography is the "how," then the creative side is the "why." A great photograph isn't the absence of blur or the perfect exposure: It is telling a visual story, and telling it in such a way that the viewer can't tear themselves away.

Whereas the technical discipline of photography has shutter speeds and ISO choices in its war chest, the creative camp has an impressive array of weapons tucked away, too.

The crop of an image, angle, choice of colors, taking the photo at the decisive moment, being in the right place at the right time, patience, persistence, and the ability to pre-visualize are all aspects of capturing the perfect creative shot.

When I am teaching, I am secretly more excited about students who come brimming with ideas but no photography skills, than the ones who know a lot about photography but haven't had an original thought in their skulls: The challenge with the creative perspective of the photographic quandary is that creativity is bone-cursingly difficult to teach. Which is a shame, because while most photographers eventually become proficient with their equipment, only a few go on to use those technical skills with amazing outcome—and all of that is down to creativity.

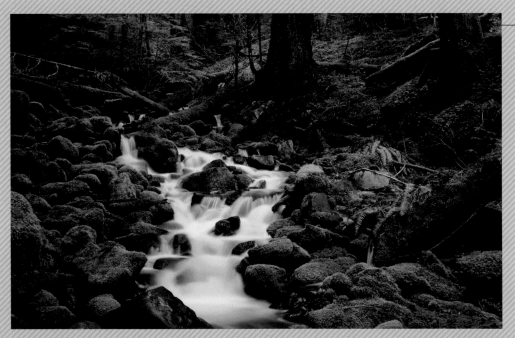

To be able to take photos of "flowing" motion, you need to be able to use reasonably long shutter speeds. This was taken at 5 seconds.

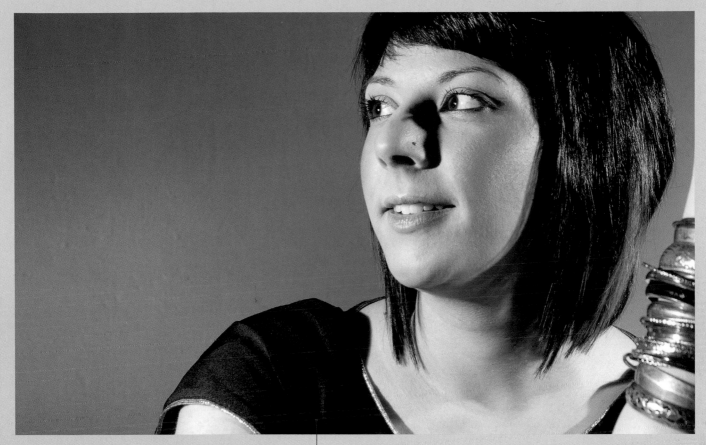

Learning creativity

Picasso, it is said, once drew a sketch on a piece of paper for someone, and then charged them a lot of money for it. "Hey, that only took you ten minutes," the potential buyer reportedly said. "No, that drawing took me thirty years," was the retort. If we assume for a moment that this anecdote is true, I'm completely with Picasso on this one: A photo can take less than a thousandth of a second to make, but nobody learns photography in a day.

To improve your photography, the key is to know where your weaknesses lie. Easier said than done, but I found that adding an extra step to my photographic workflow has been of immense value: For every photo (even if I'm about to bin it for any reason), I make a mental note of two things: A technical, and a creative thing I could do to improve that particular photograph. If, at the end of the photo editing session, it turns out I have made a lot of mental notes about focus, then perhaps the time is ripe to pencil in a practice

I'm very happy with this photo—but that doesn't mean I'm not able to find things that I wish were even better.

session. If I seem to forget to leverage the angles of my photography to the best effect, then, guess what, perhaps that's what needs to be worked on.

The great thing about self-evaluation is that this technique works well to improve both your creative process and the technical side of your photography at the same time. For every shot you're looking at, the question is simple: What could I have done to make this better? Especially for the photos you are most happy with, the answers are going to be valuable additions to your mental checklist the next time you're out and about with your photography kit. Baby step by baby step, you'll get closer to that ever-elusive perfect photo.

Using unusual angles and varying your viewpoint

Too many photos are taken at eye-level. Not that hard to understand, perhaps—we see with our eyes, and so we have a tendency to hold our cameras at that height, too. One of the lovely things about a camera, though, is that you don't have to hold it at eye height: Climb on top of something and get a bird's eye view, or hold it just above the ground for a much more dramatic view.

Bird's eye view

If you look around you in the urban landscape, you'll notice there's no shortage of things you can climb on to get higher up. Get creative with stairways, lamp posts, and trash bins to get a slightly different perspective on things.

There are many reasons to get up high when taking photos. People, for example, tend to look better when seen from above, as immortalized in the so-called "MySpace shot." The technique really works, so consider climbing up for some extra-flattering shots.

THE EVIL ADVANTAGE

Because you're not locked into the optical viewfinder, using an EVIL camera makes using wonky angles much, much easier.

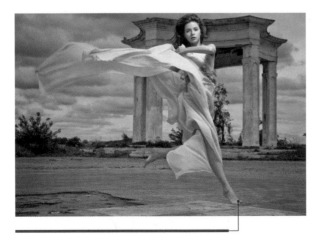

By getting down low, the impact of this photo gets better: It looks as if the model is jumping higher, and the perspective helps frame her with the building in the background.

By attaching my camera to a monopod, using a 2-second self-timer, and holding the monopod above my head, I was able to get a great overview shot of this street parade in Oslo.

THE MySpace SHOT

The fact that you look slimmer and saucier when photographed from above appears to have been noticed especially by the people of MySpace, where taking a self-portrait from above became all the rage. It became so ubiquitous, in fact, that the self-portrait-from-above is still known as a "MySpace Shot" in the photography world.

Frog's eye view

Getting down low in photography is traditionally known as having a frog's perspective. Taking photos from here, then, is known as a frog's eye view of the world. It's a tried and tested composition method, but it can work very well for many different subjects.

Anyone who has ever seen *Reservoir Dogs* knows the power of taking photos (or filming) from a low angle—it makes people look really quite unnecessarily awesome. Combine the technique with some contrasty black and white, and you're half way to *film noir* already.

By getting down low, you can create a dramatic contrast in your images.

Shots taken from a low angle aren't just for people photos—it can be used in all sorts of situations. Experiment away.

Eliminating blur from your photos

Ending up with blurred photos can be extremely frustrating, and without understanding the causes of blur, it can truly stunt your photo opportunities. Fortunately, once you understand and can identify what is causing blur in your photos, you can start doing something about it.

Focus blur: Learn how to focus!

It is generally easy to identify this cause of blur, as you will notice that other areas of the picture (such as the background or foreground) are in sharp focus, while the subject of your photo is blurry. The problem is caused when the camera chooses to focus on an object in the picture that is not your chosen subject.

To remedy this issue, simply ensure that your subject is focused. Sometimes, if your subject is at the side of your shot your camera will want to focus in the middle—so simply put your subject in the middle of the shot, focus (by depressing the shutter button half way, and holding it half pressed) and then re-frame your image by aiming your camera so your subject is where you want them to be.

Subject movement: Tell them to stand still!

When your subject moves while you are taking a picture you will often end up with blur. In most cases you can remedy this by increasing your shutter speed, as a faster speed will leave less time for movement.

However, in low light situations you may need all the light you can get, and a longer shutter speed is part of your camera's light-gathering arsenal. In order to fix blur caused by movement you will have to increase your shutter speed, and perhaps adjust your ISO and/or aperture to compensate for the reduction of light reaching the sensor.

Great example of subject movement: The photographer in the middle is motionless, but since I was using a slow shutter speed, the people walking past are a blur.

I will be forever gutted that I failed to focus properly in this shot.

Camera shake: Get a tripod!

There are a few solutions to camera shake. The quickest solution is to increase shutter speed, as it is less likely that the camera will move during the shot. You can also work on holding the camera steady by holding it with both hands and bringing your elbows into your body.

Using a tripod will eliminate camera shake in most instances as well. Finally, when you are upgrading your camera lenses look for lenses that offer vibration reduction or image-stabilization options, which will help compensate for camera shake. Note that the closer your subject is, or the longer the focal length of your lens, the more potential there is for camera shake.

Too-shallow depth of field: Use a smaller aperture!

Using depth of field is a great way to put emphasis on particular objects in your shot by blurring the background. This is a popular technique for portraits, but is handy for other types of pictures as well. However, when the depth of field is too shallow you may not be able to keep your subjects in focus, particularly if you are shooting a landscape or other shot where you want everything to be in focus.

In order to improve depth of field you need to manually adjust the aperture setting on your camera. A larger aperture (lower number) lets more light into the lens and decreases depth of field, so it is preferred when you want to focus on a single subject in your shot and have the rest of the scene out of focus. A smaller aperture (higher number) will increase depth of field so you can have more of your shot in focus.

CAMERA SHAKE RULE OF THUMB

To avoid camera shake, the rule of thumb is that you can shoot without a tripod with shutter speeds equal to the inverse of the focal length of your lens. Don't worry, it's easier than it sounds. If you are shooting with a 100mm lens, you can safely shoot hand-held up to 1/100th of a second. For a 35mm lens, that would be 1/35th of a second, and for a 400mm lens; 1/400th of a second. For longer shutter speeds, use a tripod!

Silly me; I was trying to hand-hold my camera with a 6-second shutter opening. That was never going to work out well.

The Rule of Thirds

A lot of study has gone into what makes something pleasant to look at. Needless to say, marketing and advertising gurus have spent most of their time and money on this research. The funny thing is that they found out something that has been known among the art community for hundreds of years. The phrase "Rule of Thirds" was coined as early as in 1783, but artists had been implementing this "rule" in practice long before then.

We discussed the Rule of Thirds briefly in Chapter 2, but let's go ahead and take a closer look here, because it really is a fantastic way to improve your photographic composition in a single, easy-to-remember rule.

The Rule of Thirds itself is easy to understand: create a set of imaginary lines that divide the screen into nine equal-sized pieces, and place important bits of your photo along those lines.

Use the negative space

The problem people tend to run into when it comes to the Rule of Thirds isn't the lines itself. That bit is easy. The challenge is what you do with the rest of the space; surely you can't just leave it empty?

Whether you are working with web design, typesetting, painting, or photography, the use of the area not covered by your main subject is actually rather important. The concept is known as "negative space." What you fill your negative space with adds a lot of "feeling" to the photo, even if you never really intend the audience to study it in detail.

The key point with negative space is to make it inevitable that your viewer's eyes drift to the place you want them to focus on, either by ensuring that your main subject is the only sharply focused part of the image, or by taking the photo in such a way that there simply isn't anything else to look at.

This photo shows the Rule of Thirds perfectly. Her eye and the corner of her mouth fall on the corner intersections of the Rule of Thirds—and the back of her head (where the light falls off) is another third.

This photo shows the Rule of Thirds—and adds a lovely expanse of negative space to force the viewer to look at the cockerel.

The vast expanse of black "negative space" in this photograph is what gives it impact.

Exercise

Leverage what you know about shooting with a limited depth of field, negative space, and the Rule of Thirds to create a powerful portrait of a friend.

Leading lines

If you think you have a mind of your own when you're looking at a photograph, you're sadly mistaken. Humans are remarkably predictable in how they scan a photograph, and how they perceive information. Take a look at the photo on this page, for example. In workshops I've run in the past, I have flashed the photo up on the screen for five seconds, and then turned the screen off, asking the workshop participants a simple question: "How many people were in that photo?"

You'd be amazed how many workshops I've done where everybody agreed that there was nobody in the photo at all—even though you've probably already cheated and taken a second look. Yup, there's definitely a hitchhiker there! The reason this happens is that people tend to follow the road with their eyes, and then follow the next natural line in the picture—the row of clouds taking your eyes from the little house at the top of the hill to the top right of the photo. When your eyes make it to the top right, they have "run out" of picture, and suddenly you'll lose interest in the photo.

The problem with this photo is also a great illustration of how powerful leading lines are: Unless the lines in an image cause your eyes to stick somewhere, we are less inclined to look at the photo for very long. To use leading lines to their full effect, then, you have to ensure that they help your audience find what you want them to look at.

An exercise in leading lines

Take a look at this photo, and pay attention to how your eyes move around the photograph.

Even though this is a very "busy" photo with a lot of detail in the background, your eyes naturally find the main subject. This is because both the horizon and the brick wall lead naturally to the model's face.

Symmetry and repetition

Somewhere deep inside our brains, we are calmed by the presence of order and simplicity. There's something safe and nicely balanced about an image that has symmetrical or repeated elements in it.

Armed with the knowledge that we are pre-programmed to find patterns, repetition, and symmetry, you can implement this into your photography.

Patterns are everywhere; you just have to be on the lookout for them. Whether it's a picket fence running along a road, a row of lamp posts, the bricks in a wall or a dense forest, all the patterns we surround ourselves with can be leveraged into photographic effects.

Perhaps you can get too literal with the concept of symmetry, but the visual effect in this photo is so striking that the viewer is likely to do a double-take.

The relatively repetitive white brick pattern interrupted by the metal door gives a minimalist impression, but there is a very obvious focus.

Something about symmetry and repeated subjects in a photo makes us automatically start comparing and playing "spot the difference."

In a sea of colored crayons, it isn't hard to guess which one you'll be looking at.

A feeling of depth in photography

There are a few 3D cameras out there, but that's not the kind of "depth" we're talking about in this case. Photography is generally a two-dimensional medium, but that shouldn't stop you from thinking about depth in your images.

Photos that create a feeling of three-dimensionality tend to feel more alive and dynamic than photos that are "flatter."

Foreground and background contrast

The first trick you can use to create depth in your photos is to use a separate foreground and background. By placing something behind your main subject, a contrast becomes noticeable, between the things that are close to the photographer, and things that are in the background. The simple fact that you can identify things at two (or more) different distances gives the image extra impact.

The top tip here is that you don't even need to have your foreground subject as the main focal point of the photo. As long as there is something there, the background will come alive. This can be nearly anything; a tree branch overhanging a valley, a bird flying, or a person included in the photo can tell part of the story and add context to your images.

Without a foreground reference, this photo looks quite "flat."

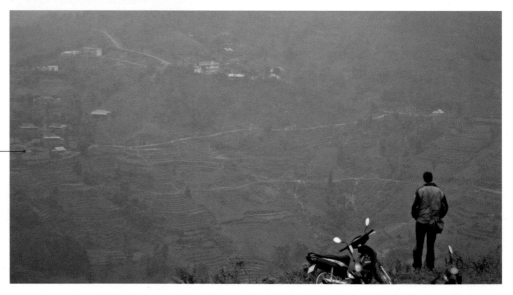

This sweeping vista wouldn't be much of a picture without the motorcyclist in the foreground. By including a person, this photo gets a sense of depth and scale.

Using depth of field to create a sense of depth

You can take the foreground/background tip a step further by introducing depth of field to the mix. As we talked about in an earlier chapter, you can get a shallower depth of field by placing your subject close to you and using a relatively large aperture setting on your camera. Doing this causes the background to drop out of focus.

By having only the foreground in focus, your viewers' eyes will magically glide across the photo, finally "sticking" to the part of the photo that is crisp and sharp. The background is still there, adding color and context, but because it isn't in focus, it won't distract the viewers from what you're really trying to show them.

You can use the very same trick in reverse, too, of course: By using a large aperture and focusing on the background, you achieve a very similar effect.

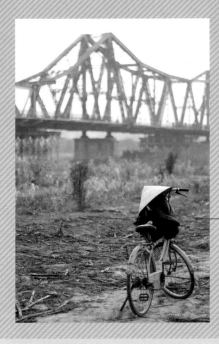

A limited depth of field helps guide the viewers eye to the bicycle, and adds a feeling of depth, too.

Lighting to create depth

If you've done any work in a photo studio, this one comes as no surprise to you. Lighting setups can often be described as "flat" if there's not much depth in the image. This is why you'd often use a three-light setup to help create an elaborate illusion of depth in studio photos.

Even if you're not taking photos in a studio, it's not the worst idea in the world to keep lighting in mind when you are taking photos. Remember, light directly from the front (such as photos taken with an on-camera flash) tends to look pretty drab and dreadful. Try to light from above or the side, as that makes an incredible difference to how the light and shadows spill across your subject's face, and that's where your depth is going to come from.

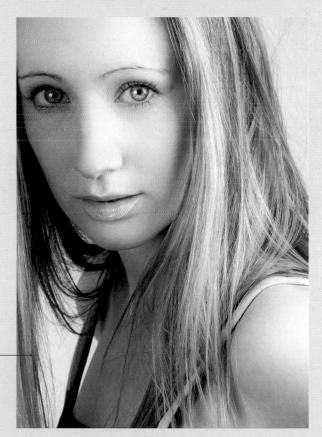

Not a bad photo, but the flat lighting means that it looks more like a passport photo than a portrait.

Same model, same shoot, same day—but a small change in lighting makes a huge difference, much improving the look.

Exercise

On your next walk through your neighborhood, look for opportunities to use framing in your photos. Is there an alleyway, a gap in a children's playground, or a cluster of trees you can use to highlight something?

Framing your images

Leading lines can be a relatively subtle way of leading your viewer's eyes around a photograph. If you prefer a more in-your-face approach—the Las Vegas neon way of attracting attention, as it were—you can introduce another photographic trick.

Framing your images is a sure-fire compositional technique that can add interest to a picture and draw your viewers into the image. The great thing is that there isn't any particular rule that says how or when you can use framing—or how obvious your framing is. You can be as subtle or as bold as you want.

A great side-effect of starting to look for framing opportunities is that it trains your mind to look deeper into your photos. You're sorting through "near," "medium," and "far" from a perspective and compositional point of view, and once you're used to that way of thinking, even if you never take a single

"framed" photo, you're well on your way to developing your method of evaluating scenes before you pull your camera out of your photo bag.

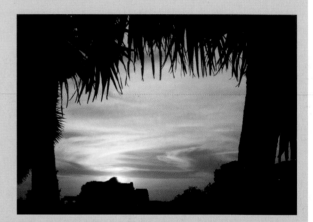

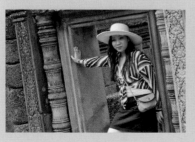

Breaking the rules

This chapter—and much of the rest of the book—is very rules driven, but I cannot emphasize enough that the rules are there to be broken. The key is to do it in a way that makes it obvious that you're breaking a particular "rule" of photography to achieve an effect, mood, or emotion.

Learn 'em, then break 'em

The reason photography has so many rules is due to the way the human brain processes images. The rules leverage the psychological responses we have when we look at photographs to full effect. It can be seen as a little bit lazy, following the rules as if we're enslaved by them, but ultimately if you're just starting to find your feet as a photographer, you need to use all the tips and tricks you have available to you to make the best possible photos in as short a period of time possible.

Unfortunately, "learning the rules" means that you end up taking the same photos as everybody else for a while. Nonetheless, there is sound reasoning behind learning the rules. It gives you a solid grounding as a photographer, and it will help develop your inner eye faster.

Nobody should ever tell you to "never" do anything. Over- or underexpose to your heart's content, play around with how you focus. And all that stuff about blur in photos being evil? Ignore it and experiment away. The most important thing about photography, after all, is creating compelling images, and if you are able to do that by breaking a couple of rules here or there—all the better!

My subject's eyes are not in focus (gasp). It's way too dark (tut-tut). And yet, it's a strong photo with a story to tell. You'll notice that it does adhere to some of the "rules": It does keep a Rules-of-Thirds-style composition, and it does use dramatic lighting and a limited depth of field to give the illusion of depth.

No Rule of Thirds, no leading lines, no nothing. The strongly centered design still helps you focus on the subject, however.

CHAPTER 7

Perfect Pictures of Perfect Scenes

More than anything else, my readers e-mail me to ask me how I took a particular photo of a particular scene. I completely understand that approach to photography, to be honest with you: It's much more fun to learn new techniques while you're experimenting with mastering a particular shot, than it is to read pages and pages about apertures, shutter speeds, and other dry theory.

In this chapter, I've collected many cool photos—along with explanations for how you can take similar shots. More importantly, I'll be talking you through the theory behind each shot. Sneakily, and without noticing— possibly even against your will—you'll learn more about photography and develop into a better photographer.

Of course, all the examples and settings shown in this chapter are merely suggestions—if you think you have a novel idea about photographing a particular scene, then there's no better idea in the world than getting your hands dirty and giving it a try.

Capturing this seascape during the golden hour has added a degree of magic to what might otherwise be a fairly flat and straightforward shot of the sea.

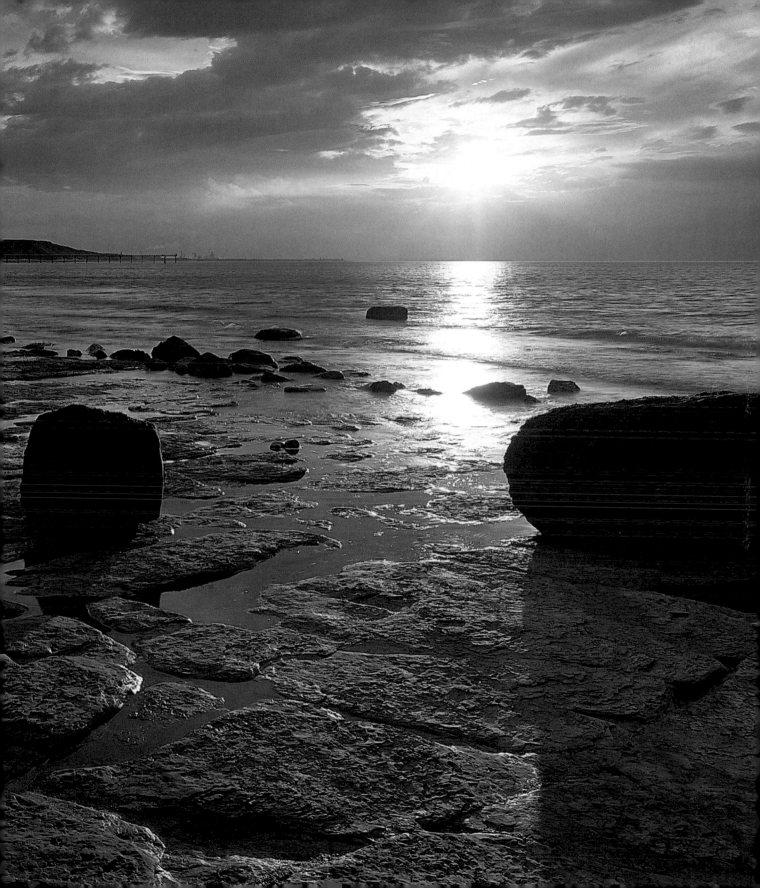

Lens	WIDE	TELEPHOTO
Aperture	SMALL	LARGE
Shutter Speed	SLOW	FAST
ISO	LOW	HIGH

Sneaky portraits/street photography

Street photography is an age-old discipline of photography. It is closely related both to architecture and portraiture, in a way. When you are out taking street photos, you're showing the inter-connectedness between people and places in a way that is quite unique.

In street photography, you're quite similar to a wildlife photographer. Instead of lions, elephants, and monkeys you have jugglers, lovers, and businessmen. Instead of a jungle, an ocean or a savannah, you have stairways, alleyways, and open spaces.

When photographing people in their natural environment—towns and cities—something beautiful happens: You draw a better photo of people and of the setting you're photographing them in than you could have done separately.

Lens choice and camera settings

There are a lot of different situations where you might give street photography a shot, and it's difficult to give advice that works for every possible situation. However, one thing that's for sure is that people rarely stand still to be photographed. To freeze them in time, you'll need to use a reasonably fast shutter speed.

Once you've decided you need a fast shutter speed (I find 1/250 second works well as a starting point), all your other choices are made for you. A lens with a large maximum aperture is useful, a high ISO is necessary, and your aperture will be whatever it has to be.

Street photography is one of the few times where I use Shutter Priority mode on my camera—shutter speed is the only thing that's important to me when I'm out there.

If you have a lot of light, you can also consider using Aperture priority—choose a nice, large aperture, and see how your photos come out. Using a large aperture has two benefits: The messy city background is blurred so your photos look better, and the extra light you get helps reduce the shutter speed that's required.

Street markets are particularly well suited to street photography—there are a lot of people, and they are all interacting with each other.

In this shot, I pretended to take a photo of the fountain behind the girl. She was talking animatedly to her friends—but I like how it looks as if she is wolf-whistling at someone.

TOP TIPS: STREET PHOTOGRAPHY

Some people aren't comfortable with being out and about taking photos. Here's a collection of tips to get you started.

Find a good background. Aim your camera at a good background, focus on the people who walk by, and simply press the shutter when you see a person who looks interesting.

Seek out street performers. If you're too nervous to take photos of random strangers, start out with street performers. They are there to show off, so they won't mind having their picture taken—as long as you drop something into their hat.

Use a tele lens. If you use a tele lens, you don't have to get close to get the photos you want—you can take your shots from a safe distance.

Remember your safety

Some people react strangely to being photographed. In most countries, if you are in a public place, you are fully within your rights to take photos. Having said that, if someone seems annoyed or is behaving erratically, it's often better to just shy away rather than start a lengthy discourse about privacy-versus-freedom-of-information-gathering laws on the street.

If you're out and about with your camera, remember that you're a natural target for certain criminals, too: They can see you have an expensive piece of equipment in your hands, and you're paying attention to your subject rather than your surroundings. If you're going to particularly grimy parts of town, consider bringing a friend with you. They don't have to bring guns to protect you—but two pairs of eyes are always better than one.

THE EVIL ADVANTAGE

Because most EVIL cameras look so innocent, they are absolutely perfect for street photography—the people you're photographing will think you're a hapless tourist rather than a serious photographer. Excellent stuff!

Top tip

Before you run out and take photos on the street, it's a good idea to know what your rights are (and what the law is) where you're taking photos. A quick Google search with "Photographer rights" and your country should give you all the info you need.

Traveling gives some great street photography opportunities, too. I find that my street photos say more about the country in which they were taken than all my typical tourist snaps.

You can capture some truly intimate moments on the street.

CASE STUDY Candid scenes

In the world of photography, "candid" covers a lot of ground. I've taken enough street and candid photos to fill hard drives, and it was extremely hard to pick a photo to represent the whole genre—but I think this photo is a fantastic example of a shot where everything came together.

"Locking up the shop" is a great example of a split-second opportunity.

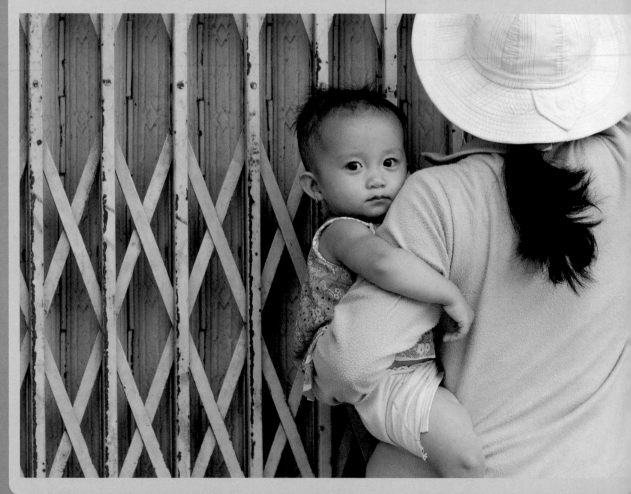

About the photo

This image was taken near Can Tho, in the Mekong Delta in Vietnam. I spent five days on a motorbike, exploring off the beaten track, guided only by an iPhone, Google Maps, and a compass. It turns out that Google maps had terrible coverage of the area, so most of the time, I was driving on huge swathes of "green," even though I was clearly on a road of sorts.

A lot of the street photography I did on that trip was rather moving: Since it was just me on a motorbike, people came out of their houses to wave, and I was frequently offered food and drink just for being there. The theme of the trip was to become the kids, who would run up to the side of the road, waving and shouting "Hello! Hello!"—the only word they knew in English.

Capturing such a trip is hard—but the candid shots were the ones that did it best; people simply getting on with their everyday lives.

How was it taken?

This photo was taken from the motorbike. I saw the child turning around to look at me as her mother was locking up the family shop, and I saw an opportunity: Bringing the bike to a stop, I simply lifted the camera, let the autofocus do its thing, and shot the picture. The mother heard me take the photo and turned around. She was perfectly happy for me to take photos (she did, in fact, encourage me to take more, and loved seeing the photos of her little girl on the LCD display on the back of my camera)—but the moment I had wanted to capture was gone.

It was with some trepidation, then, that I checked my photos later on—and I do admit to doing a little jig of happiness when I saw this shot.

After the "winning" shot, the mother wanted me to take some more photos of her little girl— with shouts of delight when she saw the photo on the LCD screen of my camera.

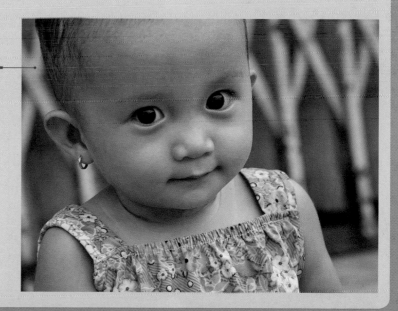

Getting great photos of your pets

Big or small, young or old, four-legged or…other, we all love our furry (and not so furry) friends, so it's no wonder that we are all concerned with getting some great pet photos so they can live on in our memories long after they are gone.

No matter how cool and collected your pet is, they may not respond well to the bursts of light coming from your camera, so natural lighting is a good choice for most pet photography. Preferably take your pet outside for pictures, or at the very least set up your shoot in a room with a large window and lots of light. If you are shooting outside consider waiting for an overcast day, as direct sunlight will cause too many shadows.

The one exception to this rule is if you have an animal with a dark coat, which will need bright sunlight or flash to help bring out all the blues, browns, and blacks in their coat.

TOP TIPS: PET PHOTOGRAPHY

Patience. While you may get your dog to sit/stay for a few minutes, it's likely you will not have the same luck with your cat (hamster, snake, etc.). You will have to be patient if you want a good pet photo, and you will also need to get down on their level for the best shot.

Focus on the eyes. Your pet's eyes communicate a lot about them, and can be soulful, playful, or downright devious. When taking photographs of your pet, have your camera focus in on the eyes first.

Movement. Pretty much anyone can take a decent pet photo given the right equipment, but the truly remarkable pet photos are the ones that not only show off how lovely your pet is, they also give insight into what they are really like. Running, playing, sleeping, or getting-into-trouble shots all show off a part of your pet's character that few get to see.

Get in close. Pets have a wonderful amount of color and texture, as well as their beautiful eyes that you can capture using a good macro lens. However, if you are trying to get some "natural behavior" shots of your pet you may want to stand back and use a good zoom. "That's right, Rocky, just ignore me in the living room, playing with my camera, and continue eating my favorite pair of slippers."

Get the eyes sharply in focus to "connect" better with your animals.

Black animals need a little bit of lighting magic to make their coat stand out well.

Camera settings and lens choice

Unless they are sleeping, you will need a relatively quick shutter speed to capture a crisp shot of your pet. Combining this with a wider aperture can give you sharp pet photos with a nicely blurred background, to enhance the importance of your furry pal. Also try using continuous shooting mode (where you hold the shutter button down and the camera takes a burst of shots) to get some great action scenes.

Animals with darker fur, skin, or scales may be more difficult to capture in photo, particularly on a bright day. Play with your exposure levels and see if you can help bring out more of your pet's natural tones. It also may be a good idea to ensure that you have a contrasting background so they stand out more.

Pets are very much like children, and usually pay very little attention to what you want them to do. In order to get a particular shot you are going to have to be very patient. If you are getting frustrated consider putting the camera down and trying another day, or recruit someone to help you get the right behavior by showing a toy, treat, or calling the animal when you are set up and ready.

THE EVIL ADVANTAGE

Some pets don't mind you taking photos, while others can be really skittish. EVIL cameras tend to be quieter than most SLR models—which helps avoid scaring your favorite critters!

Good framing, good exposure—and a great little action shot of a hamster playing. Who says animals don't have personalities?!

For animal portraits, closer is better.

Lens	WIDE	TELEPHOTO
Aperture	SMALL	LARGE
Shutter Speed	SLOW	FAST
ISO	LOW	HIGH

Landscape photography

I wouldn't be at all surprised to find out that landscape photography is the second most popular photographic genre, after portraiture. Like painters from the Romantic period, both seasoned professionals and amateur photographers turn to the wilds of mother nature for inspiration and expression.

Taking landscape photos can be rewarding, relaxing, and (if nothing else) is an excellent excuse to go for a long walk every now and again. Apart from getting a bit of fresh air, it's also a great way of learning to know your new photographic equipment: The trees won't run away from you, the horizon won't get offended you're taking its photo, and the mountains are happy to hold very, very still for however long you need to get all your camera equipment and settings in the right order.

Beautifully framed and simple in color, this photo is a magnificent example of how rich a story can be told in a simple landscape.

TOP TIPS: LANDSCAPE PHOTOGRAPHY

Straighten that horizon. If you're going to include a horizon in your image it is important that it is either straight, or at a significant angle. A slight angle makes your photo look shoddy!

Balance your foreground and background. All photos are very different, so it is hard to say whether you should have the fore- or background as your main focus. As long as it looks right, you're onto a winner. Try compositions with a majority of foreground and background to get a feel for what works best.

Use the Rule of Thirds.

Use a small aperture. By using a smaller aperture you get a greater depth of filed. Perfect for ensuring that both the foreground and background in your images are in perfect focus.

Use a tripod. A side effect of having to use a small depth of field and a slow ISO is that your camera will need to use a slow shutter speed as well. By using a solid tripod you can ensure that camera shake doesn't disturb your final photograph.

Use leading lines to "lead" the viewer's eye.

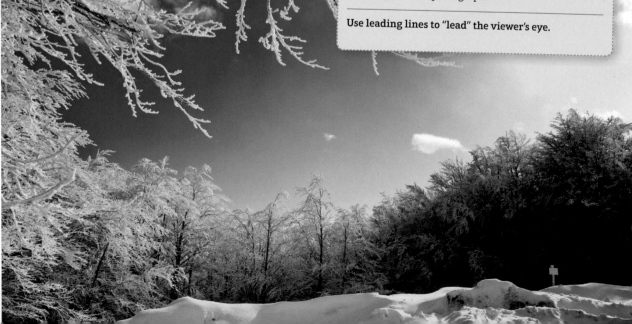

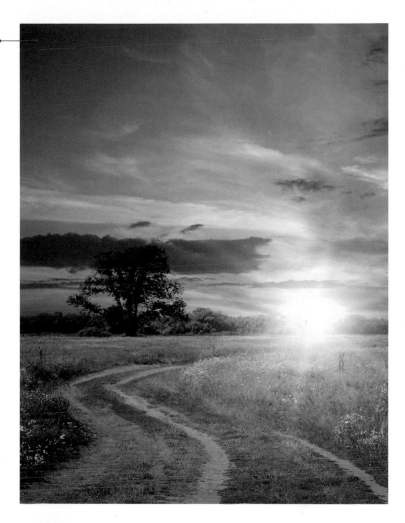

Strong leading lines and a beautiful golden glow make this an appealing landscape shot with much impact.

Technically, landscape photography is probably one of the easiest disciplines: Bring a tripod with you, use a wide lens and a small aperture, and you can't really go wrong.

One thing worth keeping in mind, however, is to use a low ISO. In landscape photography, you have the luxury of time—use it to take the photos you have dreamt of. The real challenge, then, isn't the technical side of the photos—it's the creative side. It's easy to get a tree in focus, but how will you be able to illustrate the awesomeness of the forest you are standing in is a different matter altogether.

Like anything else in photography, you have to think about telling a story. If anybody is going to give your photo a second glance, there has to be something that can be experienced; it has to resonate with the viewer.

How you speak to someone differs from person to person, so the best place to start is to attempt to tell a story that resonates warmly with you. The lessons learned in the Composition chapter are more important in landscape than in any other genre of photography as they, more than anything else, are the weapons in your storytelling armory.

Exercise

Find a good viewpoint over a valley, and try to take a photo which incorporates a fore- and background to create an appealing composition.

Top tip

To avoid camera shake, place your camera on a firm surface. A tripod works well. To prevent your camera from vibrating because you're pressing the shutter-release button, use a remote control or the 10-second self timer. Perfect photos without camera shake every time!

Ensure you have some interesting elements both in the fore- and background of your shots.

Lens	WIDE ——————— TELEPHOTO
Aperture	SMALL ——————— LARGE
Shutter Speed	SLOW ——————— FAST
ISO	LOW ——————— HIGH

Architecture and cityscapes

There are so many fantastic buildings, some new, some hundreds (or even thousands) of years old, and so many beautiful cities that it's hard to resist the urge to capture them all. Or, at least some of them.

By learning the best ways to photograph buildings, cityscapes, and architectural subjects you can ensure that you end up with the "best" shots that will truly represent how you feel about each subject. With that in mind, here are some tips to get you started.

Top tip

If there's a horizon in your photo, make sure it is straight—nothing makes a photo look weirder than a slightly crooked skyline.

Lens choice

All photographers have different lens preferences, and the same goes for architectural photography. A wide-angle lens is great for shots where you want to fit in the whole subject (such as a skyscraper), or for photographing skylines. Be aware, though, that wide-angle lenses will cause some distortion.

A fisheye lens is also popular for this type of photography, as it lets you get into the image, which makes it great for street-level-to-sky shots where the photo is surrounded by buildings.

Finally, the hugely expensive tilt-shift lenses are used by some of the more professional architectural photographers to get the advantages of a wide-angle shot, while eliminating distortion. If you really want great, close-up shots of buildings and other subjects this is the way to go.

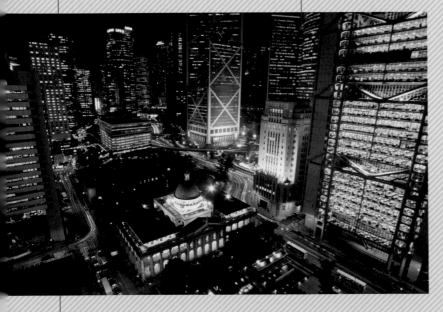

Shooting with a wide-angle lens helped capture this shot of Hong Kong.

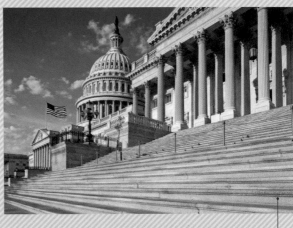

By using a tilt-shift lens, it's possible to ensure a whole building is in pin-sharp focus—even though different parts of the building might be at different distances from you.

TOP TIPS: ARCHITECTURAL PHOTOGRAPHY

The number one rule about photographing buildings and architecture is to not take your shot from too near the base of the structure. If you take a shot from this location, you'll find that your shot is skewed because the base of the building will appear larger than the top. The shot will come out much better if you can take it from a higher point if possible—even if you have to take it from a distance with a zoom lens.

Vary your angles. A straight shot of your subject, and then at an angle. Each shot will give a different perspective, and you may find that you prefer one shooting position over the other.

Use leading lines to lead the eye. Remember what we said about leading lines in an earlier chapter? You can draw the viewer's eye into the photo by including a pathway that leads up to the structure. The same goes for staircases, escalators, and landscape features.

Include people. Sometimes people can explain the "story" behind your shot, such as with old buildings, farms, etc.

Don't forget about the details. While a whole building or city scene may be nice, sometimes the interest is more in the details, so zoom in and see what you come up with. Also don't forget to check out the interior of buildings—they often have details that are just as interesting as the exterior.

Camera settings

Depending on the time of day, you may need to reduce your shutter speed in order to let enough light into the lens to illuminate your subject, particularly if you are taking the shot at twilight or later.

Conversely, for deep shots (like cityscapes) you need a higher f/stop number to keep it all in focus. A lower ISO is better, as this will reduce noise on the photo. Invest in a good tripod so you don't come home with blurry shots.

When you are setting up a shot, consider the context of your photo and whether you want to include just the subject, or the surrounding space. Does the picture make sense if it is just the subject, or does it need space or surrounding buildings to give it some context? You may want to experiment with close-versus-wide shots to see how including space can change the feel of the picture.

Nice, even lighting helps your buildings come into their own.

In this detail shot, I used f/9.5 to ensure I had enough depth of field to get the whole building crisply in focus.

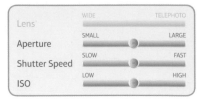

	WIDE	TELEPHOTO
Lens		
	SMALL	LARGE
Aperture		
	SLOW	FAST
Shutter Speed		
	LOW	HIGH
ISO		

Up-close photography (macro with EVIL)

Personally, I am fascinated by the views photography gives me that I cannot get in any other way. I love using long shutter speeds and creating motion-blurred photos because it's something you can't see in real life. Similarly, using very short shutter speeds can help you see phenomena that you couldn't see otherwise, too: a droplet of milk splashing into a bowl, or a horse frozen in mid-leap, there for you to look at in great detail.

Macro photography opens a similar magical world, enabling you to photograph tiny things. Flies, peppercorns, soap bubbles, flowers, computer monitors, even simple dirt—everything becomes more interesting when seen through the magnifying magic of a macro lens.

Best of all, it doesn't have to be an expensive hobby: All interchangeable-lens camera systems have something called "macro extension tubes." These are metal rings with a body bayonet fitting on one side, and a lens bayonet fitting on the other. In essence, what they are doing is moving your lens further away from the lens body. Since there are no optics in here, there's no such thing as a "good" or a "bad" extension tube, so head to eBay and buy the cheapest ones you can find.

When you move the lens further away from your camera body, you lose a bit of light, but your lens can focus closer to your subject. A lot closer. You can stack several of these extension tubes on top of each other to get even closer—until your lens is touching the item you are trying to photograph. The result is great up-close photos.

A dedicated macro lens can help you get closer to your subjects.

A photo of an eye on a computer monitor, photographed macro-style.

Use your limited depth of field in macro photos as a creative tool.

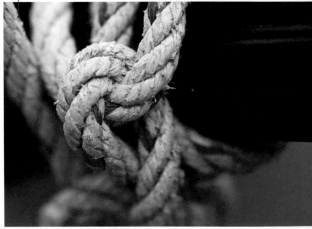

At first, you'll worry too much about getting close to think about it, but when you are starting to get to grips with macro photography, remember that the normal "rules" of photography—like lighting and composition—still apply.

Can anyone say "extremely limited depth of field"? This is a photo of an ear bud of an MP3 player.

FOCUSING

When you are working with macro extension tubes or bellows, you can no longer rely on your autofocus to focus for you. Instead, you will focus by moving your whole camera closer to—or further away from—your subject. It takes a bit of practice, but once you get the knack for it, you'll get the photos, too!

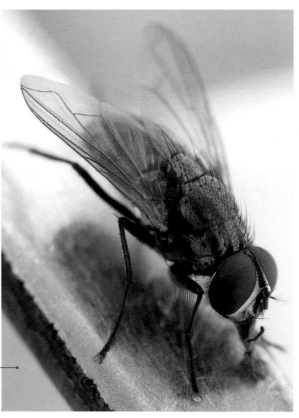

Taking photos

When you're getting very close to your subjects, all bets are off when it comes to camera shake. It is simply too easy to move your camera as you're taking the photos, which results in blurry pictures. Considering the magnification you will be working at, any movement to the camera is going to be a problem—so embrace your tripod, and grow some patience. You're going to need both.

The other thing you need to know about macro photography is that you will have extremely limited depth of field. If you get close enough, you may only have fractions of an inch of depth of field, even if you use a small aperture. Unfortunately, there's not that much you can do about it; it's how macro photography works. Embrace this limited depth of field and use it to creatively explore what can be achieved with your camera.

It takes a steady hand and more than a little bit of luck to photograph a live fly.

Travel photography

It may seem odd to have a section in this book about travel photography. Surely, travel photography incorporates a little bit of everything? There's a bit of portraiture, some architecture, a spot of wildlife photography, and some landscape photos here and there, too.

It is during my travel photography that I've most strongly felt the benefit of using an EVIL camera. My Olympus E-P1 packs an incredible potential for quality into a diminutive package, and the vast array of lenses and extra equipment available is simply baffling.

Limited depth of field and a curious-looking Fanta logo give a bit of the Thailand flavor in this photo.

A pair of shoes found in Malaysia.

In a hot-air balloon over Turkey.

A trader checks his email outside his carpet shop.

The yard in front of the Blue Mosque in Istanbul.

Only in Thailand would you find someone up to his knees in water, but still toting an umbrella while riding a motorbike…and those are the moments where you're glad you have a camera handy.

A sunset in Cambodia.

Considerations when traveling

If you are going to carry a camera with you everywhere, it had better be a solid contender that can deliver photos you are happy with. There is nothing as frustrating as coming home with a set of photos that are less good than you know you are capable of.

With that in mind, I was a little worried when I went on a huge trip recently, bringing only my EVIL camera, leaving my beloved SLR camera at home. I'll be honest with you: I only missed my SLR camera when the sun had gone down, and then only because I'm so used to my 50mm $f/1.4$ lens.

Having said that, I did manage to take a formidable number of glorious photos with four pieces of photographic equipment:

- Camera body
- Wide-angle zoom
- Prime lens
- Gorillapod

Because the collected equipment was so small and light, I was able to keep it with me in my hand luggage on the plane, or in a jacket pocket the few times I found myself in less salubrious parts of town.

The locals

Depending how far afield you are going, bear in mind that not everybody is used to having cameras pointed at them, and that in some parts of the world, being photographed can have serious consequences. There are native tribes of some countries, for example, who believe that a photograph takes away a piece of your soul.

A little bit of research ahead of your trip goes a long way. Also, it's not hard to understand the universal sign for "Stay out of my face with that camera"—if someone is holding up their hands to stop you from taking a photo. In those cases it's best to put your camera away, smile, apologize, and walk on.

In some countries, people will come running to you, eager to be photographed. Sometimes, they'll want a bit of money (one-dollar bills are appropriate as thank-yous nearly everywhere), or they might just want to see their picture on the LCD screen of your camera.

Finally, it's important to keep your wits about you. So far, I've only had positive experiences in photographing random strangers while abroad, but you never know if there's a bad apple among the people who flock around to look at you and your camera.

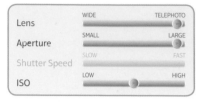

	WIDE	TELEPHOTO
Lens		
	SMALL	LARGE
Aperture		
	SLOW	FAST
Shutter Speed		
	LOW	HIGH
ISO		

Portrait photography with natural light

Lens choice and camera settings

Traditionally, portraits were always taken with long lenses—it has been said that 100–150mm lenses are perfect for portraits. The problem with wider-angle lenses is that they can cause distortions. Get too close, and their noses will look huge, or if they have one part of their body closer to the camera than another, it could look strange. Of course, this is something you can explore for effect, but if your goal is to make your subjects look good—a longer lens is probably a good idea.

Personally, I like taking my portraits with a 50mm lens. On a crop-sensor APS sensor, that means it's the equivalent of a 70mm lens; it's a little shorter than the commonly accepted portrait-lens length, but I quite like the results.

As for camera settings, there are as many different possibilities as there are photo models. In some circumstances, an extremely shallow depth of field can look great, so you would need a large aperture. A shallow depth of field is a nifty short-cut to great-looking portraits, so shoot wide open and see if you like the results you get. In other cases, setting a smaller aperture with its greater depth of field allows you to show off the background in the image for context.

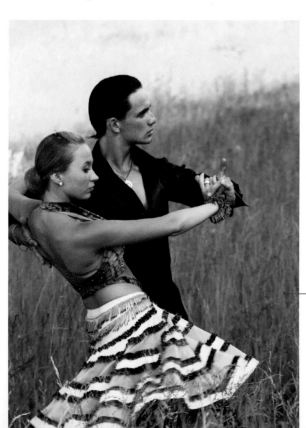

Rapid movement in your photo in this case meant that a faster shutter speed had to be used to freeze the motion in the shot.

Using a wide-angle lens to photograph people can cause odd facial distortions.

Beautiful soft sunlight spilling in through a window gives you gorgeous, classical portraiture lighting.

The sunlight reflecting back and forth between the buildings causes a beautiful soft light.

I love this portrait. The large aperture (f/2.8) with a focal length of 150mm blurs the background enough that you don't notice it that much, but the observant viewers realize she's on a tennis court.

Dealing with shadows

Even though there's a lot of beauty in sunlight, the big, bright, burning ball of fire in the sky does have an unfortunate side-effect: It tends to cast very harsh shadows indeed, and people don't look all that great with black swathes of shadow cast across their faces.

Shadows are caused by strong, directional light; The sun is an excellent example of such a light source. There are three ways of dealing with this challenge:

Make the light less directional—This is the easiest way of dealing with direct sun: Take your subjects out of the directional sunlight, and place them somewhere else. The simplest method of accomplishing that is to ask them to go stand in the shade. If you want to get more high-tech about it, you can use a reflector to reflect some of the sunlight back into their face, which will "lift" the shadows a little, giving a more even light.

Make the light source "bigger"—If you have a bigger light source relative to your subject, it means that the light comes from more different angles. You can accomplish this by placing a large translucent diffuser between your subject and the sunlight.

Add more light—Strictly speaking, if we're going to be doing natural light photography, adding more light is cheating, but sometimes there's no other way to achieve the right results. It may feel weird to use a flash in broad daylight, but your camera's "fill flash" feature can help you remove some of the shadows from your models' faces.

Lens	WIDE ——————————○ TELEPHOTO	
Aperture	SMALL ——————○———— LARGE	
Shutter Speed	SLOW ——————————— FAST	
ISO	LOW ○———————————— HIGH	

Portrait photography with artificial light

I have a confession to make. I was afraid of flash photography for a long time. I used flashes, of course, but I never really understood how to get them to work for me. That fear was cured after I did a couple of shoots with continuous lighting.

Artificial light comes in two flavors: continuous lighting and flash lighting. Lightbulbs, torches and floodlights are examples of continuous lighting, while flash lighting ranges from the small built-in flashes you get on some cameras, to high-end studio strobes that send out enough light to dazzle a bat.

Generally, for learning photography, it is easier to work with continuous lighting because you can immediately see what you are doing. These days, I wouldn't use anything except flashes, but I'll readily admit that if it hadn't been for doing a few shoots with shop lights, I still wouldn't be comfortable with multi-flash setups.

Studio and camera-flashes can be more tricky to get to grips with, because they only illuminate your subject for a fraction of a second. Nonetheless, flash lighting tends to be much brighter, and in the hands of a good photographer, flashes are very effective.

CHEAP LIGHTS

Most hardware stores sell 500w halogen spotlights, branded as "flood lights" or "shop lights." They are cheap, and getting the color balance can be tricky, but they are a great first step into the world of artificial lighting.

Two 300w halogen spotlights are the source of light in this shot. It's hardly the most impressive studio shot in the world, but I think this was the very photo where it all started making sense to me.

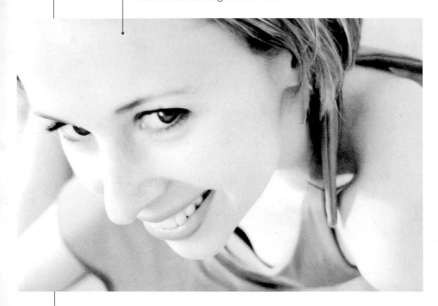

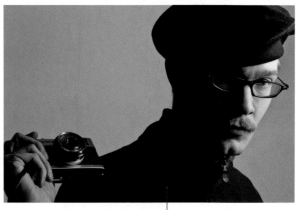

A single flash can give beautiful lighting. If you want more flexibility and control, add more flashes and light accessories.

Making your subjects sparkle

If you read the previous section, "Portrait photography with natural light," you're already well on your way to understanding what portrait photography is all about. It's also a good idea to check out the "multi-flash setup" section in the "For the Love of Light and Color" chapter, to get a better understanding of how you can use multiple flashes to capture the portraits of your dreams.

For guys, however, harder, more directional light can look tough. Unless that guy is me, of course—then it just looks silly. Those little white dots in my eyes are known as "catchlights."

The great thing about taking photos with artificial lighting is that you have full control over what is happening in your frame. Here are some of the top tips for making your studio shots work out better:

Soft lighting is generally more flattering in portraits, especially for women.

A 50mm is definitely my lens of choice for portraiture.

Don't fall into the trap of taking it all too seriously. If a stuffed elephant is what it takes to add a bit of slapstick to the proceedings, go for it!

TOP TIPS: STUDIO SHOTS

The great thing about taking photos with artificial lighting is that you have full control over what is happening in your frame. Here are some of the top tips for making your studio shots work out better:

Use a catch-light. By making sure your model's eyes reflect a little bit of light back to the camera, it adds a "twinkle," which makes people look more alive.

Turn-turn. Inexperienced models sometimes have problems looking "natural" on camera. Have them turn their back, and then when you tell them, turn back to the camera. This movement often helps people relax enough that the photos come out much better.

Use props. If your model has a hobby or a job that involves props (knives for a chef, spanners for a mechanic, perhaps a camera for a photographer), encourage them to bring the props to the shoot. Sometimes having something familiar to handle helps make a model look more natural.

Go high. If your model is a little bit on the plump side, taking the photo from slightly above has a slimming effect. Getting the model to look up into the camera also helps reduce any double chins.

Glasses. Can be a problem in portraiture. If possible, consider taking their photos with empty frames—or at least ensure they are turned slightly sideways from the flashes so they don't reflect in the lenses.

Light the background separately. If you have enough lights, use separate lights for your foreground and background. Make sure none of your foreground lights "spill" onto your background, and the photos will look much more professional as a result.

Have fun with it. Taking photos is fun, and being photographed is likewise. Have some fun with it; it'll show in the final result.

CASE STUDY Shooting a model

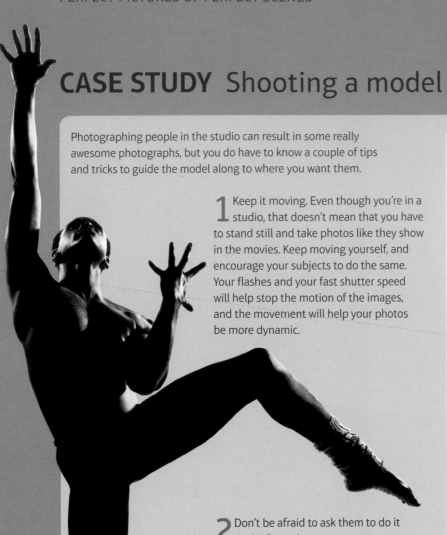

Photographing people in the studio can result in some really awesome photographs, but you do have to know a couple of tips and tricks to guide the model along to where you want them.

1 Keep it moving. Even though you're in a studio, that doesn't mean that you have to stand still and take photos like they show in the movies. Keep moving yourself, and encourage your subjects to do the same. Your flashes and your fast shutter speed will help stop the motion of the images, and the movement will help your photos be more dynamic.

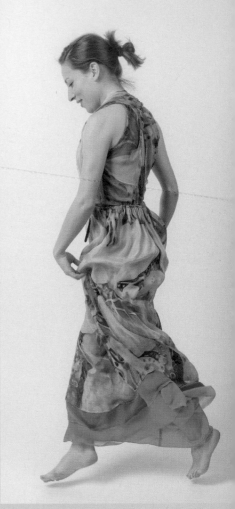

2 Don't be afraid to ask them to do it again. Sometimes, you spot a great opportunity, but you aren't fast enough on the shutter, or your flashes didn't fire properly. There's no shame in showing your model the photo you nearly got, and try to explain what you wanted. If you can recreate it, you'll get the shot of your dreams.

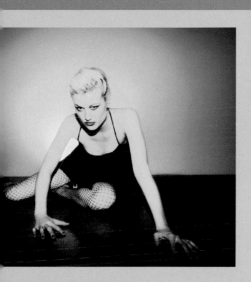

3 Direct your models properly. If you want somebody to do something specific, you have to find a way to explain it to them. Personally, I'm a big fan of just miming or showing people what I want them to do: No chance of a misunderstanding, and me trying to do a pirouette always seems to lighten the mood in the studio.

4 Go for details. By getting in close, you might be able to capture a particular detail of someone's personality that you wouldn't otherwise have been able to get. A particular movement, perhaps, or a thoughtful pose. By mixing up the up-close and overall shots, it gives you a lot of variation in your photos, and it keeps things moving in the studio, too.

5 Capture personality. If you're taking a set of portraits, you will want to capture the personality of the person you are taking a photo of, but if the goal is to have a bit of fun, then don't hesitate to let your models pick a persona —a cartoon character, a superhero, or a profession. For example you can ask a shy and timid friend to pretend to be a bodyguard, or your tone-deaf mate to be an opera singer. If nothing else, it'll liven up the shoot!

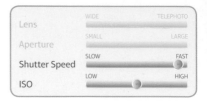

	Lens	WIDE	TELEPHOTO
	Aperture	SMALL	LARGE
	Shutter Speed	SLOW	FAST
	ISO	LOW	HIGH

Photographing children

Kids are fun to photograph, but they are also spontaneous and reluctant to follow instructions, so getting great photos of kids takes a lot of patience, a bit of luck, and a fair amount of practice. However, once you get the hang of it and with the help of the following tips you will soon be taking fantastic photos of kids.

Different approaches

For the most part your photos of kids will be separated into two groups—babies and children. Because babies are somewhat immobile and tend to remain laying down or sitting, it is best to start by getting down to their level, so get on your belly for some great shots of their perspective.

With older kids you may have to crouch down to get a shot "on their level," but you also have to be able to move around a bit if you are taking action shots. Generally you will get more candid shots if you catch them being involved in something, rather than trying to get them to smile for the camera. When shooting active kids it can be beneficial to use a burst or continuous shooting mode so you can capture the subject kicking, jumping, or falling down.

Try photographing children from eye-level or lower to engage with them better. Yes, that probably means you'll be on your knees or stomach for much of the photo shoot.

Patience and a streak of opportunism are key to capturing good photos of babies.

Giving kids something to do makes your photos come to life, and they'll soon forget you're even there.

Camera settings and lens choice

Aperture Priority (A or Av on your camera mode wheel) mode will let you control depth of field, so you can switch between portrait shots with a fuzzy background and deep shots that give the viewer a sense of what is happening in the photo. Note that a lens with a wider aperture (lower f/stop number) will allow you to let in more light for faster photos.

The best lenses for children's photography will allow you a range of wide vs. zoom options, and will give you a reasonable amount of flexibility in low light situations. A zoom lens will let you get more candid shots of your kids, as you won't be as intrusive, but wide-angle lenses also let you get the whole picture. For portrait photography it can be a good idea to get a nice, bright prime lens, which will give you lots of light for nice blurred backgrounds.

Try to keep the ISO as low as possible to reduce noise, but try to balance that out with a fast shutter speed (since kids rarely hold still). A shutter speed of 1/200th of a second is good for normal shots—for action shots you may want to increase the shutter speed to around 1/500th of a second.

As long as you can keep the children interested, you'll have willing photo models.

Be prepared and keep it fun

Kids have a very short attention span, so they aren't going to be happy with waiting for you to set up a shot, arrange props, and so on. Try to have most of the shot prepared ahead of time. If you are really serious about photographing children you may want to consider a two-camera approach, with one camera set up with a wide-angle lens and one with a zoom, so you don't have to make the kids wait while you change lenses.

It may take a few sessions to get the shot you are looking for, but in the meantime you are learning a ton about photographing children.

Sometimes, a bit of moonlight is enough to make scintillating photographs.

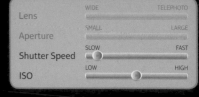

Lens	WIDE	TELEPHOTO
Aperture	SMALL	LARGE
Shutter Speed	SLOW	FAST
ISO	LOW	HIGH

Night-time photography

If you love sparkly city scenes, starlight skies, or the neat effect of blurred traffic, you'll need to learn about night photography, and you will soon find that with a few tricks there are virtually no limits to shooting after the sun goes down.

Although the time for "night" photography is considered to begin at least an hour after sunset you may want to consider setting up just before sunset—so you can capture some excellent sunset and silhouette shots as well. Dusk is also a great time to get photos, and you'll see some amazing colors.

Eliminating camera shake

In most cases, unless you have a flat and stable surface to put your camera on you will absolutely need a tripod. Consider getting a tripod with a versatile tripod head so you can change the angle of your shot.

Even with a tripod you may find that camera shake is interfering with your photos, likely due to the movement caused by pushing down the shutter button. To avoid this problem, set up your shot and use a timer (two seconds is fine) to automatically take the shot, or get a wireless-remote shutter button.

If you are shooting with an SLR and are still seeing camera shake in your photos, find out if your camera has a "mirror lockup" function. This eliminates the slight shake caused when the mirror is flipped up before the photo is taken. On an EVIL camera, you're one step ahead already: No mirror, no mirror slap!

A 30-second shutter speed made the water under the Golden Gate bridge turn into a tranquil blur just after sunset. The camera was standing on a big, solid concrete block—Alcatraz.

Top tip

When you include water in your photo you'll find that it gives more color, makes the shot softer, and even gives your photo a glowing effect. This is why cityscapes, bridges and fountains look so stunning at night.

Lens choice and camera settings

If you really want to draw people into your night-time photo then you'll need a decent wide-angle lens, such as a 10–22mm or a 10–20mm. Otherwise, unless you can take the photo from a mile away you may miss a lot of the substance from the shot.

Most beginner night-time photographers may feel more comfortable starting in Aperture Priority (AP) mode, which will let the camera choose the proper shutter speed depending on your aperture setting. To keep everything in focus an $f/8.0$ setting is usually ideal, but you can also experiment with smaller apertures (up to $f/16$) to get great effects. Remember, watch your light meter carefully.

Unless you want to specifically highlight something in the foreground, or are taking a night-time portrait, do not use flash. See the flashlight tip for info on using light to draw attention to a subject.

Even though using a flash generally is a poor idea, using a flashlight is a neat way to highlight part of an object, or one object while keeping the others dark. With long exposures you can use your flashlight to "paint" a large object for stunning results. Give it a try!

A low ISO (as in 100 or 200) is key for night photography. Remember that as long as you have a tripod you can set the exposure as long as you need to get the right amount of light. In fact, by using exposure times of several minutes, you can get shots that look like they were taken in broad daylight.

Your camera comes with a Live View feature, so use it! Live View can be particularly helpful if you like to focus manually, and can help you capture a perfectly focused shot.

Cities have amazing potential for night-time photos.

You can easily capture scenes like this at night by using a slow shutter speed and holding your camera completely still while traffic is rushing by.

By using a flashlight with a red and one with a blue filter, I was able to "paint" this barn in two different colors at night.

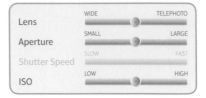

	WIDE	TELEPHOTO
Lens		
	SMALL	LARGE
Aperture		
	SLOW	FAST
Shutter Speed		
	LOW	HIGH
ISO		

Product photography, no matter what you are photographing, takes a level of perfectionism that borders on the obsessive.

Still life photography

Generally, "still life" is the art of taking photos of objects that don't move. Flowers and fruit are classical still life subjects, but modern photographers often blur the lines between still-life and product photography. Personally, I'm of the opinion that if it isn't moving, it isn't going to move, and if it's smaller than a dog, it's probably a still life.

When creating a still life, as a photographer you have a lot of flexibility: You arrange the items in your still life however you want them. You have full control over the lighting, the subject, and your camera. Short of your wine glass falling over there aren't going to be any surprises, which means that still life photography affords you a rare luxury: all the time in the world to labor over the perfect shot.

A good still life should look so perfect and yet so real that it nearly looks impossible. This means that you have to be careful about what you are photographing. If you include fruit, for example, spend a bit of time picking the best specimens from the market, and show them from their best side.

Classic still lifes are a bit cheesy, but they are a great way to spend a few hours on a rainy day, and get some good practice in with your camera as well.

Many photographers consider product photography their bread-and-butter work. Art photographers tend to dismiss the product crowd as "technicians," but personally I think that's a bit unfair—product photographers may not have the creative freedom that, say, portrait photographers have, but on the other hand they do tend to be some of the best technical photographers you'll find.

As we discussed in Chapter 4, it takes a lot of dedication to make it in the upper echelons of product photography, but that doesn't mean that it's not interesting to give it a go anyway.

Product photos can be used to illustrate concepts; in this case, spa treatments.

Exercise

Take a photo of a bowl of fruit, and make it look as tasty as possible. Then get feedback from a non-photographer to see if they agree that your photos look scrumptious enough to eat.

It's a pretty photo, but not very useful: You couldn't use this on a menu, for example, because the only thing you can identify is the chargrilled tomato.

Food photography

This is a sub-genre of still life photography and a particular favorite of mine. I love food, whether it means I get to make it, eat it, or take photos of it—or all of them.

Food photography is quite challenging, as it turns out that a lot of tasty food doesn't actually look very good. You can get a long way by lighting your photos well, however: Artificial lighting works, but you can also just place the plates near a window and exploit the golden rays of the sun to light up your food photos.

In a way, food is a pretty cruel still life subject: it doesn't look good for very long. Pastries start sagging or looking stale, meats turn gray, and greens look sad very quickly in the heat from the other foods. The secret is to set up your shot—with an empty plate, if you have to, or with something that doesn't spoil as easily. Once you're completely happy with your camera settings, lighting, background and overall setup, all you need to do is to swap the plates and take the photo. Cheating? Sure, but who cares—the results look fab!

A San Francisco classic: clam chowder in a bread bowl. This was photographed in direct sunlight. I blocked the light from hitting the background, which is why the bread bowl is standing out so well.

Desserts are great opportunities for food photography: They're colorful, and it's a poor dessert that doesn't look flavorful in a photo.

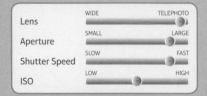

Lens	WIDE	TELEPHOTO
Aperture	SMALL	LARGE
Shutter Speed	SLOW	FAST
ISO	LOW	HIGH

Not-so-still lifes

Photographing smoke

Of course, life on a rainy day isn't all about still lifes. There are opportunities to take photos of moving subjects too, and I figured I'd share two perfect rainy-Sunday-afternoon projects with you: Photographing droplets and smoke.

1 Use an incense stick for your smoke source.

2 Turn off all the lights in the room.

3 Try to avoid turbulence in the air: Close windows, and put a blanket by the foot of the door in the room you're using to take photos, to stop draft from disturbing your images.

4 Use an external flash, and make sure the flash light doesn't hit the background. The easiest way to do this is to shoot the flash from the side, and block the sides of the flash to ensure the light doesn't spill onto the lens or the background.

5 Set up your camera with a relatively large depth of field (it helps get the smoke in focus), manual focus, and manual exposure settings. 1/150 and f/8.0 works well for me.

6 Take a few photos, and then look at the results closely. Adjust your camera, smoke, and flash position if required. If you are doing it right, only the smoke should show up in your photos.

Photographing smoke can be an exercise in frustration, of course, but the results can look amazing. It's the perfect rainy-day project. Give it a try.

Capturing droplets

Photographing droplets as they hit a surface isn't for the faint-hearted or the impatient. I've tried quite a few times to get the perfect "corona" captured as part of a droplet shot, but it appears there's no such luck to be had. Nonetheless, the lessons you learn from attempting to take photos of droplets are applicable in many other genres of photography, so why not give it a shot.

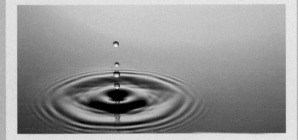

1 Use an eyedropper to drop your liquid onto a plate. Water or milk both work well. I've found that the opaqueness of the milk gives the photos a ceramic-type feel to them.

2 You don't have to use a flash, but you're going to need a lot of light.

3 You need a very fast shutter speed to freeze the motion of the drops. However fast your camera body can go—that's probably the right shutter speed.

4 Use a tripod, not to stabilize the camera, but just to have one less thing to worry about.

5 Manual focus and manual exposure are a good idea. There's no point in re-focusing and re-measuring every shot: Nothing changes between shots, so getting it set up perfectly once should be all you need.

6 It's perfectly possible to take the photos manually. It's all about finding a rhythm: "Droplet falls, take a picture." Adjust your button-pressing based on the results you're seeing on the camera's LCD screen. We are talking fractions of a second between a good shot and a useless one, so expect lots of failed photos, and a fair amount of experimentation. Don't give up!

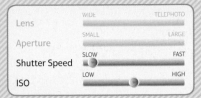

	WIDE	TELEPHOTO
Lens		
Aperture	SMALL	LARGE
Shutter Speed	SLOW	FAST
ISO	LOW	HIGH

Streaks of light

The view from my house in Holloway, London, after nightfall.

A not-very-impressive-looking building in the city of Liverpool, England, comes to life when photographed as a "light-streak" photo after dark

Moving Pictures

Five years ago, if anyone had suggested to me that they were going to make a movie with a stills camera, I'd have declared them madder than a box of ferrets. "Stills cameras," I would tell them, "Are for stills. If you want to record video, why don't you go buy a video camera?"

I'm a bit happy I never put that sentiment in a book, to be honest with you, because it seems as if I would have been proven rather horribly wrong. What happened was that people started to realize that the video quality on digital SLR cameras and, later, on EVIL cameras rapidly got very good indeed. Combining the full-high-def resolution with extremely good quality video and interchangeable lenses meant that you suddenly had a rather powerful tool at your disposal.

One of the most exciting aspects of using an interchangeable-lens stills camera to make movies is the fact that you can experiment with lenses. To an experienced photographer the thought of getting excited about using a lens with your camera might seem a little over the top. But to an amateur filmmaker with very little money, having a video camera that actually allows you to switch lenses is something of a luxury. Traditionally, digital video cameras come with a fixed zoom lens, and although these are pretty versatile they can also be quite limiting, especially in terms of maximum apertures, and so on.

Traditional video cameras have their advantages, but dollar-for-dollar, EVIL cameras tend to be better value and quality.

STUDIO

SCENE	TAKE	ROLL

DATE	SOUND
PROD. CO.	

DIRECTOR

CAMERAMAN

What are the advantages?

Compare the video quality of a digital EVIL camera with that of a similarly-priced video camera, and you realize the video cameras often end up losing the battle. Soon, it becomes an economy of scale: Put simply, there are a lot more consumer stills cameras and lenses out there than interchangeable-lens video cameras. Dollar-for-dollar, the stills cameras are simply better at videos.

It ought to be mentioned, too, that the other way around—trying to take photos with a video camera—is an exercise in masochism at the very least.

Then, something else happened. As people continued upgrading their stills cameras for better, bigger, faster, and higher-resolution models, they got video as part of the camera body package, whether they wanted it or not. Next, when more videos started appearing online, showing off the incredible quality that could be achieved with interchangeable-lens stills cameras, photographers that already had cameras with video potential built in started experimenting, causing a huge boom in people using their equipment in ways they hadn't dared dream of before.

Then, the big boys joined the game; the season finale episode of popular TV show House, for example, was shot on a stills camera (the Canon 5D mkII), and the amateur- and short-filmmaking world has embraced the new technology with open arms.

THE EVIL ADVANTAGE

When you are shooting video on a digital SLR, the mirror tilts out of the way, and you are using the SLR camera in exactly the same way as you would use an EVIL camera; Live View all the way, and your viewfinder becomes useless. When used in this manner, the pentaprism and all the extra technology built into a SLR is all just dead weight—so when you rock up to a video event with your much smaller and lighter EVIL camera, expect a few looks of envy...

Some good lighting goes a long way when it comes to making your videographic masterpieces look better!

There are a lot of accessories available to make video-recording with stills cameras even easier.

Challenges when recording video

It is important to remember that, good as they are, both SLR and EVIL cameras are still stills cameras at heart. You can get amazing quality, but there are a few things you need to be aware of, especially if you come from a video background, as you may run into a few surprises.

Stills cameras, when used to record video, don't really cope all that well with hand-held operation—because it's more difficult to hold the camera, you will often find that hand-held footage will come out very shaky. On the other hand, that's why there's a tripod hole at the bottom of the camera—all you need is a sturdy surface, and your problems dissolve into nothing.

The built-in microphones also tend to be pretty dire, and while many cameras have a microphone port for recording audio at higher quality with a good mike, only very few cameras have a built-in headphone jack, so you won't be able to monitor the sound through headphones. Depending on your desires for quality, you may need to record sound separately.

Shooting video with your EVIL camera

There are a lot of different approaches to video, all depending on what you are trying to achieve. Shooting a football match is going to be very different from making a short film, for example, and filming wild animals differs from the techniques you would use to film a beautiful sunset.

Of course, the actual controls on your camera will vary, so you are better off taking a look at your camera manual to find out how using your camera in video mode differs from taking still images.

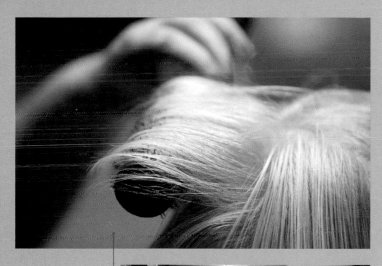

Instead of lengthy shots telling a long story, try to use "cutaways" to tell sub-parts of the story—it breaks up the viewing and keeps it interesting.

TOP TIPS: SHOOTING VIDEO

1 Record multiple takes. Even if something seems perfect, it can't harm to have a back-up recording. It could well be that your second take is even better.

2 Use close-ups. A 20-second shot of someone getting out of a car is boring. Use closeup shots of them grabbing the car handle, putting their shoe down in the dust, undoing their seatbelt, etc. The rapid-fire editing keeps things interesting.

3 Show, don't tell. Seeing a character doing something (say, shaking their head) is more powerful on-screen than hearing them say something ("no, I didn't steal that car").

4 Pay homage. There is nothing wrong with borrowing from a movie scene you like. Lighting, camera angles, or a snippet of dialogue is all fair game; just make it your own.

5 Use a tripod. Despite the fact that shaky-cam is quite popular in fly-on-the-wall-style documentaries, it's good form to avoid making your audience seasick. Use a tripod.

6 Use your zoom carefully. One advantage proper video cameras have over EVIL cameras is that it is easier to control the zoom on video cameras. Unless you buy additional equipment, it's nearly impossible to get a nice, smooth zoom. Set the focal length, and use it for the duration of the shot.

7 Make a storyboard. Create a comic-book version of what you are hoping to shoot before you start filming. Visualizing it in advance helps get a uniform feel for your movie…and you don't even have to worry about being able to draw.

8 Three-act structure. For nearly all types of film, you need a beginning, a middle and an end. They're simple storytelling techniques, but they'll ensure your film is watchable.

9 Make the movie for you. Chances are, you don't have to worry about box-office success. Make a movie you enjoy making, and would enjoy to watch.

10 Continuity. No matter if you shoot over several days or over half an hour, keep an eye on continuity. The red car in the background vanishing and re-appearing between shots looks silly, and can easily be avoided.

Editing to music

One great way to learn about your equipment properly is to shoot and edit something to music—a music video, perhaps, or a short film.

Music videos are particularly interesting to put together. You don't need a lot of expensive editing software; a copy of iMovie or Moviemaker (both come with your operating system; for the Mac and for Windows, respectively) goes a long way.

You may have noticed that whenever you watch movies or television, you'll see that the tension of the shows you watch is enhanced with music. Switch to the world of music videos, and it works the other way around: The imagery is there to reinforce the impact of the music.

The techniques used for both types of program is very simple: They edit the video to fit the music, rather than try to fit the music into the video. All good and well, but how do they do it?

Editing video to music is an artform in its own right. Done well, you can turn a fine piece of music and some cool video footage into a jaw-droppingly good multimedia assault on the senses.

One of the secrets of making music and moving pictures work together is to ensure that the visual cues from the video sync up perfectly with the video. This might seem like an impossible task, but there's a little trick that'll help you hugely. Before you sit down to edit the video, listen to the music you want to use carefully: what are the parts of the music that you want to "meet up" with its visual counterpart? That's going to be the vital part of your editing work.

Matching video to music and sound

Instead of trying to guess where to start the music and the video footage from your EVIL camera to make them "meet up," use your editing software to skip directly to the part of the music you had in mind. Move the video back and forth until the beat of the music matches perfectly to the visuals.

Do this with all the main points of the video, and then stop moving your video tracks. You can now layer the rest of the video "on top" of these key points, safe in the knowledge that the crescendo of your magnum opus will remain intact throughout.

When you show off your video, your viewers will notice that your music and the visuals match up—and they'll think you're a super-hero video editor at the same time. Just don't tell them how easy it was!

Whatever you are editing, putting video to music is a lot easier than vice-versa.

Better videos through better lighting

To make your videos look even better, make sure your scenes are well lit.

Quality of light comes in two distinct flavors: quantity and quality. You need a bit of both to make your videos sizzle, but that doesn't mean you have to head to your local film supply store to spend a lot of money on lighting equipment.

Most of the lighting lessons that apply to photography, unsurprisingly, will apply to video as well.

The two things you have to keep in mind is "How much light do I have?" and "Where is my light coming from?" People, for example, tend to look better when they are lit from the side and above. The easiest way of getting the feel for this type of lighting is to go outside: The sun at about 5 p.m. is a perfect example. The light source should be behind your right shoulder. When the actor is facing you, the lighting will be pretty close to perfect.

Indoors, we have to think slightly differently. A 500W halogen work lamp can be bought cheaply from your local do-it-yourself emporium. If you raise it up in the air (put it on a book shelf or similar) and point it at your actors, you'll get very harsh, dramatic lighting. Use the light directly from the side for a Sin City-style feel.

For a less harsh, more "human" lighting, point the work lamp at a white ceiling, and look at your actor on your EVIL camera screen. Because the light is reflected (known as "bouncing") off the ceiling, it will be a beautiful, soft light source that won't throw the harsh shadows we associate with direct lighting.

The easiest way to learn how to light properly is to use a teddy bear. Not as a light source, obviously, but as a model: stuffed animals tend to be a lot more patient than humans when you're first starting out. Put the bear on a chair, set up your camera, and start experimenting with the lights. Try direct lights, bounced lights, and dimmed lights. Try mixing light sources, and try "shaping" the light by shining the shop light through an object with holes or slats in it for cool lighting effects.

Once you feel you're getting the hang of your lights, take the teddybear's place, and perform a monolog to camera to see how your new lighting setup works with a real live person.

Proper video lighting can make your videos look great, but you don't have to run off to the rental place right away; be creative, and you can create your own well-lit scenes.

Use harsh, directional light to get a film noir feel to your video work.

File formats, codecs, and storage

If you thought the world of stills images was difficult with its JPEG, Raw, and TIFF, then you're in for a nasty surprise when you start looking at video. The number of compression schemes, video formats, audio formats, and types of footage you can get is absolutely bewildering.

In my experience, there's a level of experimentation required for every project you ever work on, to try and get different pieces of video, sound, and music to play nicely with each other.

Camera format

Most stills cameras record video in a delivery format known as h.264. That's great if you want to upload your video straight to YouTube or similar, but if you want to edit your video further, you're going to have to convert it (or "transcode" it, as it's known in video editing language).

There's a great piece of software called MPEG Streamclip (available from http://www.squared5.com) that does the trick.

Remember that if you think you may do a re-edit of the videos you are working on at a later date, it's imperative that you keep the original video files. This can be prohibitive, however, as high-definition video and audio can often be very space-consuming. You don't want to lose your original video footage, of course, but at the same time, a biggish high-definition video project can easily fill up even the biggest of hard drives.

Export formats

Things used to be a lot more complicated, but it is getting much simpler: If you want to do just about anything with your video, export it as MP4 video, using h.264 encoding.

The h.264 format makes YouTube—and most of the other online sharing services—happiest. It's an amazingly efficient compression algorithm, which walks a fine balance between file size, quality, and ease of use.

Figuring out the what-is-what of video formats can take a bit of trial and error—but it'll all be worth it once your video artworks are online!

Showing off your video online

Move over Cronenberg, Scorsese, and Tarantino, you've made your first cinematographic masterpiece. While Disney is considering the letter you sent them about the distribution rights, how can you get your stroke of genius out there?

If you immediately thought "YouTube," you are obviously on the pulse of the Internet: YouTube easily wins as the biggest and most popular video site, but it's not without its flaws. For one thing, their ten-minute-maximum upload limit is the bane of the life of all artists who like creating videos of eleven minutes and beyond.

By all means, upload your finely crafted motion pictures to YouTube, but before you marry your creative aspirations to a single site, have a look at two of its competitors that are snapping at its heels.

YouTube alternatives

Vimeo: YouTube made it easy to quickly share videos with your friends, often directly from your mobile phone or editing software, but if you're in the business of creating art,

Vimeo is well worth a closer look. With a much less cluttered interface, it's obvious that Vimeo was designed by filmmakers. You won't find any clips from the football world cup or poorly pirated music videos here: It's all about original content, carefully crafted by creative creatures all over the world. The ability to add a custom thumbnail is also very welcome.

Blip TV: If your aspirations are beyond a single movie and you're instead aiming to create a whole series of content, look into Blip. Its interface makes it easy to create your own TV series online, and helps your users by enabling them to skip to the next episode, and find out more about the series.

There are about a dozen big video sharing sites out there, and they all have their strengths and weaknesses. Think about what you're trying to achieve with your video: For full "viral" potential, YouTube is hard to beat. To distribute your own TV series, look to Blip, and for short films, consider Vimeo. Well, at least until you hear back from Disney about that distribution deal.

Using a wide-angle lens is crucial for establishing shots in video. This is a still frame from a panning shot: Moving the camera from the trees upwards to the building gives a beautiful, dynamic effect.

CHAPTER 8 // MOVING PICTURES

CASE STUDY Secretariat

Released in theaters in 2010, *Secretariat* was a major Disney picture "suggested by" the story of the horse that won the triple crown in 1973. It has not been won since. The film itself is an uplifting tale of triumph over adversity and the pursuit of a dream, but to stand out it was clear from the start that the horse racing would need to be exciting and dramatic. Coming out only a few years after *Seabiscuit*, it was going to need to do something special, too.

One of the options that I spoke about with the director of photography, Dean Semler, was the emerging digital SLR with video, but these cameras and lenses were still pretty big and heavy. "It was at that point that I discovered the Olympus PEN, and Olympus gave us six cameras to work with at the track. We tried the results against those of a relatively small 16mm film camera, and a few others,

and decided it was not only the way to go, but the least dangerous; with its size and weight we could put it pretty much anywhere.

"While the race scenes were composed of shots from a number of different cameras, the camera we could get closest to the horses and jockeys was the PEN. We mounted it on a pole (a fiberglass painter's pole beat the pool-cleaning pole in our less-than-scientific tests). By leaning over the side of a truck, I was able to hold the camera within an inch of the ground, with a 17mm lens. The wide angles we got, right behind the horses' hooves, were amazing.

"With a bit of Hollywood ingenuity, we also found ways to mount the camera on jockeys' wrists and shoulders, and even slung one beneath the horse. "

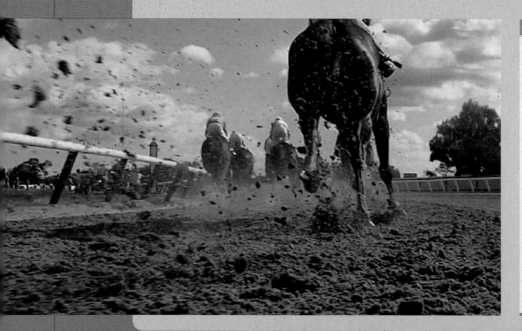

KRIS KROSSKOVE

Kris was a camera operator on *Secretariat*, and director of photography for the second unit that captured the all-important action shots. His other credits include *Back to the Future, Part II; Iron Man 2;* and *Born to be a Star.* His show-reel is one of the most exciting few minutes you can possibly imagine.

Horse's head
With the camera mounted on a boom arm, it's easily possible to run a monitor lead back to the following truck and connect to a live monitor.

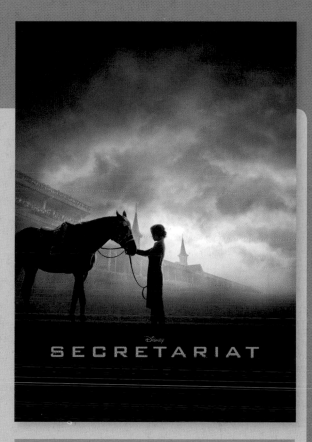

SECRETARIAT

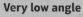

Low angle
Getting in close to the action can be done in many different ways—a monopod goes a long way. Using an EVIL camera can help avoid scaring the horses: It's certainly a lot smaller than most video cameras!

Very low angle
The camera can safely be used within inches of the ground, and can withstand some flying gravel.

DEAN SEMLER, DIRECTOR OF PHOTOGRAPHY

"The Olympus could sit inches above the track, a few feet behind the horses, or just a few inches from the horse's nose or chest, the jockey's hands or the jockey's face. What's more, if something happened, it could be pulled out immediately. We called it the Olycam. I used it in the dirt, right behind the horses' hooves, and looking forward down the track as they broke out of the gate. I also put one at the top of the start gate, looking straight down on Secretariat as he broke out. It was a quick piece, but it's in [the final cut]. The silliest rig for it was on a saddle strap under the horse's belly, looking back between his back legs. As funny as it sounds, it's in the movie. We also put it on the jockey's shoulder, so you could see over Secretariat as he overtook the others."

Digital Darkroom

Editing photos used to be a horrible hassle. Back in the old days, you'd spend hours and hours in a dark room, coming out reeking of chemicals with photos that were sort-of-nearly what you had hoped for.

Then computers started taking over, and it was possible to scan your photos in; either by getting someone to scan them for you, or by scanning your prints or negatives yourself.

Finally, photography caught up with the current millennium, and digital cameras started changing the game. In the beginning, you'd have digital compact cameras, but then SLRs and—most recently—EVIL cameras joined the fray.

Being able to bypass the darkroom altogether doesn't mean that photos don't need a bit of a tweak here and there. Using modern software, however, beginners are finally able to make simple (and much more advanced) edits to their photographs.

In this chapter, we're going to take a closer look at the digital darkroom: software options, why you should shoot in Camera Raw, and then a series of guides on how you can get the most from your photos.

The digital darkroom can't save a bad photo—but it can make a good photo look much, much better.

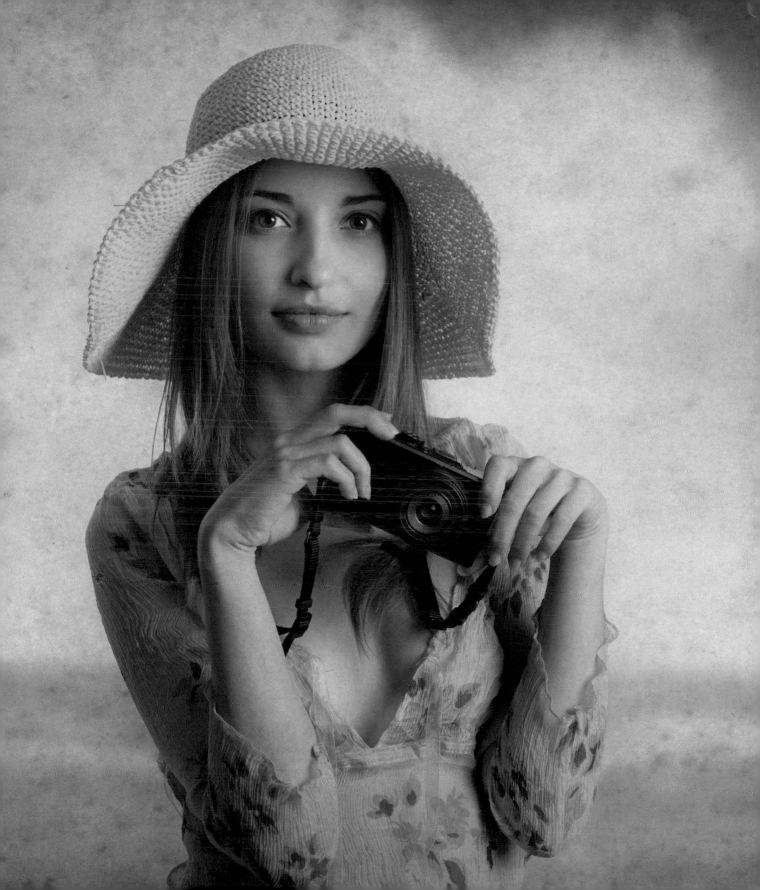

Shooting in Camera Raw

How your camera records images

There are three main imaging recording formats: JPEG (also known as JPEG), TIFF (also known as TIF) and Camera Raw (also known as Digital Negative, Raw, or any number of similar names).

To understand the difference between the different file formats, we have to take a look at how the camera records a photo. It all starts with the exposure: Your shutter speed and aperture determine how much light hits the sensor. The image sensor records the data it finds, and multiplies the light captured by the ISO setting. If you are shooting at ISO 200, for example, the light measured by the imaging chip is multiplied by two.

This is the raw data that is passed through to the processor inside your camera. Now, if you are taking photos in Raw, this data is simply saved to a file. If you are taking photos in JPEG or TIFF, the camera processes the raw data: It applies sharpening, white balance, and any color/contrast settings. The problem is that as soon as the camera applies sharpening, it cannot be unsharpened again without a reduction in quality. Similarly, once white balance has been applied to a file, that white balance is "locked in." Until the camera processes your photo, it exists in a state where everything is possible.

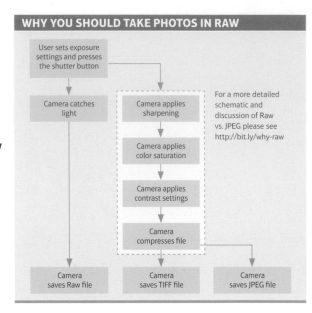

WHY YOU SHOULD TAKE PHOTOS IN RAW

User sets exposure settings and presses the shutter button

Camera catches light

Camera applies sharpening

Camera applies color saturation

Camera applies contrast settings

Camera compresses file

Camera saves Raw file

Camera saves TIFF file

Camera saves JPEG file

For a more detailed schematic and discussion of Raw vs. JPEG please see http://bit.ly/why-raw

When you're shooting in challenging lighting situations, the flexibility of Raw might save your photos for you.

File compression

TIFF files store the "rendered" or "processed" image in its entirety, without compression—which means that you still lose some flexibility, but at least your photos are as good as they can be, without compression artifacts. TIFF files are "lossless," so you can open, save, and close them a million times without seeing any image degradation.

JPEG files, on the other hand, compress the files, in addition to "processing" them. I have to admit, JPEG compression can be very good indeed, but no matter how you look at it, it is a "lossy" file format. This means that you lose data every time you save a file—and if you were to open, save, and close a JPEG file, you lose a little bit of quality every time you save it. It may not be noticeable; but if you've gone so far out of your way to invest in a high-end SLR or EVIL camera, do you really want your files to degrade as you're working on them?

Lossless editing

So, Raw files are brilliant because they don't "render" your photo: You can do all the edits that your camera would have done on your computer after the fact. Sharpening, contrast, white balance, and so on—it can all be done in software.

The other great Raw editing trick is the ability to do "lossless" editing. Software like Adobe Camera Raw and Lightroom open up your Raw file, and a "change" file. Every time you make an edit, instead of applying the changes to your Raw file, it keeps track of your edits in a separate place.

Why and what to edit

It's a very long time since photography was about taking a photo, handing the film over to a developer, and getting some prints. After the digital photography revolution, a lot of photographers (myself included) stopped seeing "opening the envelope" as the end of the photographic process. In fact, many of us now see photo taking as the beginning—rather than the end—of the workflow.

Global and spot edits

Photo editing is generally split into two different disciplines- one is "global edits," the other is "spot edits." As the names implies, the difference lies in how much of the photo you edit at once.

Global edits are edits that apply to your whole photo at once. Contrast, color balance, sharpening, noise reduction, cropping your photo, and exposure corrections are all examples of global edits. For various reasons, most photographers tend to do global edits to their photos before they do spot edits, mostly because you'll occasionally find that adjustments that apply to your whole photo negate the need for doing local edits.

Spot edits are the kinds of edits that have an effect only on a limited portion of your image. You might decide to "clean up" a discarded can of coke on the ground in one of your photos, for example, or to remove spots, acne, cuts, or other imperfections in somebody's face.

WHAT TO EDIT?

There's a huge difference in the levels of edits you might find in images, depending on what the photos are for. In news/reportage photography, photo editing is generally frowned upon, although some publications are less "honest" than others with their photography.

Somewhere in the middle of the editing gamut, in portraiture, you might decide that your main goal of a photo shoot is to make someone look gorgeous. A lot of photographers have a rule that they will edit "temporary blemishes" like acne and spots, but leave "permanent blemishes" alone; scars, tattoos and freckles, for example, are permanent. The reasoning behind this is that permanent features of somebody's face and body are part of their character, and should probably be kept.

The other extreme of photo editing world is glamour and fashion magazines, where the difference from the photo taken in a studio and the photo that goes on print can be drastic: Bodies are "re-sculpted," faces are slimmed, skin is smoothed, legs are made longer, and every gram of fat is digitally removed.

What degree of editing you choose to use is up to you. As an exercise of learning your tools, it can be interesting to do an extensive, elaborate edit of a photograph—the tricks you pick up along the way are useful even if you decide that the full digital plastic surgery treatment is a bit much.

Before and after a couple of simple global edits—how's that for an improvement?

Before

After

Global edits: crop and color corrections, straight out of the camera.

Spot edits: removing fish and tidying up image in general.

What software to use?

There is a lot of different image-editing software available out there, ranging from free, via entry-level software, to packages that will set you back as much as a new camera body can cost.

You may have heard of Photoshop. It's a fantastic software package that started out being just for photo editing, but these days it's a behemoth that can be used for almost everything. That's a blessing, as there are ten different ways to do anything you could dream of doing to a photo. The flexibility comes at a price, however. Photoshop has a very steep learning curve, and beginners are almost invariably scared away by it. In addition, you're looking at a huge price tag.

There is a cheaper version of Photoshop out there as well. Named Adobe Photoshop Elements, it's a stripped-down version of its bigger brother. It's easier to learn, but its simplicity can often be deeply frustrating to people who have more advanced photo-editing needs.

All-in-one packages

There is a lot more to editing photos than just making your photos look fabulous. There's little doubt that Adobe Photoshop and its baby sibling Adobe Photoshop Elements give you a lot of flexibility, but there are better overall solutions for photographers out there.

A good photography software package does much more than just offer you a way to edit photographs: Ideally, you are looking for a piece of software that takes care of your whole photography workflow, including downloading your photos to your computer, tagging them so you can find them later, viewing, editing, and exporting them, and taking backups.

Of course, it's possible to design your own pipeline that takes care of all of this, but isn't it easier to have everything in one place? I encourage all my students to take the all-in-one approach to photo editing, mostly because if photo editing is fast and easy, it also becomes fun. Fast and fun means that you learn much, much faster than if photo editing is a chore. Do consider investing the extra money for a proper software package.

The two main contenders for all-inclusive photo-editing packages are Apple's Aperture, and Adobe's Lightroom.

Aperture is only available for Mac, and there have been some questions about how committed Apple are to their professional product lines: Apple's Shake and Final Cut Pro products used to be professional-grade software. However, the former was axed altogether, and the latter was recently reduced to a tool that professional video editors are unable to use. It's a shame, because I'm a huge fan of Apple in general.

Developing a workflow

When photographers talk about "workflow," they generally mean everything that happens after you've pressed the shutter. It covers the whole process from downloading your photos to your camera through to their final destination, whether that's Facebook, Flickr, postcards, or a gallery wall.

In this chapter, I am walking through the workflow in Adobe Lightroom step by step. It is possible to do each of the steps manually as well, but it adds hugely to the complexity and the amount of time it takes to go through your workflow.

Getting your photos into Lightroom starts with the Import settings.

How you choose to keyword your images is up to you—but try to do it in a way that's going to help you find the photos you're looking for in the future.

1 Downloading your images

It's a great idea to use a card reader of some sort to get the photos off your camera. Some computers have built-in card readers that are generally very good—but you can pick up a cheap card reader online relatively inexpensively.

It's easiest to import the files directly into Lightroom. Insert your memory card, and Lightroom pops up with its import dialog box. Here, you can add additional EXIF data, such as your copyright information, keywords of your photos, and you can rename your files as well.

File names: Personally, I always rename my files using DATE—FILENAME. This means that all my image file names are unique, which saves me a lot of time. I can send low-resolution JPEGs to a potential client, for example, and if they decide they want to use a high-resolution version of a file, I can simply type the file name into the search box in Lightroom. Because the file names are unique, the correct file shows up right away.

Metadata: I have a metadata preset that inserts copyright information into my files as I import them, which means that I never forget to mark my files properly—including my email address in case somebody wants to license the photos for use.

At this point, you can also choose to apply "develop settings." If you want to turn a whole batch of photos into black and white, for example, you can choose a developing preset here.

2 Keywording your images

If keywording sounds like a bit of a chore, then I have to admit that you're probably right. The thing is, Lightroom has a very fast and efficient search engine built in—but it can only search metadata. If you remember that you took a photo of a yellow frog at one point, but you can't remember where or when, you could spend hours going through all your photos. If you've keyworded the photo with "Yellow" and "Frog" all you have to do is type in "yellow frog" in the search box, and it'll pop up immediately.

At import, I usually keyword my photos with everything the photos have in common. After a session of street photography in Ho Chi Minh City, for example, I would tag my photos with Travel Photography, Travel, South East Asia, Vietnam, Street Photography, Hanoi and Ho Chi Minh City. If I'm in a hurry, I may also tag the photo with "TO-TAG," which is a reminder to myself to do a search for TO-TAG at a later date, for additional keywording.

Once you've done your general keywording, you are already well on your way to making your photos easier to find, and depending on how many photos you take, you may decide to leave it at that. If you want more fine-grained search options, however, you can go through your most recently imported photos to add additional keywords. Words like "boy," "child," "male," "funny hat," "motorcycle," or "landscape" can come in useful later—or the name of the person or brand of product in the photos, and so on.

Developing a workflow

3 Time for a backup!
Now that you have all your photos keyworded, it's time to start thinking about taking a backup. Lightroom makes this easy for you; simply select all the images you just imported, and from the File menu, choose Export as Catalog. This exports the whole photo shoot, digital negatives and all, to one handy place.

I'd propose that "handy place" is an external hard drive that you only use for Raw files, before you've started editing them.

Yes, I wrote "Ivan the Terabyte" on the hard drive I use for travel. Because I am that geeky.

4 Ranking your photos
Ranking photos means giving your photos a rating from one to five, in order to help you decide which photos you are going to take a closer look at for editing.

Depending on how you take photos, you may be able to skip this step: If you've just been on a leisurely stroll and taken the odd photo here and there, it's easier to just dive straight in and do your editing.

If you've just done a studio shoot, however, you might have taken several hundred photos. The last thing you want to do is to spend an hour editing a photo, only to discover that a photograph shot a couple of frames after is much better than the one you just edited.

In Lightroom, the Star system works well for this. Pressing X marks a photo as "rejected." I usually reserve this for photos that are technically flawed: If it's grossly over- or underexposed, or out of focus, I know that no amount of editing can save the photo, so I'll reject it—and later delete the image files. For everything else press one of 1–5 on your keyboard. I use 1 and 2 for acceptable photos, 3 and 4 for ones that warrant a closer look, and 5 for photos that I think have potential of greatness.

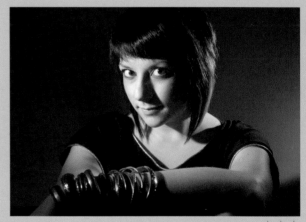

★ ★ ★

★

Once you've ranked your photos, you can show only the photos with, say, 3 stars or more, which should significantly reduce the number of photos you have to edit.

5 Global and spot editing
We'll be looking at the actual editing process a little bit later in this chapter, but once you have ranked your photos, it's time to do the global edits, and then the spot edits to your photographs.

6 Sharpening and export
The final steps of the process are usually done in a single step: exporting and sharpening. It's important to know that nearly all digital photos need to be sharpened as the very last step before you export them—the reason for this is that the amount of sharpening depends on the media (Web? Magazine? Canvas prints?) and size you're going to use them on. There's more on sharpening later in this chapter.

Finally, you export your files to the destination you want—we'll cover that in more detail in Chapter 10: Sharing and Evaluating.

7 Backup again!
The final step before you pack away Lightroom is to do a last backup. Lightroom will prompt you to do weekly backups anyway, but it's always clever to take a separate backup of your photos after you've edited them. There's no point in doing all that work, if you lose it all, should something bad happen to your computer.

Global editing

Any edits you make to your photos where the changes apply to your whole photo are known as "global edits." It may sound a little drastic, but the truth is that most photos benefit from a couple of tweaks in order to really stand out.

1 White balance
The first change needed on a lot of photos is a color tweak—we talked about this in Chapter 2 already, but let's take another quick look at the process.

By picking the white balance tool and clicking on the wall behind the camera lens, I ended up with a lovely photo; much better from a white-balance point of view.

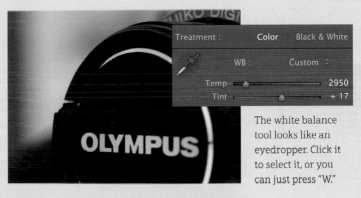

The white balance tool looks like an eyedropper. Click it to select it, or you can just press "W."

Ah, that's better.

Global editing

2 Crop

Now that the photo is white balanced, it's easier to see what you have to work with. In my case, I think I would like to do a crop next. Press the crop tool or "R" on the keyboard to get the crop tool working.

You now get a grid with the image split into nine equal-size parts. Yes, that's the Rule of Thirds you're seeing—isn't that useful!

You can use the crop tool to crop and rotate your image. For this particular photo, I'm going to do both.

3 Exposure adjustments

The next step is to take a closer look at the exposure—is your photo slightly over- or underexposed? Because we shot the photo in Raw, it means we have a lot of extra data to work with compared to when you shoot as JPEG files, so a slight under- or overexposure is not a problem, we can fine-adjust things here.

The Exposure slider does exactly what you'd expect it to—if your photo is a little underexposed, you can increase your exposure here, and vice-versa.

Recovery helps you if your photo is overexposed: It can't recover completely blown-out areas, but if you want to try and tease back just a little bit of extra detail in highlight, it's worth a shot.

Fill Light is nothing short of magic. It simulates using a fill flash, by taking the medium-dark areas of the image and brightening them. Of course, it's always better to use a diffuser or a reflector to fix any problems as you're taking the photos, but I'll have to admit that Fill Light has helped me out of a pinch many times.

To adjust the black clipping, you use the Blacks slider. This is great for adding additional shadows to an image —or for increasing the contrast in an image a little bit. You can use this slider to add drama to your photos quite easily, too, a technique that's especially effective on black-and-white photos.

Finally, you have a Brightness slider, which makes the mid-tones of image lighter or darker; similar to the Exposure slider, but Exposure adjusts all the tones equally.

A quick crop and rotate later, and we're much closer to the action.

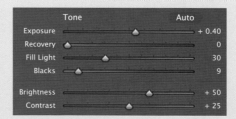

Under Basic, you'll find a series of exposure adjustment sliders.

For this photo, I decided to add a little bit of fill light (30), a little bit of Blacks (9), and a tad of extra exposure (+0.40).

Lightroom is a completely non-destructive editing tool. All changes and adjustments you do to your images are kept in a separate file, and your original files are safe. This means that you can experiment to your heart's content. If it all goes horribly wrong, you can always press the Reset button (bottom right), or go through an unlimited number of undos (History, bottom right, under the Navigator palette). These undos remain available even after you quit Lightroom, so you can always go back if you regret a choice made earlier on in the editing process. If only real life was like that!

If you're taking photos at particularly high ISOs filtering out "color noise" is particularly effective. Slide the Luminance noise reduction slider up about half way, and then increase the Color slider to see its effect.

4 Color adjustments

Next, it's time to do any color adjustments you want to apply; these are already discussed in Chapter 2, so leaf back and get those adjustments in place now.

There are a lot of creative options available in the Develop mode in Lightroom; you can do split toning to create selenium or sepia tones, for example, or to do creative black-and-white conversions. I highly encourage you to play around with the settings—if it all goes horribly wrong, you always have the "reset" button in the bottom right of your photo.

Zooming in to 3x magnification shows quite a bit of noise. These images show before and after noise reduction.

5 Noise reduction and sharpening

One of the things that keeps getting better and better—both in-camera and using computer software—is noise reduction algorithms. A few of the steps I did earlier in this workflow made the noise in the picture more visible—especially increasing the exposure and brightness.

So, in order to pull the noise back down a little, I applied some noise reduction (44). The noise reduction settings are quite powerful, but try to filter out too much noise, and your photo comes across as fuzzy; experiment to see what works best for your photos.

Sharpening is something you have to do quite carefully—and it's usually best to save this step towards the end of your workflow, when you export your images. Having said that, some cameras are distinctly "soft" before you've sharpened the images a little; Leica's M8 and M9 cameras, for example, are fantastic cameras indeed, but unless you sharpen the photos, you'd be forgiven for thinking they weren't.

Sharpening advice varies a lot from camera to camera, but I'd recommend you play with the settings a little—or do a quick search online to find out which settings other people are using.

In this case, I decided to reduce the vibrance (-37) and saturation (-40), and up the clarity a little (+50).

Spot-editing

Once I've concluded my global edits, it's time to get to work on spot-edits. Most photos can benefit from the odd edit here and there. People have spots, things get scrapes and dust on them, and landscapes are occasionally littered with the odd drink can or plastic bag. If it's ruining your photos, get rid of it!

To spot-edit something in Lightroom, you need the spot editing tool. You use it like this:

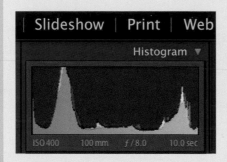

1 Go into Develop mode if you're not already there. To do a spot-edit, you drag your spot-editing tool from the bit you want to remove (the "target area"), to the bit you want to replace it with (the "sample area").

2 Select the Spot-editing tool by pressing the Spot-editing tool button, or by pressing "q" on your keyboard. Make sure the brush option is set to "heal," and not to "clone."

3 Always do your spot-edits zoomed in, so press Z to zoom into your image.

4 Try to replace as little as possible for every edit you do—so your brush should be slightly (but only slightly) bigger than the area you are trying to correct. You can adjust the size of your brush by using the Brush Size slider. Alternatively, if you are using a mouse that has a mouse wheel built in, you can increase or decrease the size of your brush by scrolling up or down: I found that to be a huge time saver.

5 To remove a spot, simply hover your brush over the spot. Click on the spot, and Lightroom will automatically find a nearby location to sample in order to "repair" the area you have selected.

6 Alternatively, you can hover your brush over the spot, click and hold your mouse button, and then drag your mouse to the location you want to sample. This is good for intricate work, and can often give neater results.

7 Remember that you can go back and edit the spot-edits you've done: Use your mouse pointer to grab the edge of a circle to change its size, or move the source or destination sample by dragging it to the center of a circle. To remove an edit, simply select it and press "delete" on your keyboard.

THINKING AHEAD

After you've done extensive spot-editing a few times, you start to appreciate the value of cleaning whatever you're taking photos with before taking the photos—wiping that lens cap off would have taken about 20 seconds. Time elapsed between the "before" and the "after" shot was exactly 26 minutes.

Spot-editing is the same on detailed jobs like this as it would be on people (editing out blemishes etc.), landscapes (removing rubbish or imperfections in a plant, for example), or any other photo you could think of.

The important thing to remember with spot-editing is to keep your brush as small as possible, and to do small-area edits before you do edits with a bigger brush. That way, your sample area is already cleaned up before you use it as a source for an edit.

Before spot-editing.

After spot-editing.

Exporting your images for use elsewhere

Taking photos is a lot of fun, and editing them makes them even prettier, so that's fun too. But what's the point in taking good photos if you're not going to do anything useful with them?

The great thing about Lightroom is that you can create different "export" preferences that exports your photos in the best possible way. I, for example, have exports set up for emailing photos (low resolution), sending photos to Flickr (medium resolution), making postcards (medium-high resolution, with sharpening for matte printing), and export for use in my books (full resolution, with a low amount of sharpening-for-print enabled). In your Export dialogue, you'll find the following options:

Export to allows you to choose whether you want to export to CD/DVD (great if you need to give someone a set of image files in full resolution) or to hard disk (best for everything else). You can also download a lot of different export plugins; to Facebook, Flickr…you name it. Do a quick Google search for Export, Lightroom, and your favorite photo sharing service, and you'll probably find a suitable plugin.

Export Location is where you choose where you export your photos to. I normally export everything to a folder on my desktop, but you can also set up photos to export directly to a specific folder somewhere else.

File Naming is good if you want your files to change names as you export them. For photos I upload online, I like to ensure my name is included in the file names, for example, or you can include things like "-web" or "-fullsize" at the end of file names, which is handy if you want an easy indicator of how big your files are.

It's no good having all your photos just sitting there in Lightroom—the world wants to see them!

This dialog box is your highway to getting your photos out into the world. It's boring, but important…

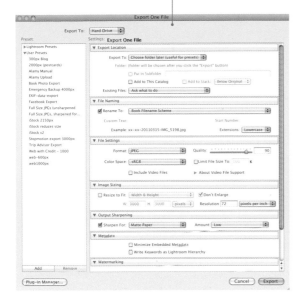

Sharpening your images for the right destination

Output Sharpening is an output setting many people overlook, but it's very important indeed. The issue is that photos that are unsharpened can look rather fuzzy by the time they reach their final destinations.

In the past, there was a lot of guessing involved with how much you should sharpen your photos, but Lightroom is making the process a lot easier, by giving you some simple presets: Sharpen for Screen, Sharpen for Matte prints, and Sharpen for Gloss prints, each with three levels of sharpening—Low, Medium, and High.

It's difficult to illustrate how much of a difference these export settings can make in a book, but I invite you to try it yourself: Export a detailed photo without sharpening, then sharpen-for-screen in each of the three amounts of sharpening. Your unsharpened photo will look dull compared to the three others.

How much sharpening you apply depends on your personal preferences—but do experiment with this setting, because that final little bit of extra sharpness can make your photos pop out of the screen in an absolutely incredible way.

File Settings is where you choose your file format (there's quite a few to choose from—but in general, you'll want DNG (Digital Negative) if you want to edit your files more at a later date, or JPEG for everything else. Because this is your very last step of your image-editing process (and because you're keeping your Raw files in your Lightroom library), this is the only time where it doesn't really matter that you're using a "destructive" file format.

Image Sizing is where you choose the output size of your files. This is perfect for stuff like Facebook; I don't want to upload my photos in full resolution there, so I make sure they are "resized to fit" 1000x1000. This means that the files are resized to fit in a 1000px by 1000px box.

Watermarking is where you can choose to embed a watermark into the photos you're exporting. I'm not a huge fan myself, but if you want to reiterate to the outside world that your photos are indeed yours, it's not a bad idea to overlay a copyright notice on your images. You can easily use a text- or image-based watermark on your exported photos.

When you're happy with your output settings, you can either use the new settings once, or save them as a preset by clicking "add" and giving your preset a name.

Fact: Without sharpening, this photo wouldn't be as cute.

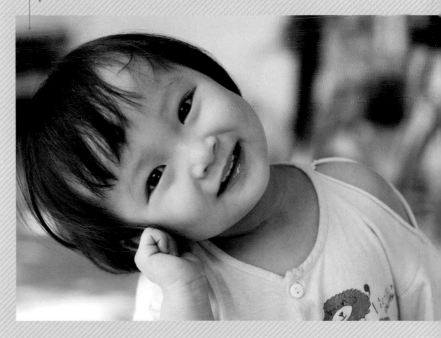

A few words about backups

Let me open with a little anecdote: I moved house once. After all the boxes had been carried into the house, both me and my housemate were exhausted, so we decided to pop to the shops to get some beer to relax for the rest of the evening. In the twenty minutes we were gone, somebody broke into the flat, and stole everything I owned—every single box. All my clothes, all my computer equipment…and all my backups, too.

Sure, having all your possessions stolen is a little bit extreme, but when you think about it, there are a lot of things that could happen: Fire, thieves, water leaks, anything. I don't know about you, but I look at it like this: My camera and computer equipment can be replaced. My years of traveling the world taking photos? That's irreplaceable.

So, think about backups before the worst happens.

Choose how to back it up

When you're at home, backups are relatively simple. Buy a couple of external USB2 hard drives, and back up all your photos to both drives. Keep one at home, and leave another drive somewhere safe: At your parents, at work, or in a safety deposit box. Basically, anywhere that isn't your house.

A recent development is that there are a lot of online backup solutions that are fully automated. In addition to the drives mentioned above, I use Mozy (bit.ly/mozhome), a fully automatic backup service. I also use Dropbox (bit.ly/drop-welcome) which is a similar service. They both work very well. Have a look at both, and see which one you prefer. Call me paranoid, but I'm using both.

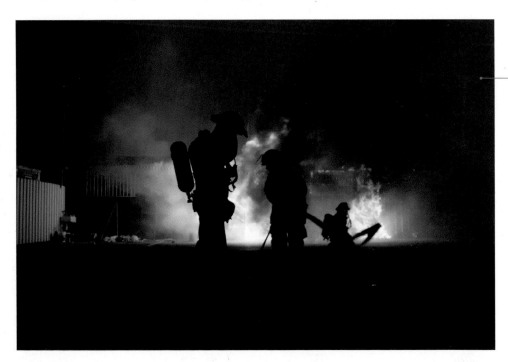

House fires; great photo opportunity, bad news if your computer equipment and all your backups are inside.

Check your backup integrity

Remember that you have to be sure that what you are backing up is actually working: There's no use in taking a backup of a corrupted file. Obviously, you can't check every file for integrity every time, but what you can do is ensure that you keep older backups, too.

Only recently, I discovered that I had deleted a folder of pictures by accident several months ago. If I had only kept a recent snapshot of my pictures folder (as it were, pun fully intended), I'd have been buggered. Luckily (or rather, due to having a sane backup strategy), I was able to dig out an older backup of my photos folder, which still contained the deleted folder, and I was able to restore my photos. Phew!

For important shoots (like weddings, for example), I immediately burn them to DVD—that way, I know I have a backup somewhere that cannot accidentally be overwritten or deleted.

Think about where you store your backups

It's important to think about how you are storing your backups. Remember that you're backing up for all sorts of reasons: If your computer breaks, an external hard drive is handy. But what if someone breaks into your house?

Personally, I keep a hard drive connected to the network hidden away in the attic. That way, a casual burglar is unlikely to run off with it, so even if my computer is stolen, I don't lose my photos.

In addition, I keep a backup on an external drive which I leave at my parent's house—it's low-tech, and the backups are generally about two months old every time I swap the drive over, but it's better than not having an extra backup. Finally, I have the online backups.

And finally...try recovering the backup

The best thing that might happen to you is that you go your entire life without ever having to restore a backup. Nonetheless, it is an extremely good idea to try it anyway.

If you're unable to restore your backups (perhaps there's a problem with the backups? Maybe the restore feature of your favorite backup package isn't working?), you may as well not bother with the hassle of backups at all: They're only useful if you can use them if the worst happens.

A bank deposit box is worth considering if your photos are irreplaceable and valuable. A huge-capacity hard drive is quite small, so you don't need a lot of space.

CASE STUDY From mediocre to retro glam

I have a confession to make; when it's raining outside, I can't motivate myself to do much photography—even if the shoot I would be doing would be happening inside anyway. Weird, isn't it? What I do love to do, however, is to sit at my computer and go through old photos. Every now and then, I stumble across a shot where I think "This thing is mediocre at best…but what if…," and when I next look at the clock, the photo is unrecognizable from its original self, and several hours have flown by.

Digital editing isn't a crutch; you can't turn a bad photo into a good one. But if you have one that is technically okay, but not very inspiring, there's nothing to stop you from working a slice of digital magic.

Obviously, you don't have to go all-out to edit your photos, but this example does show that your creativity is the only thing standing between you and creating some seriously interesting photographs.

From mediocre to masterpiece in five simple steps

1 Start with a photo that's technically OK, but that doesn't really inspire you.

2 Crop your image and adjust the brightness to your liking. Then, apply Split Toning to get a cool, retro-looking two-tone.

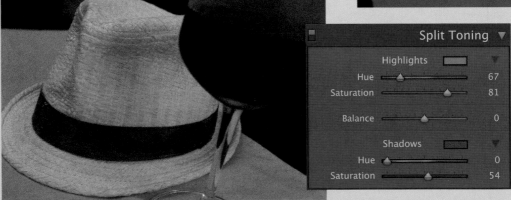

3 Find a cool texture to apply to the photo. In this case, I am using free texture of grungy, stained paper made by Max Stanworth (see http://bit.ly/qJQIqi).

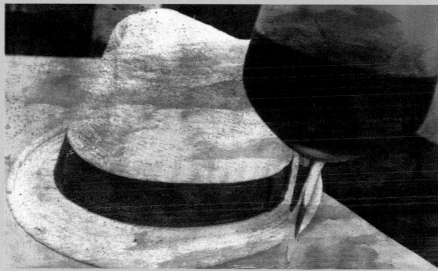

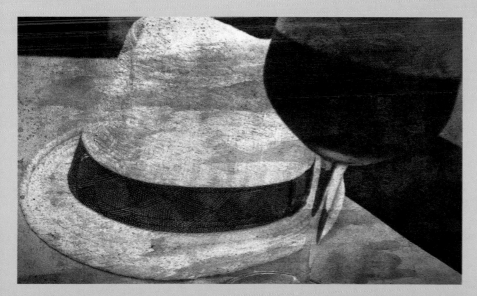

4 Open up both files in Photoshop, and place the photograph on top of the "paper" texture. Align them properly so the paper covers up the whole photo. Then, change the channel mode of the paper layer to "overlay." Back to Lightroom, add a bit of vignetting and do some final tweaks to colors and contrast.

5 Save your file, and upload it somewhere so people can admire it. Not bad for a picture that wasn't all that impressive to begin with!

Sharing and Evaluating

If there's one thing every photographer wants, it is to develop as a photographer. In order to achieve that, however, you have to go back to a very basic question: To become a "better" photographer, the big hurdle people often run into is understanding what is "better" or "worse" in the first place.

We've already talked a little bit about what makes a "good" photo back in Chapter 6: Better Pictures Through Better Composition.

To develop, then, you have to start learning to identify how certain elements of your photography can be improved. This touches on being a better technical and creative photographer, of course, but there is a lot more to it than that. Achieving enough insight into your own photography to be able to pull yourself up by your bootstraps is a challenge, to say the very least, but overcome that challenge, and you've unlocked the possibility of continuing to improve your photography forever.

You'll find that when you start experimenting with new techniques, the learning curve gets steep. This was one of my first Infra-Red photos, and obviously I still had a lot to learn.

Self-critique

1 What are you unhappy with? Can you put into words what you feel ought to be better in your photos? Are the issues mostly technical, or do you feel that it's lack of inspiration that's getting in the way of your dream photos? It's important to be quite clear about what it is you don't like.

2 What can you do to improve it? Now that you have a little list of issues with a photo, you can think about your toolbox: Do you have the knowledge and equipment to solve the problem? Personally, I've discovered that "equipment" rarely is the problem—so it's a case of applying what you know about light, lenses, and camera settings to try to find a solution to your challenges.

3 If you improve point 2, will that fix point 1? The final point in my 3-point plan is to analyze whether the solutions you've come up with are good enough to save the day. Sometimes, you'll find that you've done everything in your power and knowledge to make a photo work, but it just doesn't want to play nice. Honestly? It happens. But the great news is that the focused approach you've chosen throughout these three steps means that you've gone through a process of self-critique that will help both these and future photos.

A photo taken with the web-cam on my computer (!) was never going to be anything to write home about.

But I did see an opportunity—and after a bit of editing in Lightroom, I ended up with a vaguely useable photo. It's not amazing, but I love the challenge of using rubbish photography equipment, and seeing if I can still make something of it.

Tracking progress

One thing I often notice with my students is that they're not really feeling as if they are making an improvement. The problem isn't that you're not improving, but that you're so involved in your photography that you're not noticing the huge leaps you're making.

It's important to always keep learning, of course, but it's equally important to stand back and see how far you've come. I always encourage my students to put their photos on Flickr—and I suggest you do the same. It doesn't matter if you show them to the world, or just set them to "private" so only you can see them; the point is that the linear nature of Flickr means you can go "back in time" quite easily.

Every now and again—and especially when you're feeling you're not progressing—take a look at the photos you took six months or a year ago. You'll spot mistakes or decisions in your old photos that you would never have made today. You'll remember why you liked a photo, but you'll suddenly spot something you overlooked the first time around. That does two things: If you can fix the problems in post-production, you can go back and improve your old photos. And even if you don't, you've just noticed something you didn't notice before. That probably means that you have a new perspective, new skills, and new knowledge. Fabulous: I guess you improved more than you thought!

Looking at old photographs (in this case, from 2002), reminds me how far I've come as a photographer.

Evaluating someone else's photos

There's a huge advantage to being able to efficiently critique your own photos, because, you are always available. It is very easy to get stuck in a "pattern," however, of not spotting the downsides of a photograph—or to get caught in a spiral of negativity.

Having someone else look over your work and give you some constructive feedback can be extremely helpful. That is especially true if you are able to get feedback from several people who don't mind being honest with you. It's sometimes useful to get feedback from people who don't "speak" photography. Of course, it's handy if a photography buddy says "You should have stopped down your lens here to achieve a deeper depth of field," but sometimes a layman's view gives you a revelation or two on a more general scale.

"Why are all your models looking so grumpy?" was a big revelation given to me by a friend who didn't know much about photography. The answer was "because I told them to be," but that got me thinking: Why was I telling my models to be moody all the time? The next time I did a photo shoot, I managed to get loads of awesome shots, because the models were connecting better with me because they were able to smile. The images had more impact and "sparkle"; and when I finally did do a couple of moody shots later in the session, those photos came out better, too, because there was more of a rapport between myself and the model.

What to critique?

Personally, I like to use a template for my critiques. That might seem a little bit rigid, but truth be told, it's too easy to forget something in a critique otherwise. You may be praising a photo, and forget to look at the technical side, for example. Or, even worse, you could get hung up on a tiny technical flaw in a photo, and forget to tell the photographer how impressed you are about the premise or concept of the photo shoot.

It's easy to find a few things that are good about this photo (depth of field, lighting, and the intensity in the boy's determination to get at his hat that fell in the fountain), but the composition is hardly award-winning, and the photo lacks a strong focal point.

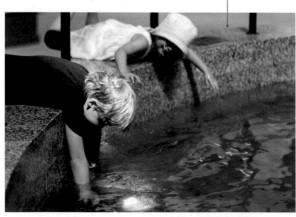

It's not as sharp as it could be, and the light is a little bit uneven—but frankly, I don't care: every time I see this photo, I'm reminded of my first try at product photography. And about how much of the beer I had to drink before I finally got this image!

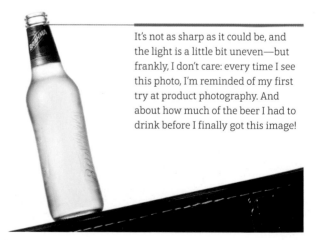

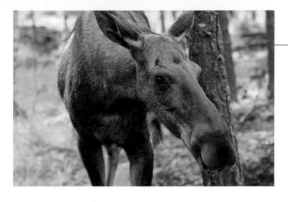

Imagine my surprise when I ran into an elk in the forest in Norway. I was so flustered that I couldn't get a single decent photo of the magnificent beast…

What should you do about critique?

Even though it's nice and useful to receive critique on your photos, it's always worth bearing in mind that, ultimately, the photographer is boss. Some of the most famous photos in the world aren't without their flaws, and some of the richest photographers in the world have yet to take a single perfect photograph.

The key to receiving criticism is to bear in mind that you, as the photographer, have a fuller "picture" of what you were trying to achieve. Perhaps a photograph that is slated by fellow photographers on Flickr still is your favorite picture for some reason—and that's perfectly okay.

You're the photographer, and you decide what to do with criticism. Take it to heart, bear it in mind, or ignore it altogether—up to you. Whatever you do, try to stay open to the possibility that someone's trying to help you become a "better" photographer. Just bear in mind that their "better" might not align with what you think of as "better."

If I knew in 2004 what I know now, I would have approached this shoot very differently—and with a lot more artificial lighting.

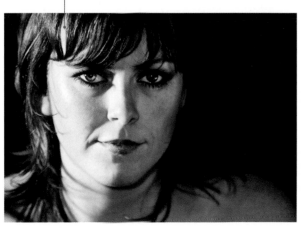

TOP TIPS: EVALUATING YOUR PHOTOS

Take your time. Look at the photo properly, make sure you haven't missed any details.

Interpret the photo. What do you see? Do you see any symbolism? What do you think the photographer meant by the photo? Is there a message, whether hidden or overt? If the photograph inspires thoughts—what thoughts, and how is the photo affecting you?

Look at the technical side of things. Exposure, focus, any blur, color treatment, sharpness, creative post-processing—all the things that belong in a photo. Has the photographer aced everything, or is there room for improvement? Remember to comment both on the positive and the negative side of things.

Artistic points. Do you agree with the way the photo is framed? Does it tell the story efficiently, or are there aspects that could be improved to make the image more impactful?

Positives. This is your opportunity to combine the good points about a photograph; even photos that leave a lot to be desired will have good things about them—find a few, and encourage the photographer to explore and develop those sides even further.

Opportunities for improvement. You know that lovely phrase "Constructive Criticism"? This is where you put it to work. Personally, I always decide to highlight more positives than negatives; so if I find five good points about a photograph, I might decide to highlight only one or two downsides.

Overall impression. Sometimes, you find yourself rambling on and on about negative aspects of a photograph, and ultimately none of it matters, because the overall result can be amazing. If that's the case, this is a great time to tell the photographer!

Sharing your photos online

To me, photography is a highly expressive art; sort of like dancing, I suppose. While many of us get a great deal of pleasure from dancing by ourselves while doing the dishes (no? just me, then), if you're feeling that you're getting the hang of dancing, perhaps you want to show off in a club, at a party, or even on stage?

It works exactly the same with photography—and the bar-to-entry is quite low: Even if you are just starting out, you can tap into the vast community that exists on the Internet to share your photos—and hopefully get a bit of feedback along the way, too.

I thought it was funny to see the Space Invader urban art looking suspiciously at the yellow thing. Only after I posted this to Flickr, someone told me what it's called (it's a Belisha Beacon, apparently).

Learning from other photographers on the net

One of my favorite sites for sharing photographs online is DeviantArt (http//:www.deviantart.com)—which has a strong community feel and a great photography section, in addition to a lot of illustrators, animators, painters, craft artists, and everything in between.

Focusing more specifically on photographers, you can't really avoid Flickr. With more than 51 million registered users and thousands of groups for special-interest photography, it's an enormous resource for just about anything you could possibly want to know about photography.

Uploading your photos and adding them to groups is a great way to get feedback, and since there are so many photographers, you're likely to find someone who is at the same level as you. When you do, contact them, and see if they're interested in doing mutual critiques. Set challenges for each other—you can get some great results.

A WORD OF WARNING

Of course, not everyone on the Internet is equally nice; in photography terms, that means that everything you put on the web is at risk of having your copyrights infringed. While you do have legal recourse to try to stop people from using your photos, it's often a huge pain, and it costs a lot of time and some money to "police" your copyright.

Depending on what you use your photos for, you may have to get permission from the people you've photographed.

Some photographers deal with the issue by watermarking their images, by uploading only low-resolution versions of their images, or by refraining from uploading their photos at all. It's a risk-and-benefit analysis. Personally, I don't like watermarks much, and I do like to share my photos (in medium resolution—up to about 1000 pixels) with my Flickr followers.

There are other considerations as well; privacy issues (who's looking at the photos of your kids?), potential future embarrassment (if you do upload photos of yourself doing dumb things, is it going to come back to you later?), and any number of other issues. Just remember that anything you upload to a public website could, in theory, be seen by anybody.

From image files to the big world

Setting your photos free in the big world is exciting—and it saves you having to worry about Christmas presents ever again!

Sharing your images goes far beyond just uploading them to an odd website here and there; as your photos get better, the opportunity for sharing them to a wider audience becomes better. Christmas gifts, birthday cards, or even art for your own walls—the possibilities are endless.

When you're thinking of blowing your photos up to big sizes, there are a couple of extra considerations you have to bear in mind. What looks nice and sharp on screen could look fuzzy when you print it in large formats—so it may be a good idea to get a good high-quality large-format print of your photo before you decide to invest in more exotic (and expensive) printing techniques.

Print quality varies wildly from company to company— and if you go to a shop to get your prints done, they can vary from shop to shop and from operator to operator in the same shop. It's a bit of a mixed bag, and there are only two ways to know whether you're getting the quality you want: personal recommendation, or trial and error.

Photographic prints aren't that expensive. Get a few prints done on letter-sized paper, and you'll get an idea how they'll come out. Also, remember what we were saying in the Digital Darkroom chapter about sharpening—if you're planning to get big prints made of your photos, try out some different sharpening settings. Especially in large format, picking the correct sharpening levels becomes important!

Turning the creativity to 11

You can get your photos printed on puzzles, mugs, bags, laptops, and wallpaper—the sky is the limit. Try a search for "Photo Gift Ideas" or similar, to be bombarded with thousands of possibilities. Here's a couple of cool ideas to get your creative juices flowing.

Touchnote (http://www.touchnote.com) is a great service that turns your photos into postcards—and they'll send them anywhere in the world for you, too. The quality is fantastic if you upload suffienctly high-resolution files, and the cards get shipped quickly.

Fracture (http://www.fractureme.com) prints your photos on glass. They really have to be seen to be believed; vibrant colors, fantastic sharpness, and a quality that is out of this world. They didn't even pay me to say that.

Canvas printing (many different vendors) is another great gift idea: Your photos are printed on canvas and then put on a wooden frame. You can either choose to put them in a frame, or just stick them on the wall as they are; the combination of the low-tech-canvas look and a well-chosen photograph makes for intriguing results.

Glossary

Adobe
A software company whose products include Photoshop and Lightroom.

Aspect Ratio
The ratio between the width and height of an image. Traditional television has an aspect ratio of 4:3, 35mm film is 3:2, and wide-screen television is 16:9.

Auto Exposure
Letting the light meter in the camera determine which shutter time and aperture should be used for a given scene.

Auto Focus
When using automatic focus, the subject in front of the camera lens is brought into focus by letting the camera determine when the subject is sharpest.

Back Lighting
Lighting a subject by placing it between the camera lens and the light source.

Bayonet Fitting
A quick-release fitting to attach a lens to a camera, common on all EVIL cameras. The alternative is a screw fitting.

Bokeh
The shape and quality of the out-of-focus highlights in an image, usually in the background.

Camera Raw
Camera Raw is a lossless file format.

Catchlight
A catchlight is a small dot of white in somebody's eye—it gives your model a "glint" in the eye that often makes a photo look more natural than if it were omitted.

Continuous Lighting
The opposite of flash lighting. Desk lamps, shop lights, and the sun are examples of continuous lighting.

Depth of Field
The amount of an image that is in focus is known as DOF. Shallow depth of field means little of the image is in focus, deep DOF means more of the image will be in focus.

Diffuser
A photographic prop used to make light appear less harsh.

Directional Light
Light that comes from a particular direction—like direct sunlight, or flash light—is known as directional. If the light comes from many directions at once, such as sunlight diffused through clouds, it's known as omnidirectional.

Display
On digital cameras, the "display" refers to the small LCD monitor found on the back, which allows you to preview your images as you work.

DSLR
A digital Single Lens Reflex camera.

Exposure
The combined settings of aperture, shutter time and ISO setting used when taking a photograph is the exposure of that photograph.

Extension Tube
A mechanical device that allows a lens to be held securely in place a distance away from the camera body.

Fixed-Focus Lens
A lens that cannot change focal length. Also called a prime lens.

Flash
A single strobe light used in photography.

Focal Length
The focal length of a lens is the distance light has to travel between the front lens element and the film or imaging chip, measured in millimeter.

Focus
Focusing a lens means that it is adjusted in order to concentrate light to give a sharp image on the imaging chip or film of a camera.

Golden Hour
The hour just after sunrise or just before sunset, so named after the warm quality of the sunlight. This is usually a great time to take photos.

Gray Card
A piece of plastic or cardboard that is calibrated to 18% neutral gray. It allows you to do light measurements and white-balance measurements.

Histogram
A function present on many cameras, giving a graph representing the gray values of a photograph. Useful for trouble-shooting exposure problems.

Hot-Shoe
The metal connector on top of all SLR and many EVIL cameras that enables you to connect an external flash units.

Imaging Chip
A light-sensitive chip that converts light into electrical signals. Used instead of film in digital cameras.

JPEG
A Joint Photographic Experts Group file is a lossy image file format: The file size is smaller than TIFF and Camera Raw files, but due to its compression algorithms, subsequent open-edit-save procedures degrade the image quality.

Memory Card
A card that holds the images you photograph. They come in different sizes, generally from 64MB to 8GB. They replace the storage element of film in digital cameras.

Monopod
A one-legged tripod. It is better than photographing free-hand, but not as stable as a tripod.

Negative Space
The shape, location, and quality of everything that isn't actually the subject of the photo.

Noise
Digital noise in an image manifests itself as specks of brightness throughout an image. It is usually especially prevalent at higher ISO settings, and at long shutter times.

Photoshop
The industry-standard professional digital image manipulation package. Currently in version CS5. The easier to use and vastly cheaper consumer version is called Photoshop Elements.

Prime Lens
Prime lenses are lenses that have only a single focal length. These lenses are generally of high quality and low price, compared to their zoom lens counterparts.

Reflector
A photography prop used to reflect light.

RGB
Common abbreviation for Red, Green, and Blue, the color channels used in digital image manipulation. The other oft-used one is CMYK, which is used for print work.

Shutter Speed
The time that a shutter is open. Typical shutter times in macro photography range from 1/1000 of a second up to about 2 seconds.

SLR
Single Lens Reflex camera. A type of system camera that uses a single lens connected to a camera body. Focusing and framing is done via the lens, during which you look through a prism and a mirror.

Subject
The thing you are taking a photo of is known as a subject.

System Camera
A type of camera geared toward taking different types of lenses, flash units, and other accessories, as opposed to fixed-lens cameras.

Threading Adapter
An adapter used on the front of a compact or EVIL camera, which enables it to accept filters and other attachments that need to be screwed into the front of a lens.

TTL
Abbreviation for Through The Lens—a flash technology where the camera measures the actual flash output as seen by the lens.

White Balance
A way to tell your camera which color is supposed to be "white."

Zoom Lens
A photographic lens that has more than one possible focal length, such as 28–100. A lens with a fixed focal length is known as a fixed-focus lens or a prime lens.

CHAPTER 11 // RESOURCES

Index

For Ziah

Thank you for continuing to dare me to do crazy things, even though I'm old enough to know better.

Acknowledgments

Even though I'm very proud to have my name on the cover of this book, it would be a complete fabrication if I claimed I could have created something quite this fantastic all on my own.

A big thanks to Angela Heidt who proved invaluable in shaping some of the initial concepts of the book.

My utmost thanks to the fantastic team at Ilex press, including Adam Juniper, Natalia Price-Cabrera, Tara Gallagher, James Hollywell and Katie Haynes. An extra special thanks to Zara Larcombe for superhuman patience and oodles of great advice.

Finally, do stay in touch. Come look me up at @ Photocritic on Twitter, http://flickr.com/ photocritic on Flickr, or http://photocritic.org!

Picture credits

The Publisher would like to thank the following agencies for their kind permission to use the following images:

iStockphoto/53BL: Enviromantic; 62TR: Plougmann; 62L: Craftvision; 62BR: Iconogenic; 67R: m.p.imageart; 70B: Xin Zhu; 70C: Kevinruss; 73R: Leah-Anne Thompson; 94: Morkeman; 96T: Michele Lugaresi; 101BC: Marko Misic; 101TR: Dragan Trifunovic; 106: Clint Hild; 110L: Gabriel Moisa; 111T: Silvia Boratti; 116: Wesley Bane; 117BR: Subjug; 117BL: Adrian Baras; 120CR: -ilkeryuksel-; 120C: Becky Rockwood; 120BC: AVTG; 121B: Vikram Raghuvanshi; 129BR: Shantell; 129T: MorePixels; 130: Kertlis; 131T: Sergiy Trofimov; 132R: Dwight Nadig; 138R: Levent Songur; 138L: Oleg Filipchuk; 143TR: Chris Gramly; 143B: Katarina Blazhievskaya; 143TL:; Intransfer; 144R: Maria Zoroyan; 144L: Amanda Rohde; 145L: Dmitriy Shironosov; 145R: Vyacheslav Osokin; 147BR: Clint Spencer; 148L: Gabor Izso; 148R: Lisa Thornberg; 151L: Trout55; 153: MicroWorks; 155B: Aleksandra Prill; 155T: Kurt Drubbel; 156: Oleksiy Mark; 157T: Nicholas Homrich; 157B: Valentin Casarsa; 158: Dean Mitchell; 163: Peter Zelei; 176: Dmitry Pistrov; 177: 3dfoto.

The Kobal Collection/161R: Walt Disney Pictures.